HEIDE CHRISTIANSEN

Charming ENGLAND

teNeues

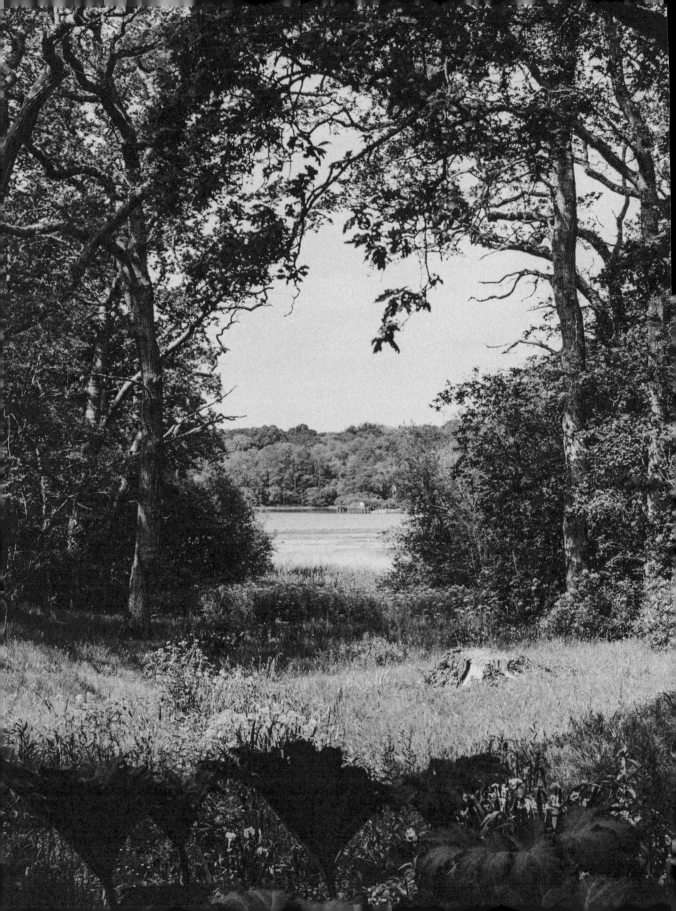

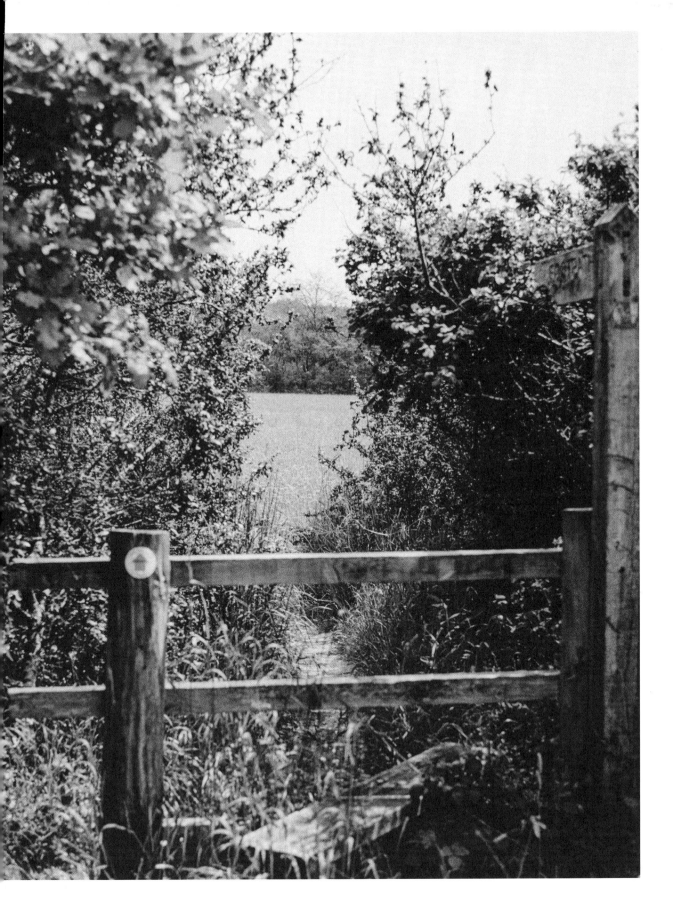

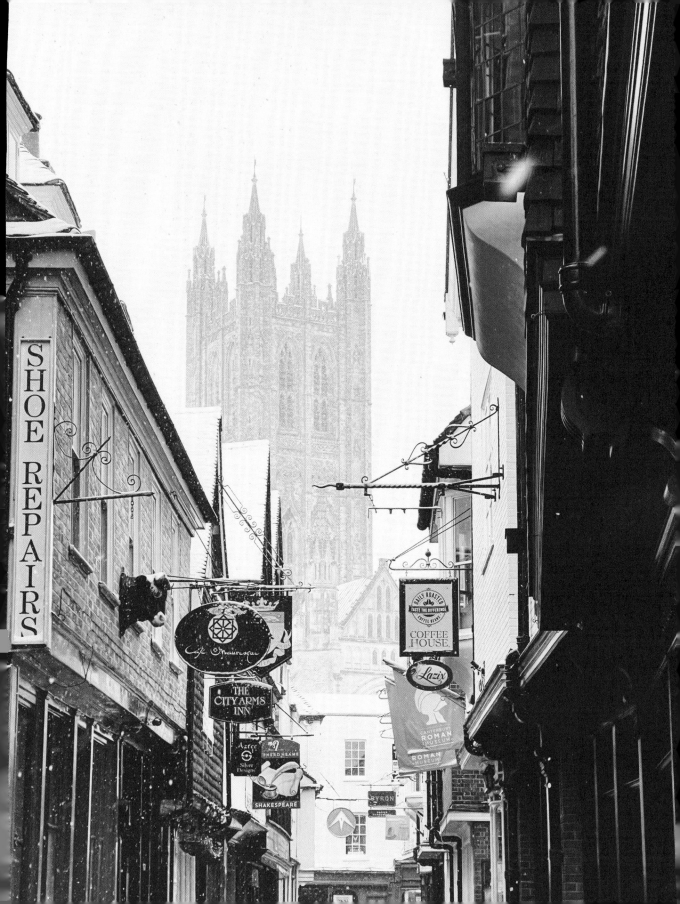

CONTENTS

FOREWORD

ENGLAND—ROMANTIC BRITAIN

A while ago I found this quote by Oscar Wilde, who was known for his pithy remarks: "I don't desire to change anything in England except the weather." Although I can probably recall a thing or two about Great Britain that could stand a bit of change, I can also well relate to the Irish writer's appreciation of certain aspects of his chosen abode: the invigorating beauty of the outdoors; the regal manors and mansions amid sprawling estates, old castles and picturesque ruins; small villages full of half-timbered architecture that look straight out of medieval times; the quirky charm of authentic fishing villages on the rugged coasts. Such comes to mind when I think of England. When I travel to Britain, I always plan at least a short stay in London, where I never tire of exploring the city's massive diversity. Each visit rekindles my amazement at the variety, magic, and charisma of this wonderful metropolis. And not only London, but so many other parts of England have enchanted me with their flair. The Cotswolds are what I most associate with Oscar Wilde's praises. I go there to experience the beauty of old things, where nobody seems to desire to change anything about the unhurried simplicity of life's rhythm. The deliberate pace is what I love so much about the tiny villages full of delightful little stone houses or thatched cottages with enchanted-looking gardens. Where else I think is most charming in England I will reveal to you in this book. Join me for an inspiring photographic journey, let's find some of the most beautiful places in Britain together and share the enchantment of Charming England. I go whenever I can.

Heide Christiansen loves exploring the most beautiful places on Earth and using expressive, tone-setting images to construct amazing narratives. Writer Anja Klaffenbach is also enthusiastic about travel and the experience of discovery. She writes about their shared passion for the world's most charming spots.

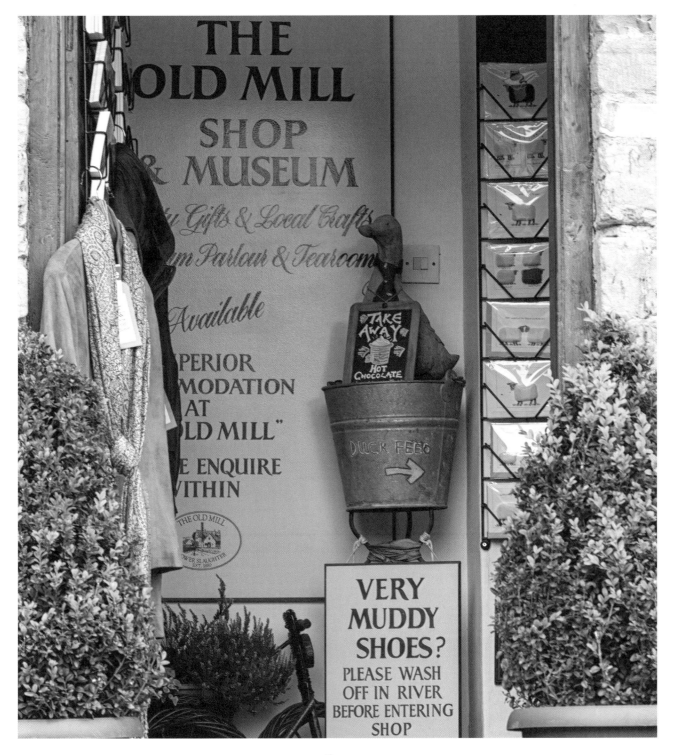

Above:
Sometimes the Cotswolds seem like a living museum, preserving the magic of times gone by for us—like the old mill in Lower Slaughter here.

Previous pages:
Charming England: Exbury Gardens (page 2), hiking (3), Dartmoor National Park (4), Canterbury (5), Notting Hill (6) and Chelsea (7). Vanilla yellow like a custard tart—some of London's bakeries whet the appetite for sweets from the outside (page 9).

p120-

Liver

The So

Plymouth

Newcastle

North

York

Leeds

Sheffield

idlands &

East

Birmingham

Cambridge

England

The

Cots-

olds

Oxford

London

The South

East

West

Portsmouth

Charming
ENGLAND

THE COTSWOLDS

THE BEATING HEART OF GOOD OLD ENGLAND

Is "good old England" still anywhere to be found? It is in the Cotswolds. The impression, here in Britain's rural southwest, is of time stood still. Gentle green hills punctuated by sleepy villages showing the visual harmony of a painting. Just as we must have seen in the old days, rows of honey-colored stone houses with close-set, white casement windows and us half expecting a horse-drawn carriage about to round the corner. Even now, the drive from Stratford-upon-Avon, Shakespeare's birthplace, to Jane Austin's Bath feels like a journey through time. This region, which stretches from Worcestershire and Warwickshire in the north across Gloucestershire and Oxfordshire and down into Wiltshire, has a rich history. There's also great hiking, and it's no surprise the area was declared to be "of Outstanding Natural Beauty". Numerous trails crisscross the extraordinarily beautiful landscape, entering villages along the way such as Bibury, Castle Combe, Chipping Campden, and the Slaughters. It is a bit like a movie set, with an obligatory Gothic-style stone church and windblown, tilting headstones on God's acre. Nearby are rows of small shops and old-fashioned pubs, where a person can take refreshment from a traditional ploughman's lunch and a pint of ale. At every turn, there's a sense that people appreciate, cherish, even nurture the past. Even if a delicatessen or little tea shop selling homemade cakes and scones has moved into the wood-paneled room that used to house the old pharmacy at the village apothecary's, it's fair to say an old-time atmosphere has survived. The charm of this quiet, even sleepy district is that no one is rushed or trying to hurry you. The Cotswolds have dedicated themselves to the maxim of slow tourism of a gentle kind: life at its own, laid-back pace, a meandering stream flowing across the Cotswolds …

Right:
Typical of the Cotswolds is the arcadian growth of wisteria up old stone walls and partially obscuring the occasional gate, which seems full of secrets like the entrance to an enchanted garden.

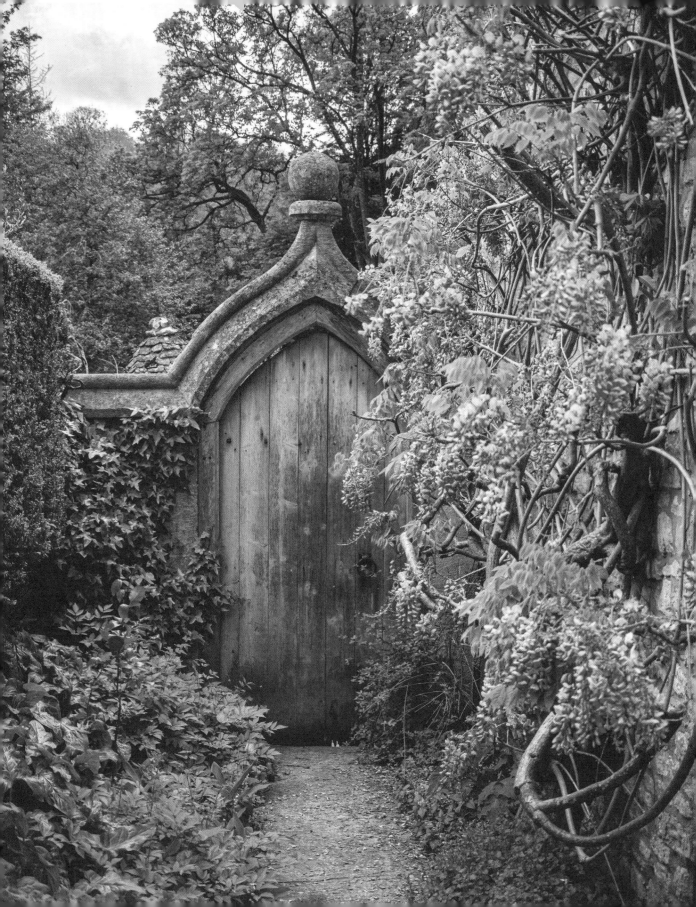

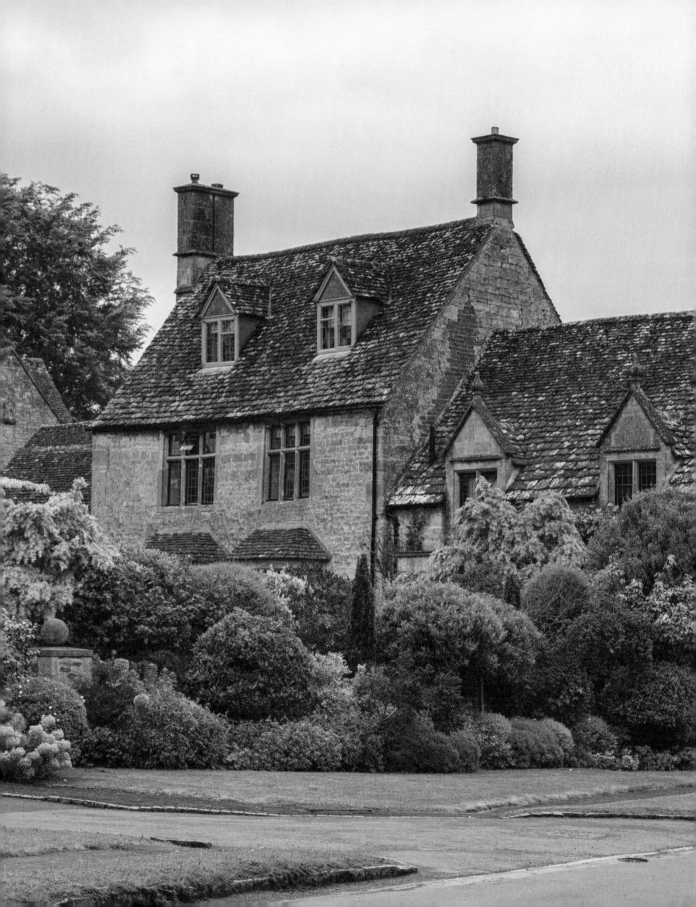

These pages:
Eccentrically English: Broadway Tower (above) is the prototypical folly, a picturesque yet useless decorative structure built for its sheer compositional effect.
Even in Victorian England, artists like Henry James and William Morris swooned for the honey-colored stone houses on Broadway (left).

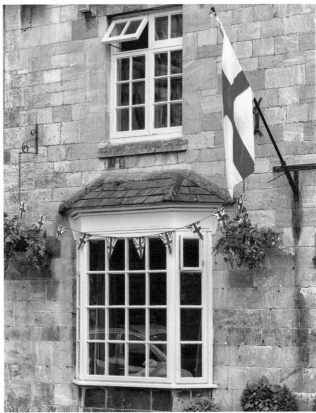

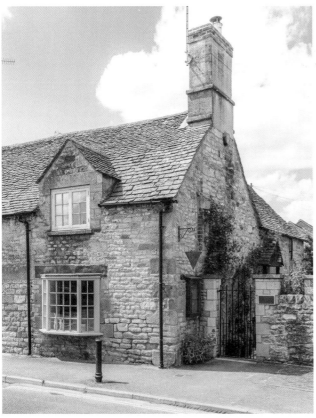

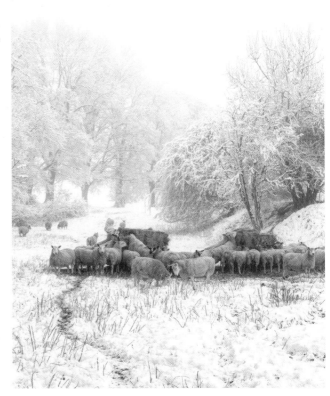

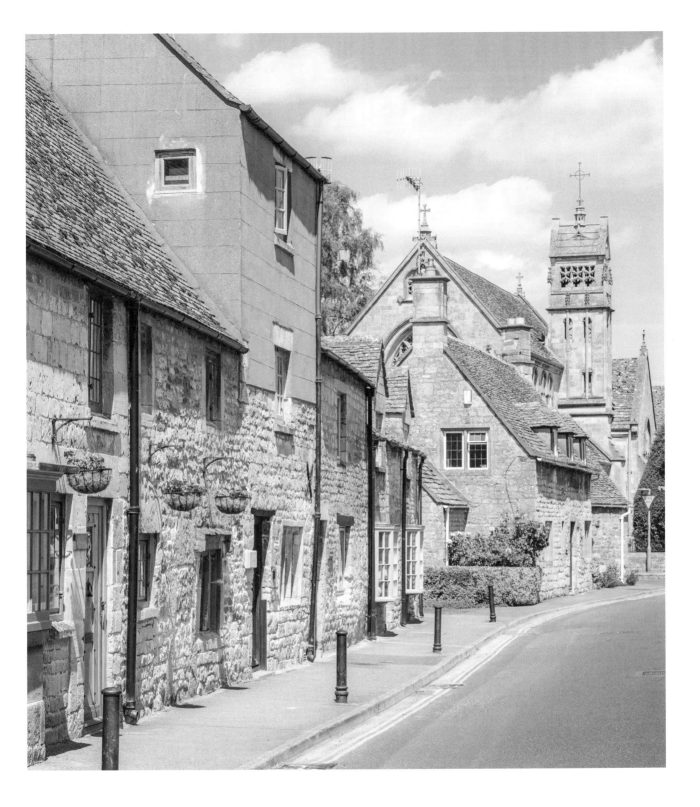

These and the following pages:
Chipping Campden and Broadway (following pages) in the northern Cotswolds became wealthy in the Middle Ages by exploiting their positions in the wool trade. A ramble through the picturesque hamlets is enjoyable: browsing small shops, stopping at one of the old-style, nostalgic tea rooms.

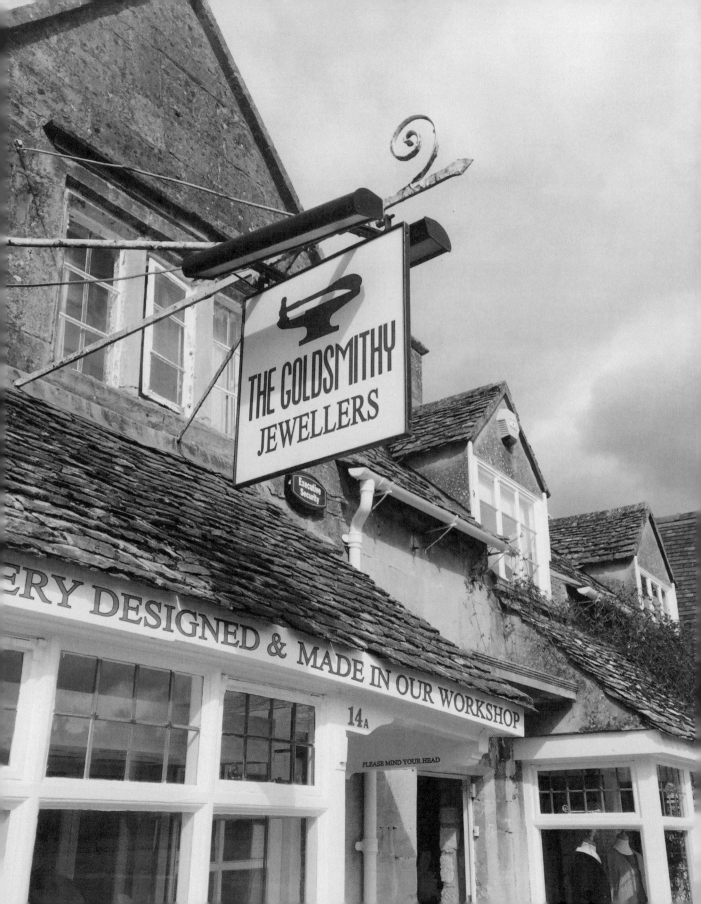

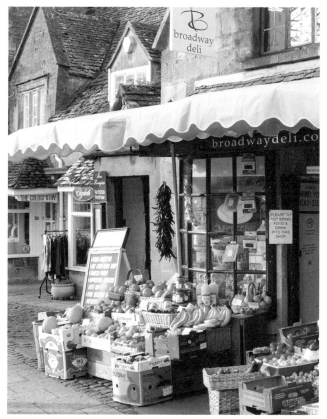

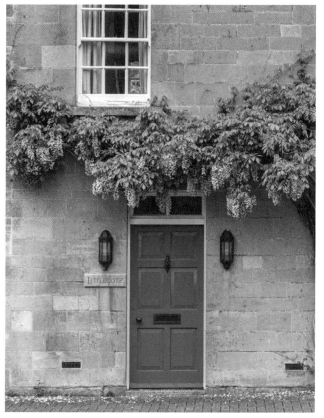

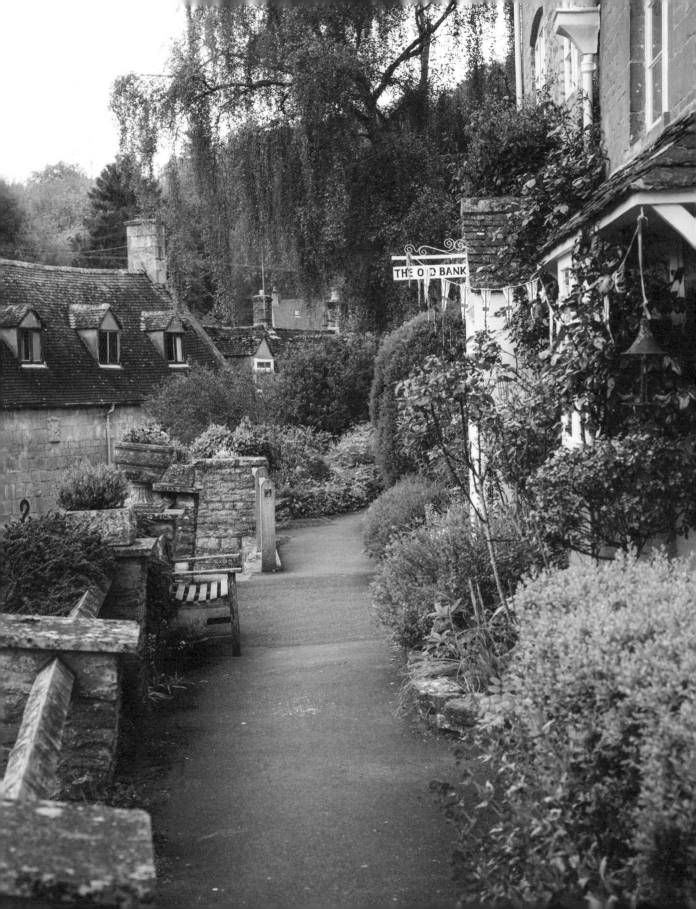

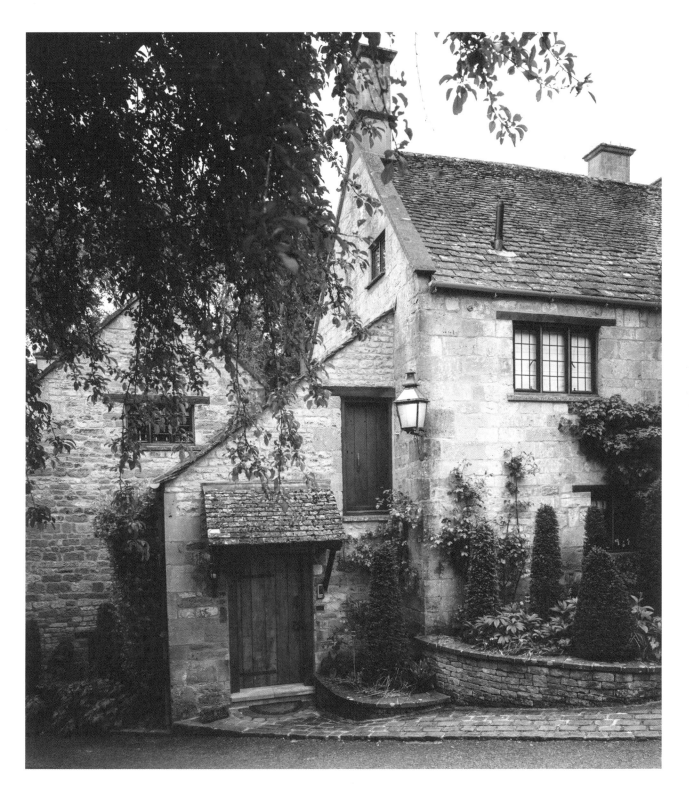

These pages:
*The Cotswolds are full of convoluted little stone buildings, built for the ages like those in Blockley (left)
or Moreton-in-Marsh (above). The warm, golden-yellow patina of the Jurassic limestone gets more striking
as the stone weathers.*

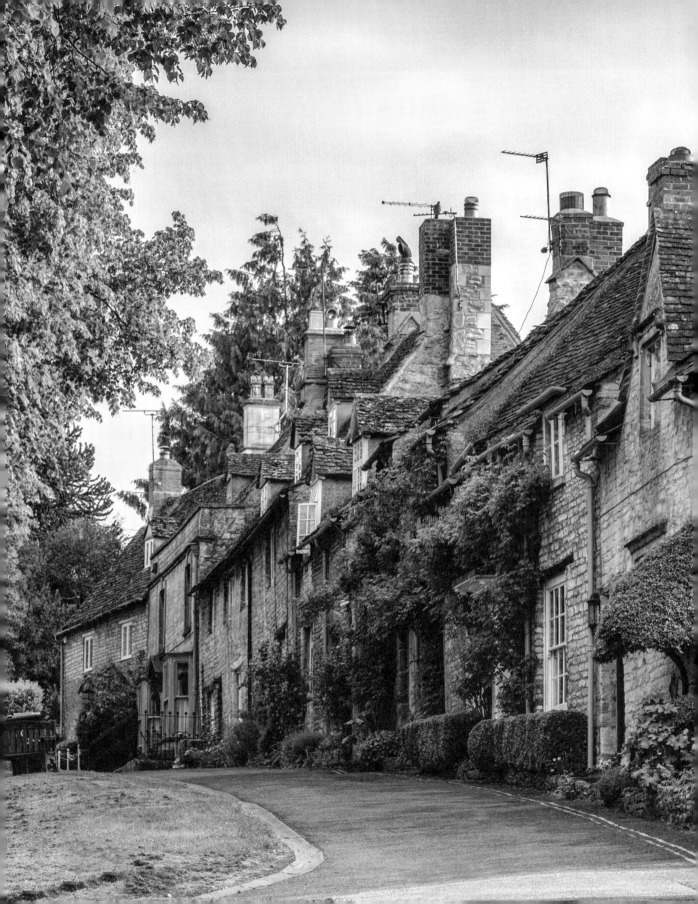

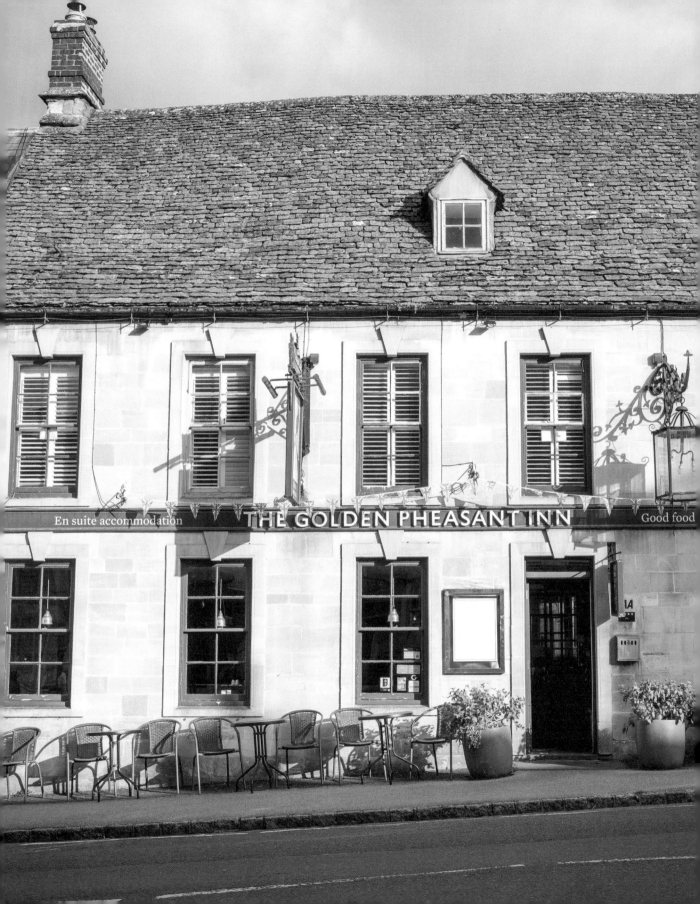

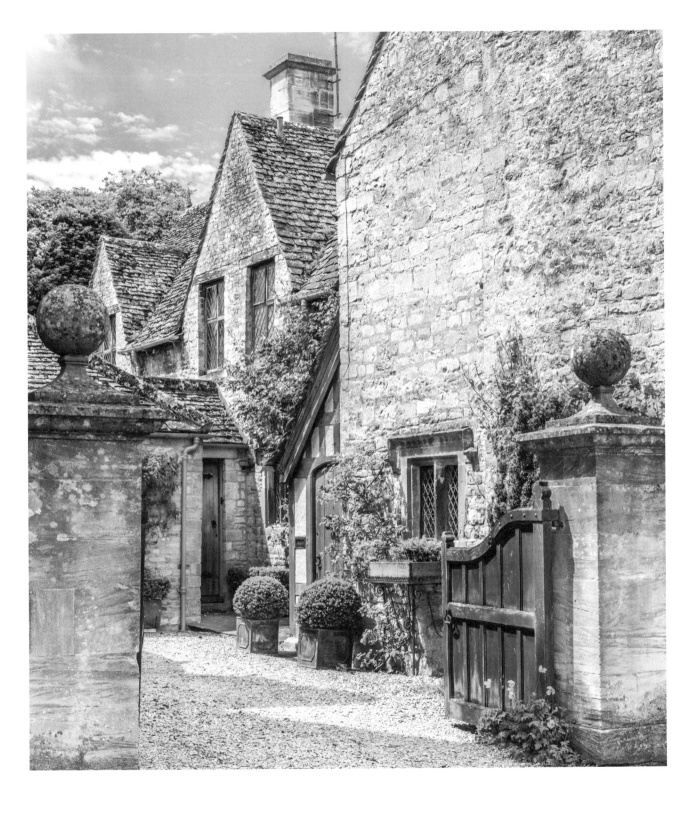

These and the previous pages:
Magical: In villages like Burford, traces of the past are well preserved.

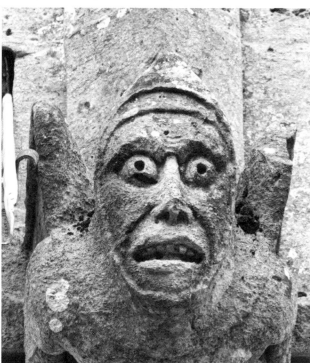
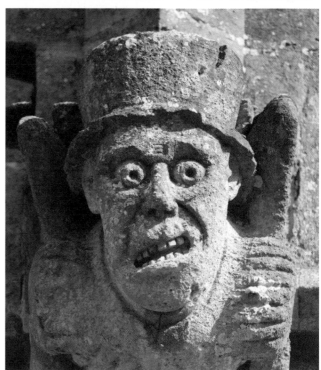

This page:
The odd, fascinating waterspouts of St Peter's Church, Winchcombe.
Right:
*A visit to the knot garden inside the walls of Sudeley Castle is like a waking dream. The other garden spaces
surrounding the castle chapel of St Mary are just as enchanting.*

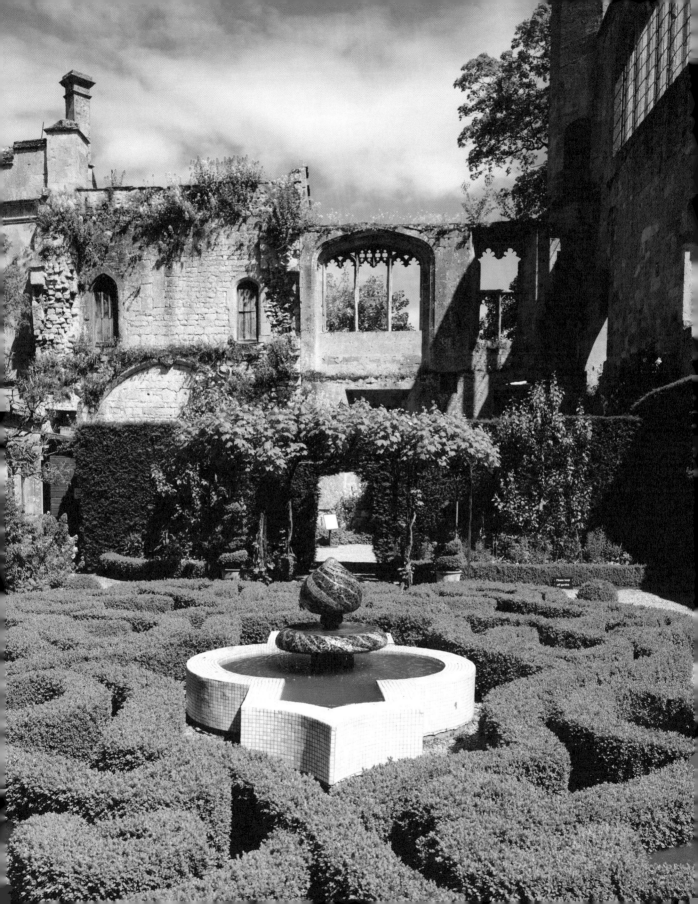

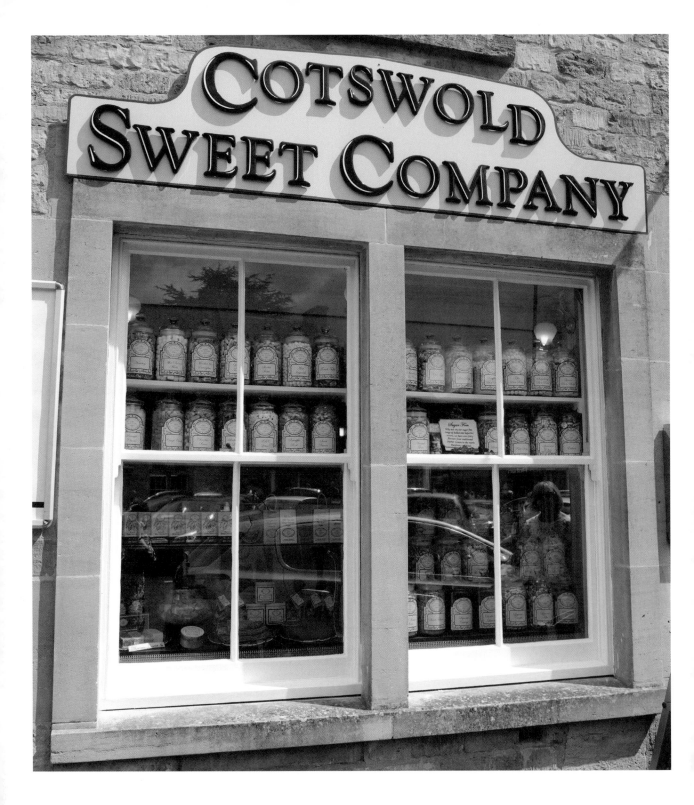

Above and at right:
It's worth visiting the idyllic towns of the Cotswolds if for no other reason than to see the charming storefronts of the old village shops.

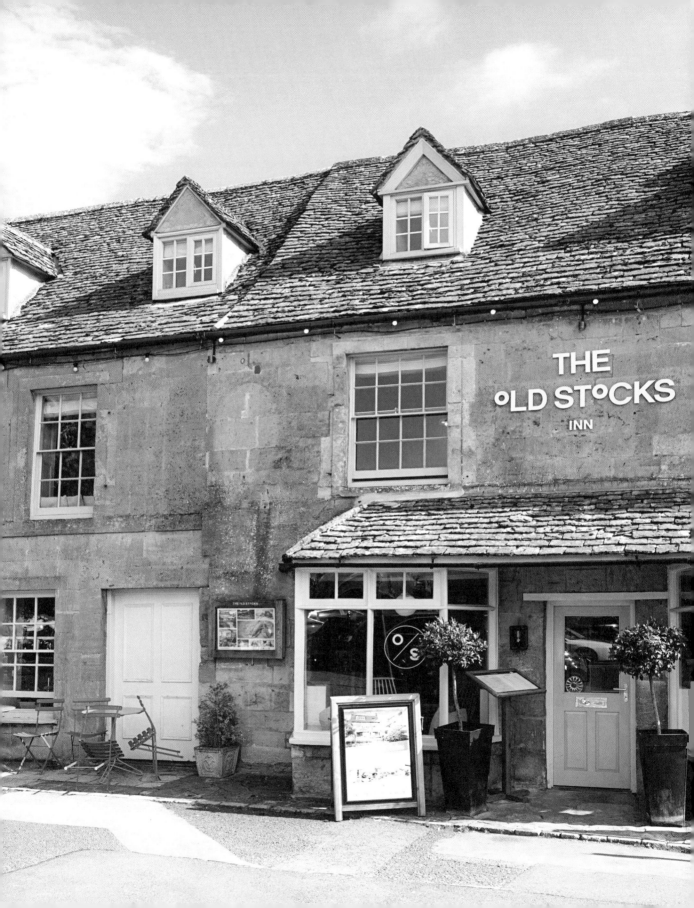

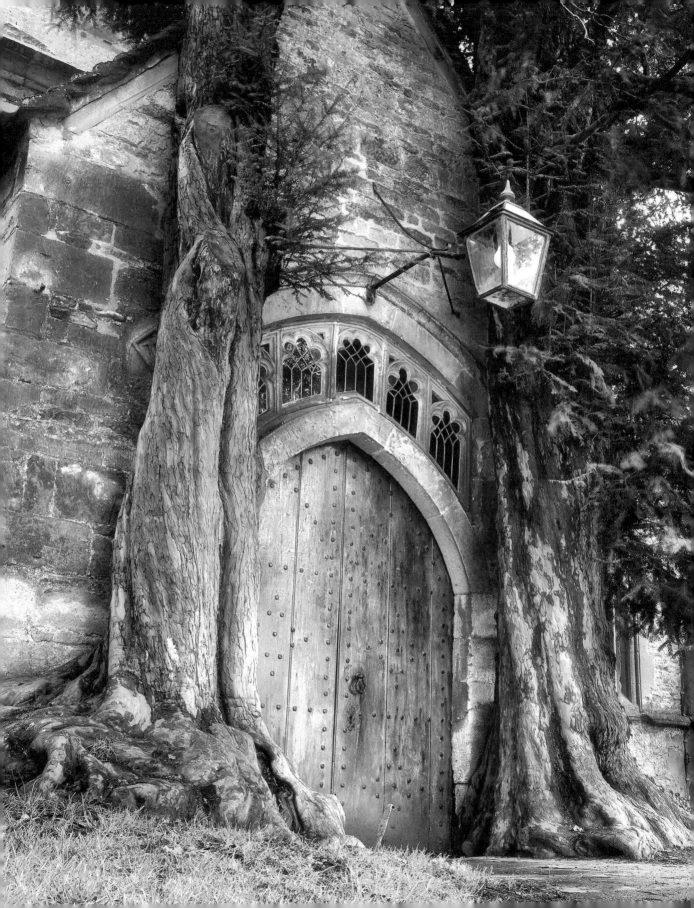

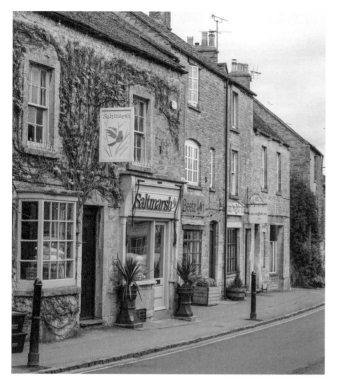
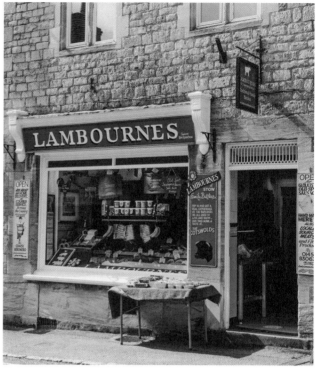
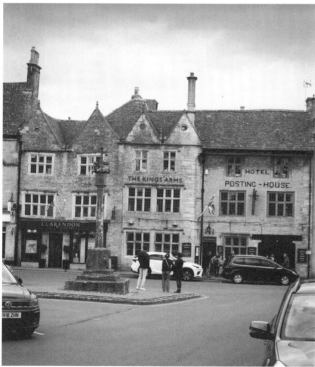
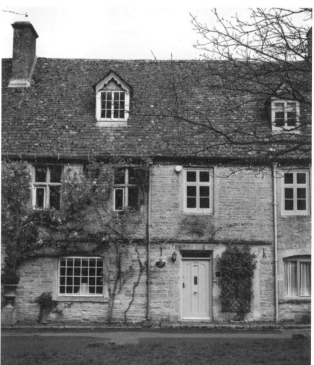

This page:
Small shops, old-style pubs: In Stow-on-the-Wold, past and present are one.
Left:
Overgrown with gnarled yew-trees: One of the doors on St Edward's Parish Church, Stow-on-the-Wold.
Is this the gateway to the faerie realm that inspired J.R.R. Tolkien?

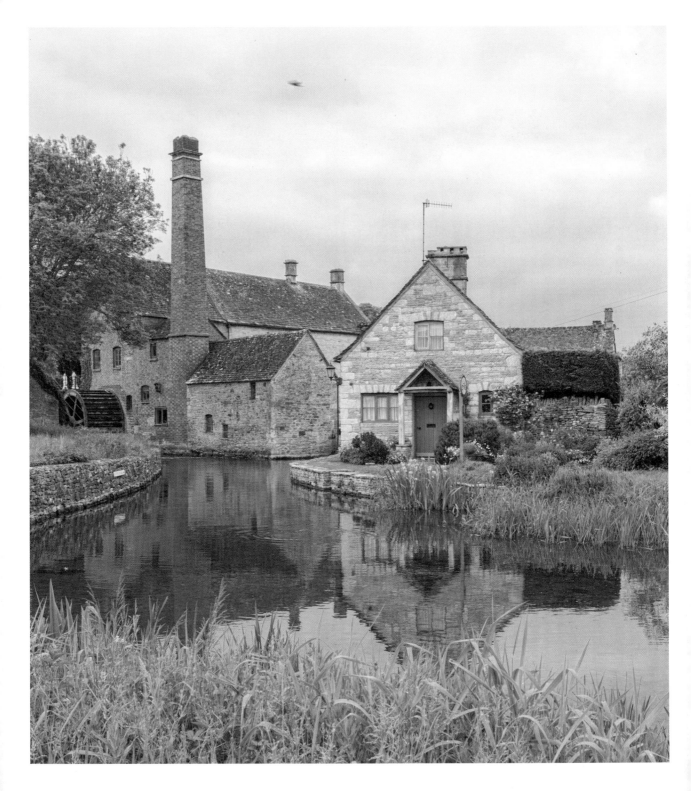

This page:
The old mill in Lower Slaughter was recorded in the Domesday Book, England's historical land register from the year 1086. Today the mill houses an enchanting little museum.
Right:
Charming little cottages, like these in Upper Slaughter, line the village streets.

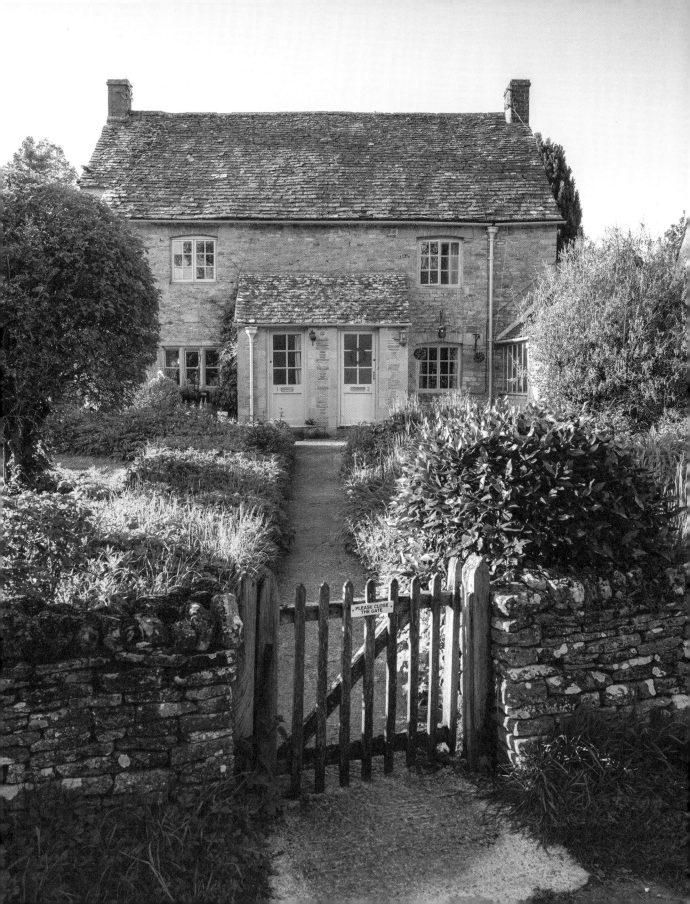

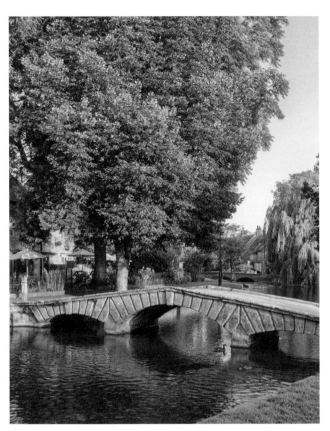
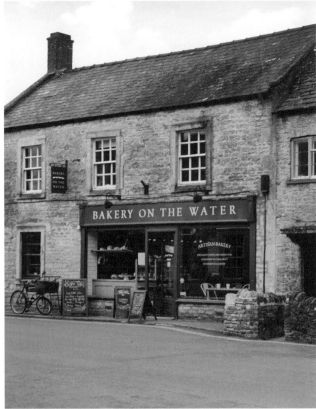

Above and at left:
The River Windrush meanders through Bourton-on-the-Water—not the only unhurried feature of life in this Gloucestershire village. Who wouldn't like to stop at Bakery on the Water for fresh buttered scones?

Above and at right:

For antique automobile enthusiasts, Bourton-on-the-Water is worth an excursion. The outstanding Cotswold Motoring Museum offers fascinating exhibits on the history of the automobile.

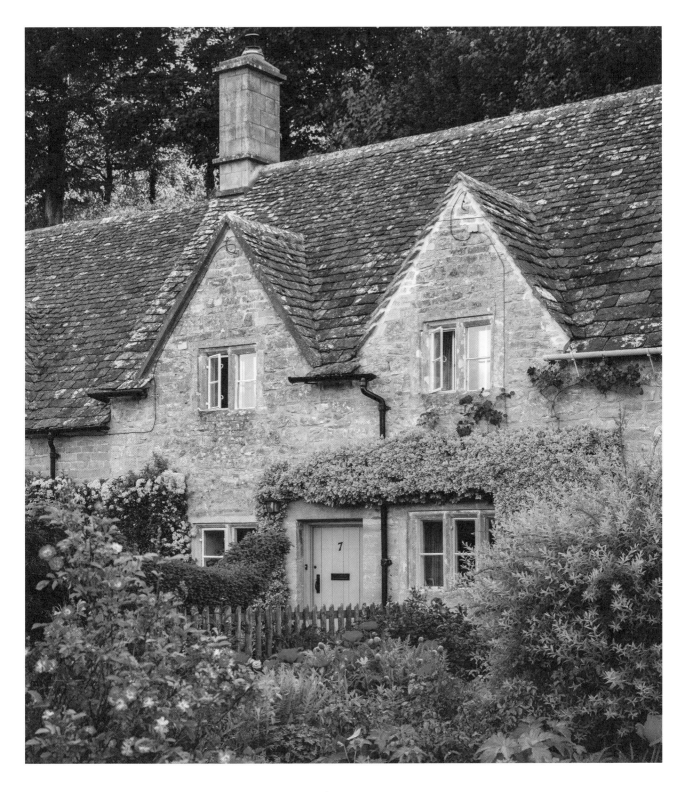

This page:
Succumb to the delirium: Beautiful flowering vines on the stone façade of this cottage in Bibury.
Left:
Bourton-on-the-Water is a great place to settle in alfresco with a pint of ale and a view up and down the banks of the River Windrush.

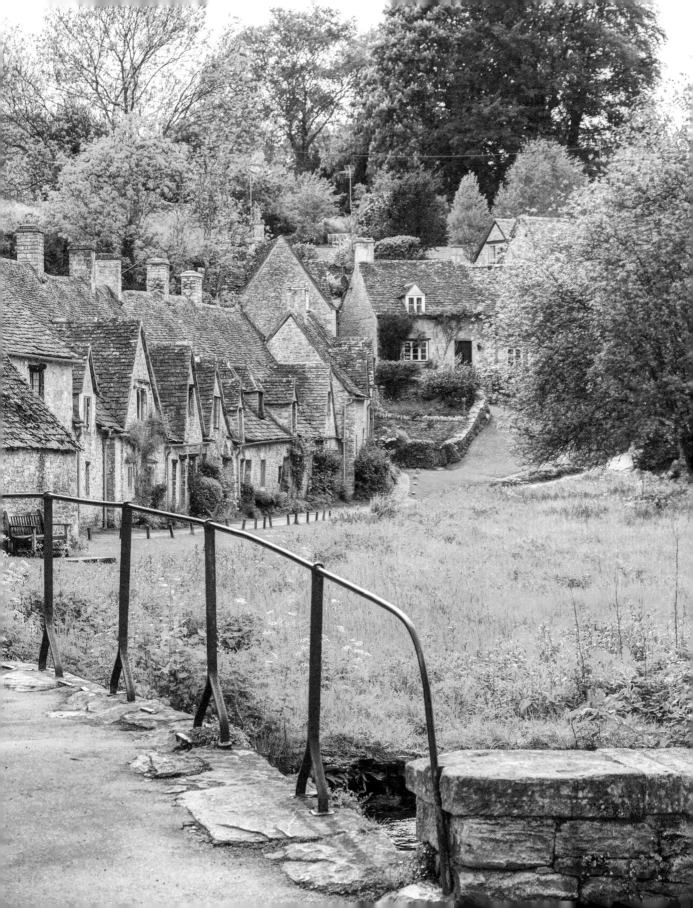

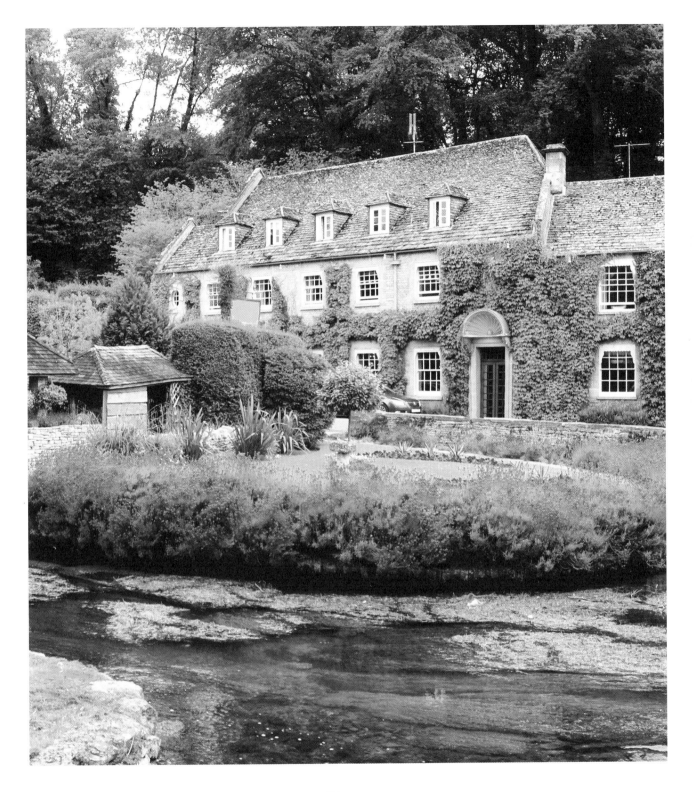

This page:
There's hardly a more idyllic Cotswolds scene than The Swan Hotel. All of Bibury feels conjured up out of a coffee-table book.
Left:
Artist and designer William Morris praised Bibury as perhaps the most beautiful village in England.

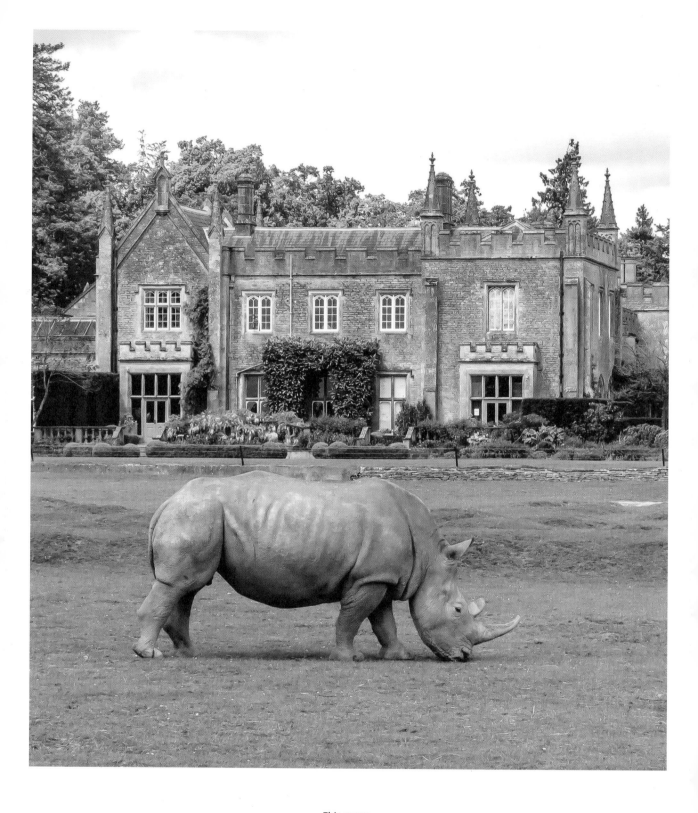

This page:
A rhinoceros in the Cotswolds? Bradwell Grove has been home to a wildlife park since the 1970s.
Right:
Victorian impressions in Burford: The twin gables of Tiverton Villa embedded in a charming garden.

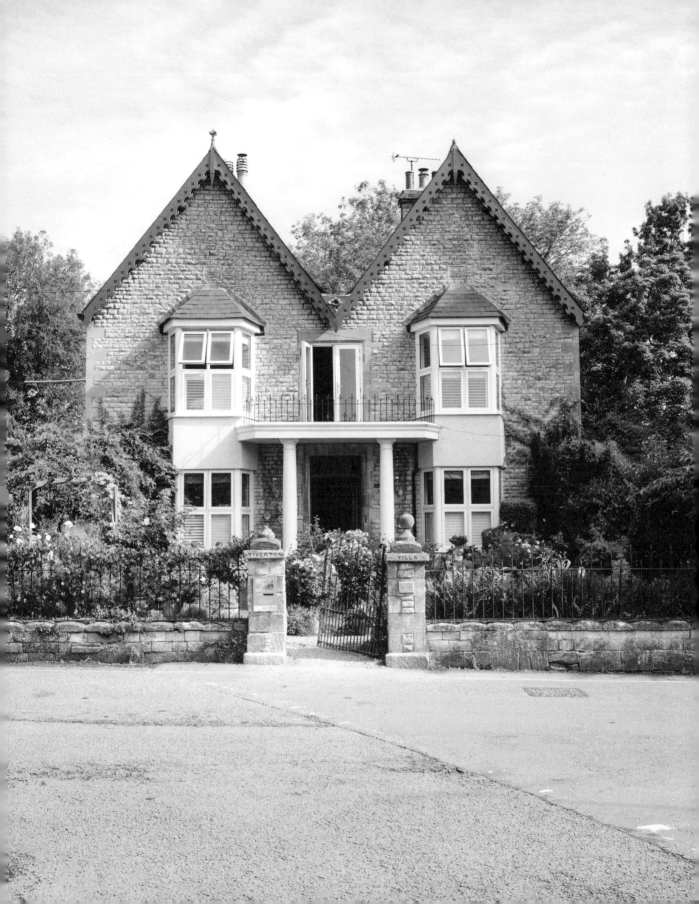

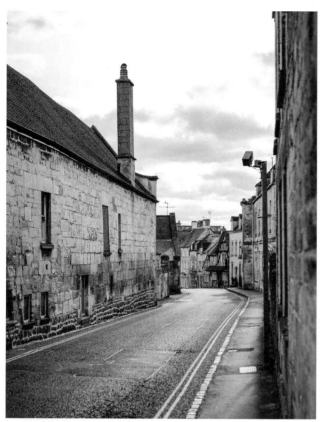

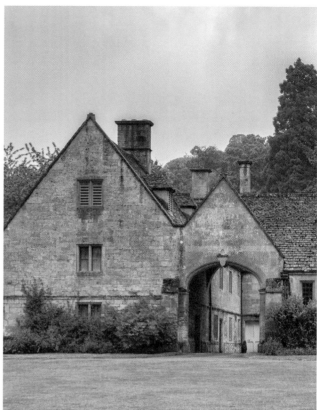

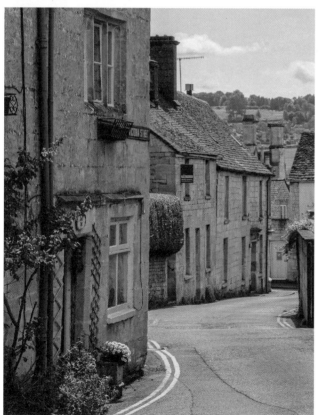

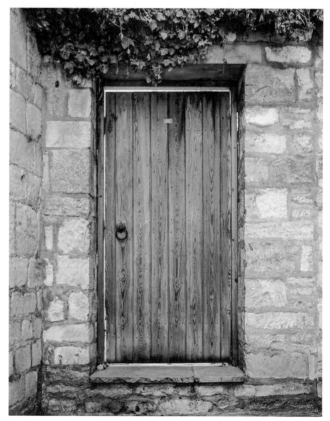

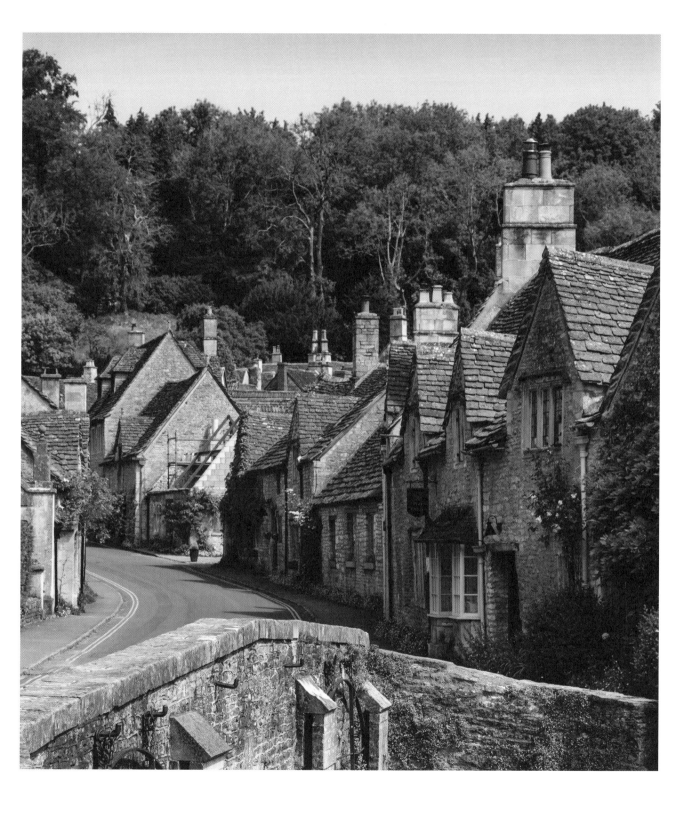

This page and at left:
Whether in Painswick (left) or Castle Combe, the sight of old, honey-yellow stone houses stood wall to wall never gets old.

This page:
Stay for the night in style or meet for afternoon tea at the luxurious Manor House Hotel in Castle Combe.
Right:
Façades overgrown with ivy and woodbine, rambling roses, here and there your typical hanging baskets:
Castle Combe is interspersed with lovely touches of color.

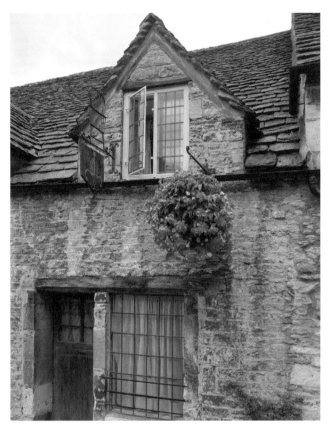
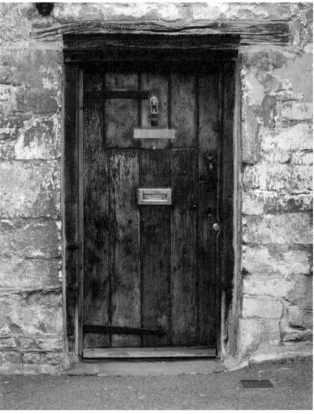
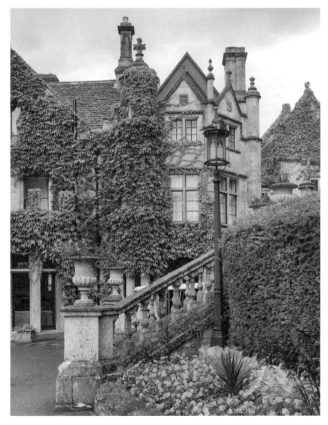

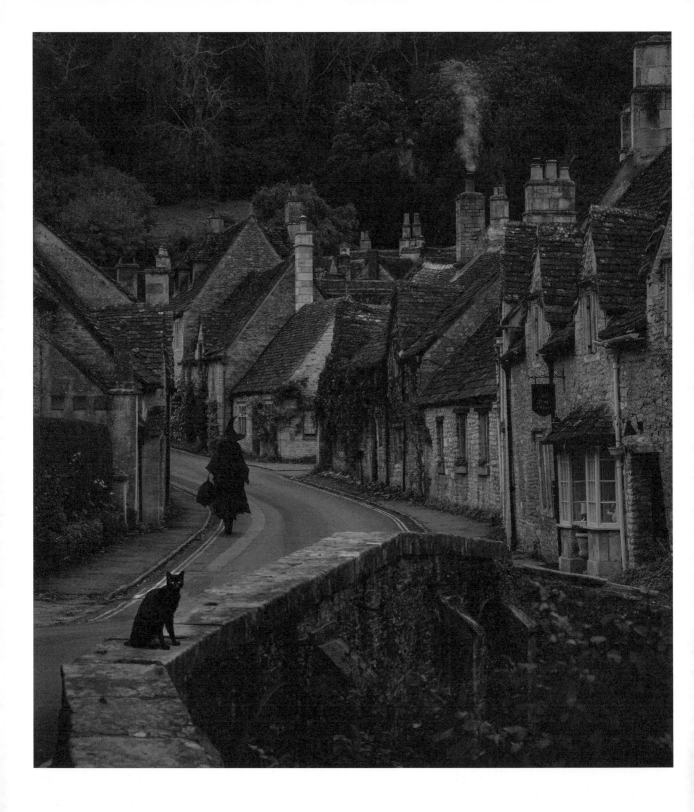

This page and at right:
*Castle Combe in the fall: When the leaves turn, the twilight wraps everything in
enchantment and mystery.*

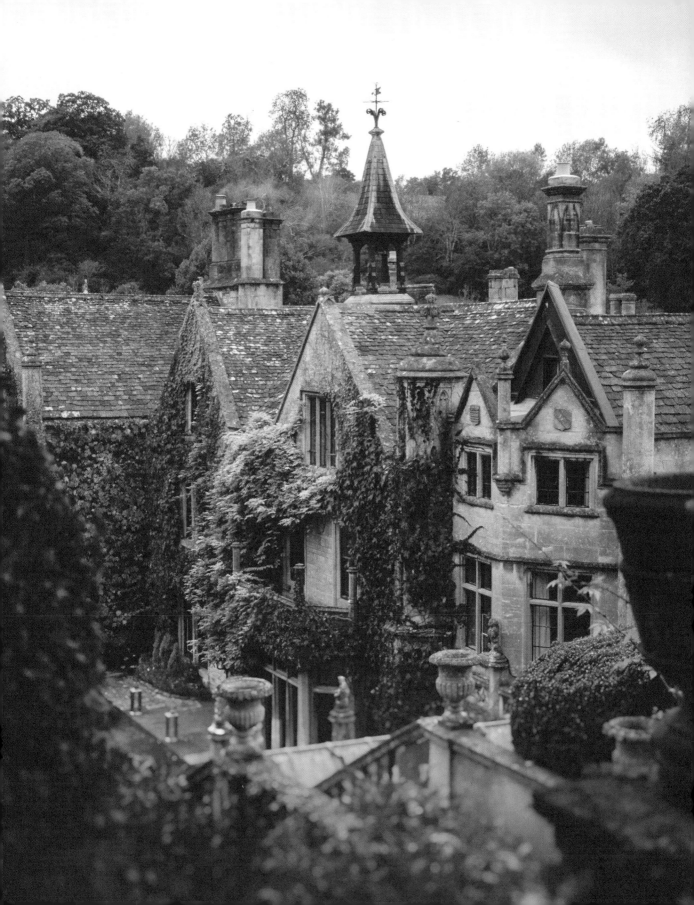

LONDON

INDIVIDUALITY TIMES A MILLION IN THE METROPOLIS

The most beautiful souvenirs of London a traveler can have are her indelible impressions of the place. No matter what you feel up for, another neighborhood is waiting to reveal itself to you at its nicest—or its most peculiar. There's no single, prototypical London. As anyone who walks the bracingly different neighborhoods daily will quickly see, the only really typical thing about London is the city constantly and everywhere reinventing itself while still holding on to and preserving traces of the past. You steadily discover more hidden alleyways or idyllic quadrangles or small, previously overlooked curiosities. Upkeep is thanks to the characteristic English blend of pride and general wackiness with a hang toward self-deprecation. London is no megalopolis of blurry indistinction. Each district has its own personality, and every turn shows a multifaceted city from a different angle. No two colorful doors or lovingly styled entrances must be alike, perfectly symbolizing the quintessential English bent toward individuality. Though an entire terrace may consist of uniform structures, stringently elegant Georgians or ranks of Victorian brick town houses to please a drill sergeant, you see their wooden doors in every color of the rainbow, bold, saturated hues or confectionary pastel glazes, playful glass inserts and antique brass knockers. No matter how small the nook is, someone has almost always tried to splash color on the urban canvas and planted something in a hanging pot or flower box, and vines are climbing the wall. A careful observer will never tire of walking around neighborhoods like Chelsea and Hampstead, basking in the lilac-blue of the wisterias or the flaming red of the woodbine in autumn.

At right and the following pages:
The democratic approach to charm and character: London's entrances may look conformist at first, but the details celebrate the famous English love of individualism.

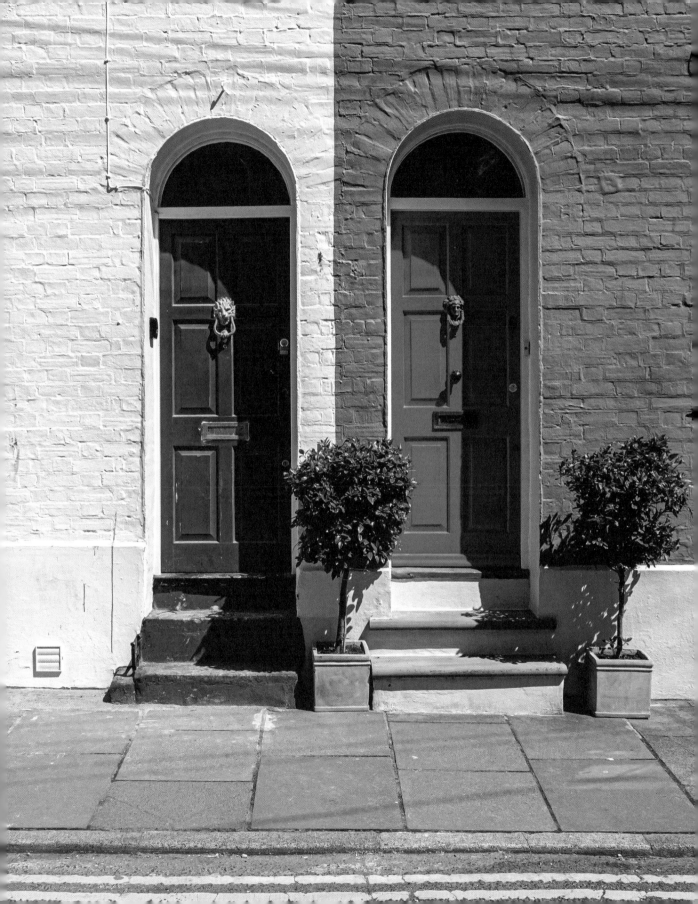

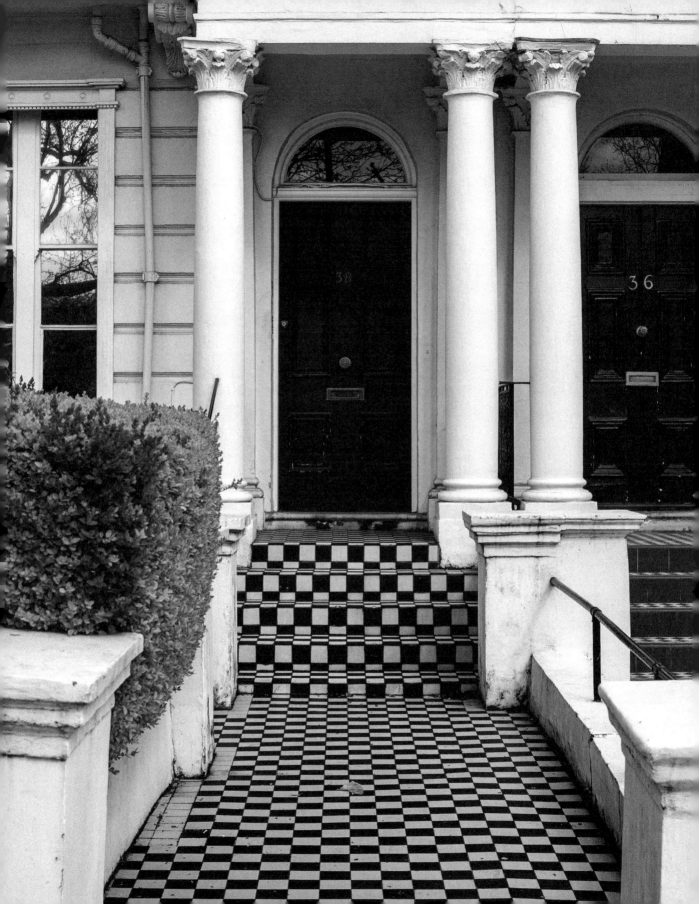

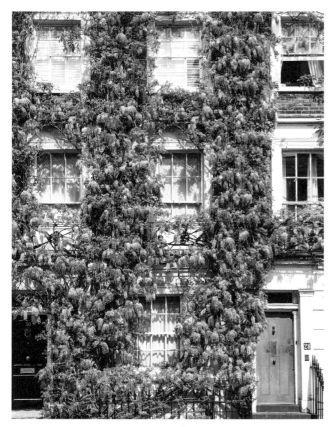

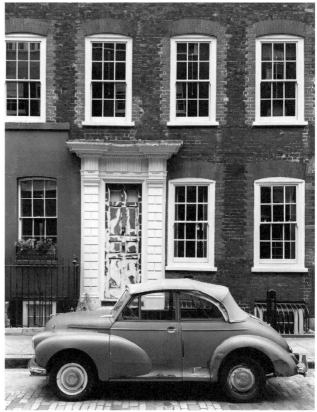

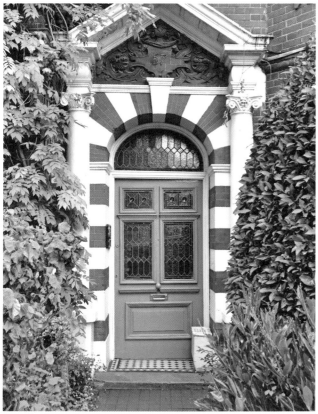

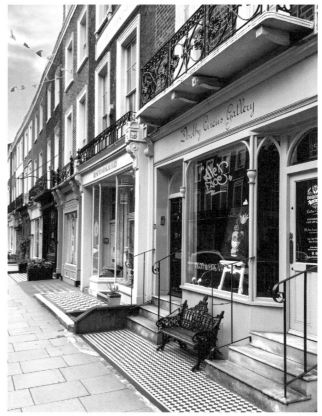

CITY OF WESTMINSTER

MAYFAIR, SOHO, COVENT GARDEN, BELGRAVIA

The heart of London beats west of center, and at a varied pace. Mayfair, the stately old quarter north of Buckingham Palace, has solid style. It's been the epicenter of high society since the eighteenth century. The elegant Georgian townhouses around Grosvenor Square and Berkeley Square have the noble flair of the Regency period—straight out of the Netflix series *Bridgerton*—with immaculately curated shops and fancy hotels and posh neighbors. Between Mayfair and Regent's Park lies Marylebone, ready with its elegant shops and creative food scene to prove that the distinguished department stores in Knightsbridge—Harrods, for example—don't have a monopoly on kicking around, shopping, and wholesale enjoyment. South of Hyde Park lies Belgravia, which has a peaceful elegance but also comes alive in the spring, for Belgravia in Bloom. For this, the cozy cafés and boutiques around Elizabeth Street decorate their façades with artistic floral displays in a feast for the eyes that welcomes everyone who didn't get into the exclusive Chelsea Flower Show. A person can probably enter a state of eternal reverie and treat themselves to afternoon tea at the pink cupcake dream-shop of Peggy Porschen. As for more flowers, Covent Garden was a flower market in its heyday, but these days the old market halls are more a destination for tourists and street artists and performers. This is where London's pulsating theater scene exists, in London's West End between Soho, Seven Dials, and Drury Lane, also a destination for acclaimed restaurants, bars, and pubs. Soho has a carefully nurtured reputation as a center for creativity, and major advertising agencies appreciate the proximity to thriving art and music scenes. What makes Soho so attractive is its diversity, the flair of the Swinging Sixties emanating from jazz clubs with swanky hotels next door.

Right:
Luxury befitting a Royal Warrant holder: Tableware manufacturer Thomas Goode has operated its flagship shop in Mayfair since 1845.

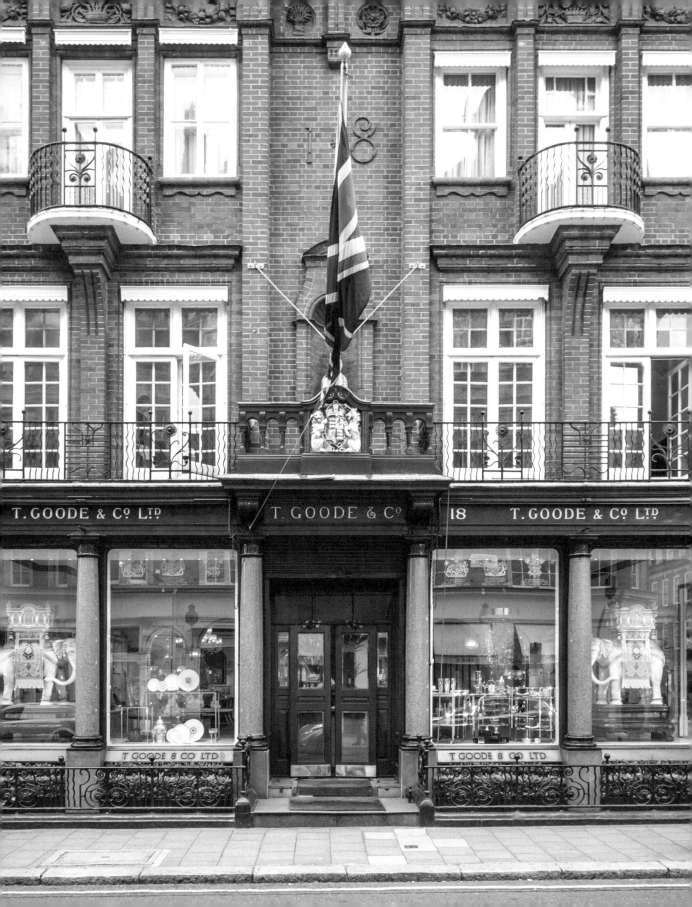

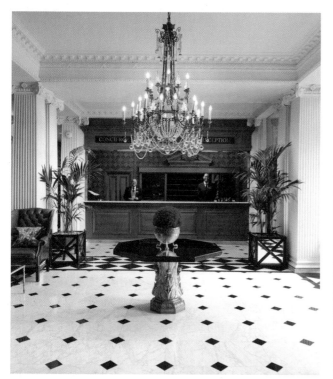

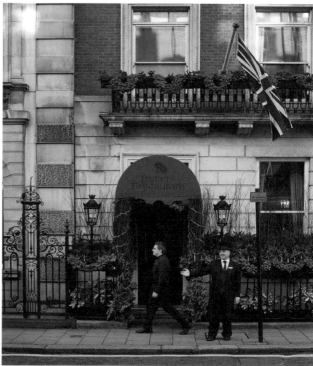

This page:
Ritzy neighborhood: The Chesterfield Hotel in Mayfair gleams with British charm, and the world's luxury brands have presences on Bond Street and Conduit Street.
Right:
Old and refined, like a good wine: Berry Brothers, wine merchants & royal warrant holders, located next door to St James's Palace for 300 years.

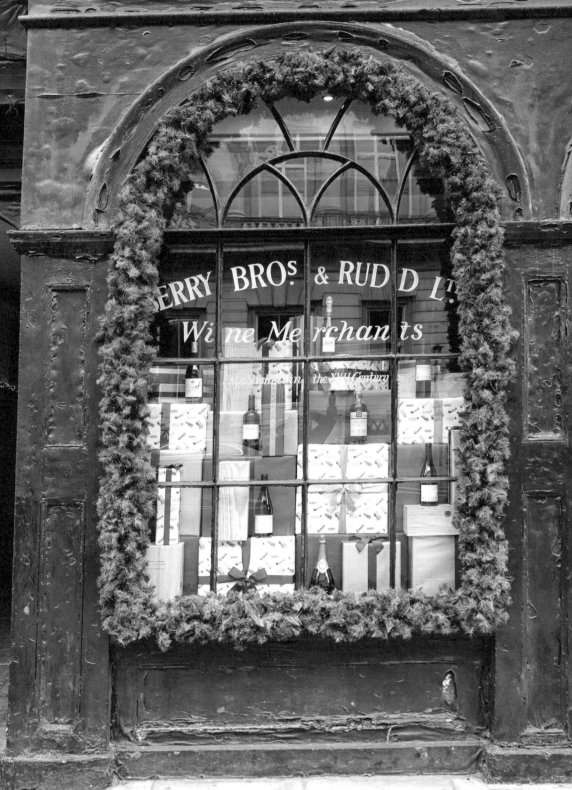

REGENT E&C SOUNDS STUDIO
RECORDING & PHONOGRAPHIC STUDIOS SOHO 379 6111

ALLEY CAT BAR + CLUB

www.alleycatbar.co.uk

Fender AUTHORIZED DEALER

Authorized Dealer GRETSCH
That Great Gretsch Sound!

REGENT SOUNDS LONDON

Fender REGENT SOUNDS GRETSCH

ALLEYCAT Bar Club

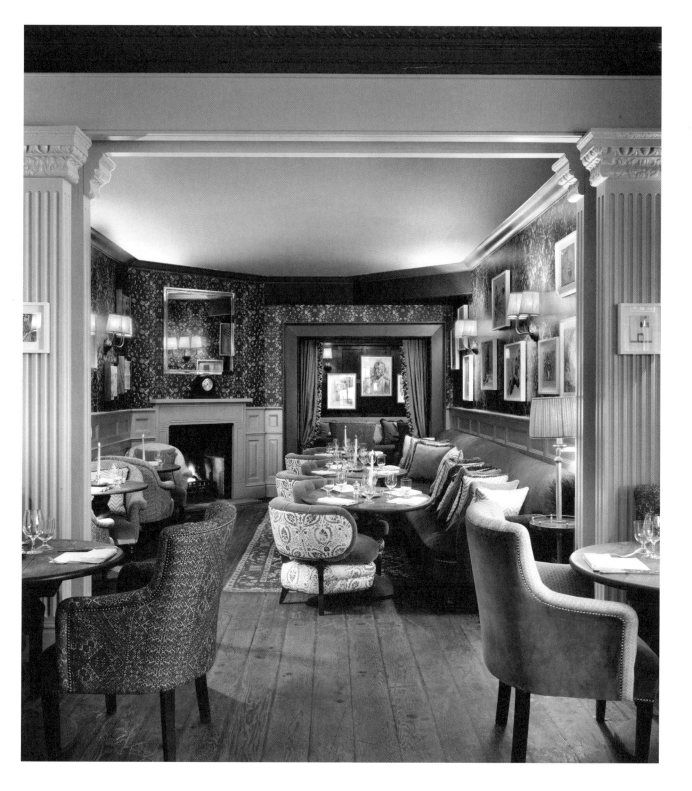

This page:
Enduringly British: At Dean Street Townhouse you can dine and stay amid the flair of ritzy Georgian townhouses.
Left:
Jazz club vibes and posh hotels—the arts-forward neighborhood of Soho is as lively and multifaceted as it was during the Swinging Sixties.

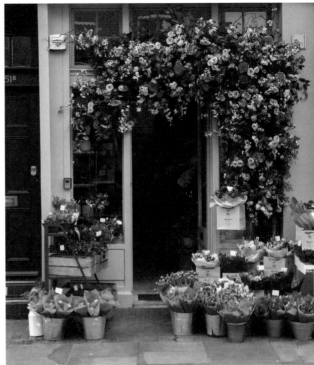

These pages:
Belgravia in Bloom: In May, during the Chelsea Flower Show, the shops and restaurants in otherwise quiet Belgravia vie with one another for best floral façade.

Following pages:
Let's go out for drinks and see a play: There are plenty of old pubs as well as new bars and cafés in and around Seven Dials and Covent Garden.

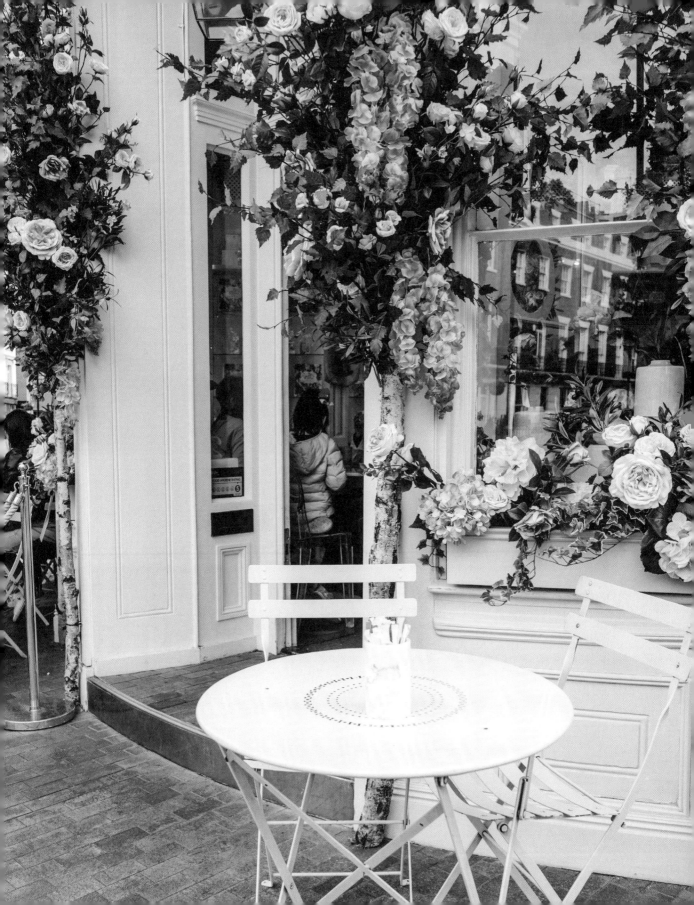

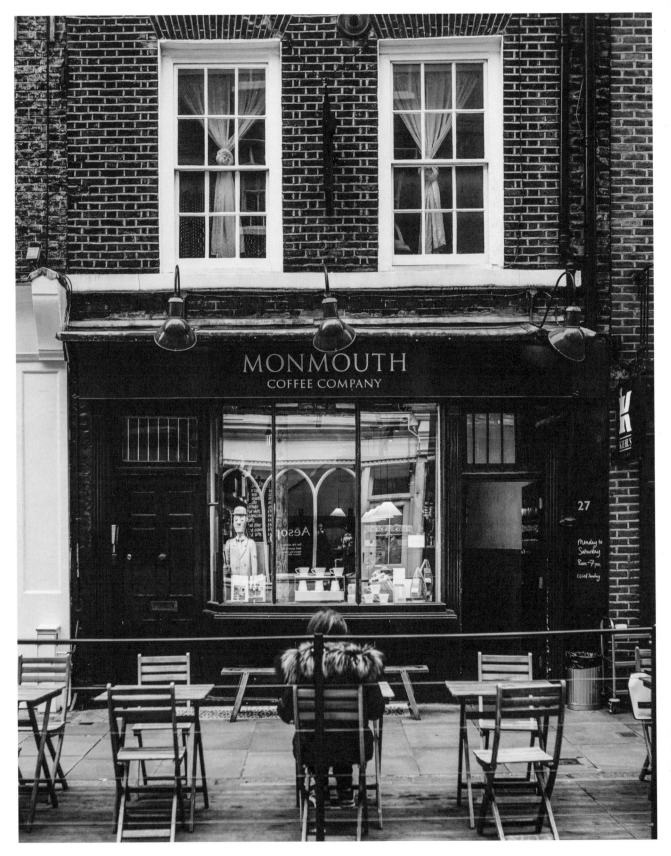

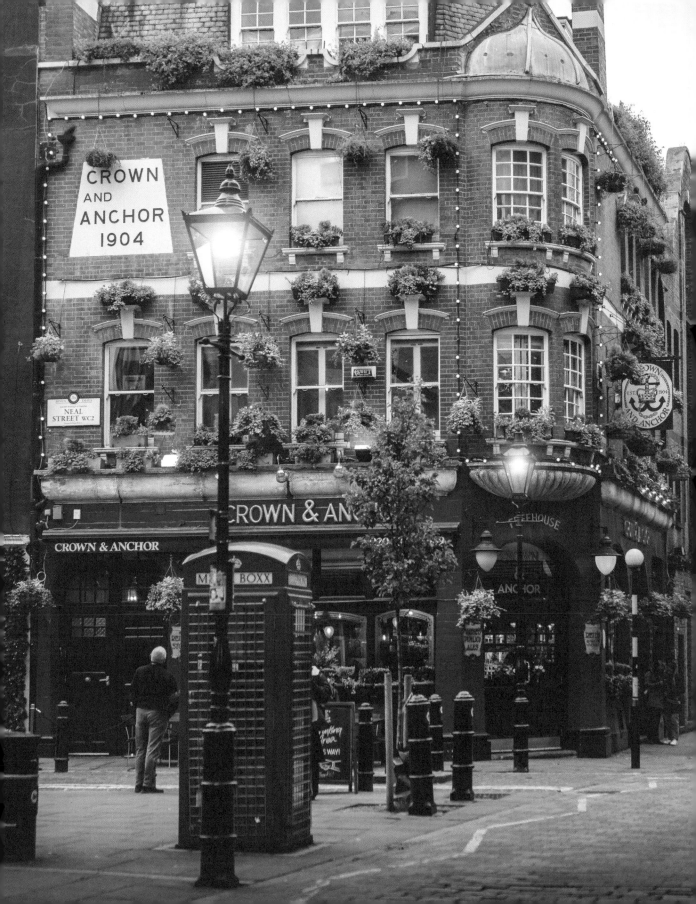

This page:
Knightsbridge, London is synonymous with shopping: South of Hyde Park is where we find exquisite department stores like Harrods and Harvey Nichols along with major luxury boutiques.

Right:
Mayfair is about as British as it gets: Union Jacks adorning Regent Street. Of course, besides exclusive gentlemen's clubs like Harry's Bar, there are also elegant cafés and pubs.

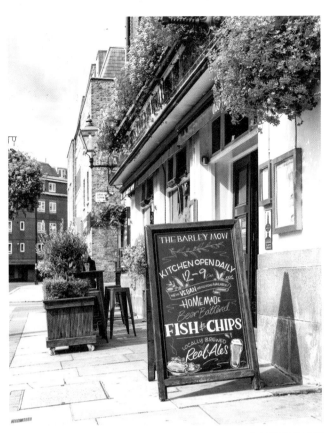

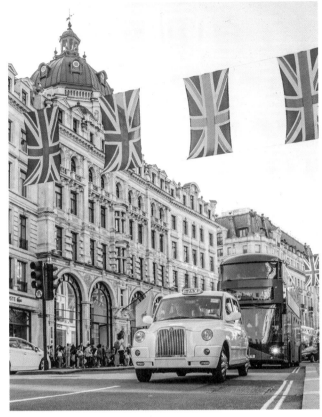

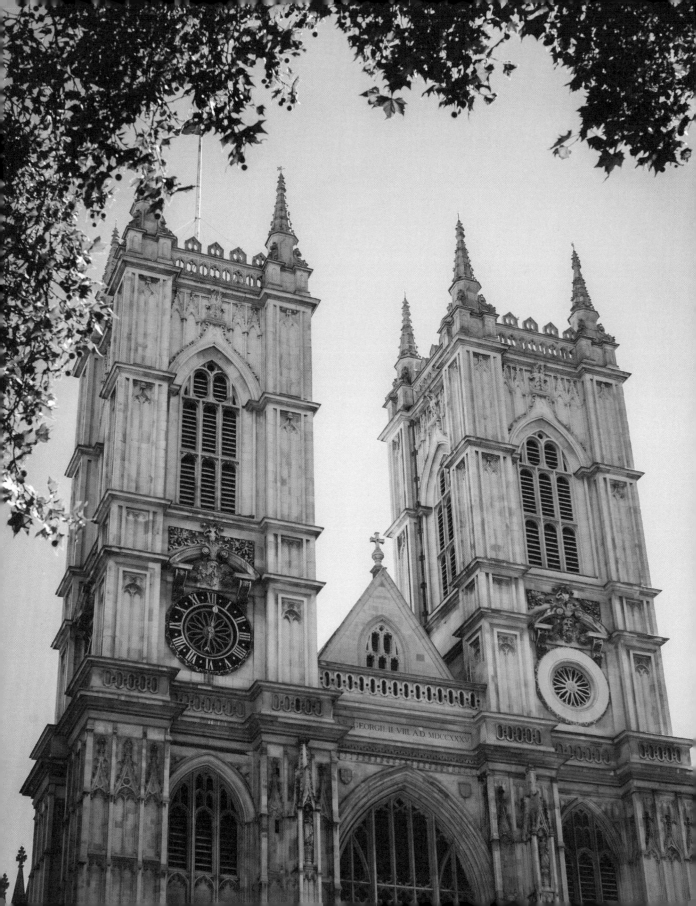

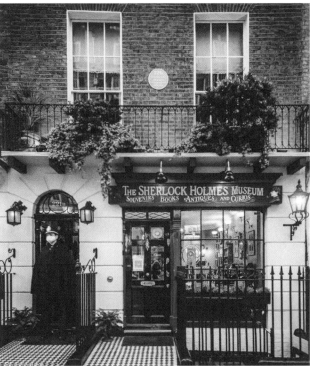

This page:
From tradition to transformation in Marylebone: Fusion kitchen at Jikoni, Sherlock Holmes Museum at No. 221b Baker Street. Posh Westminster: Craig's Court and the Corinthia Hotel.
Left:
The British monarchy stages coronations at Westminster Abbey—most recently of Charles III in 2023.

FALL IN LONDON

BETWEEN FALL FOLIAGE AND HALLOWEEN HAUNTING

If you think fall is a dreary, foggy business that only underscores the wistful side of the hectic metropolis, you can learn a thing or two from London. All the ivy-clad buildings and the trees along quaint residential streets begin to glow in the hues of the foliage, warm shades of orange, red, and Indian yellow, as if autumn alone lets you perceive the natural qualities of the city. Many public gardens and small, hidden places now boldly compete for attention with their bright foliage. Londoners love their parks when the trees of autumn go for glory. Londoners will arrange a haul of multicolored leaves around their front doors for good measure, too. As the trees shed foliage, it's exhilarating to watch the shifts between fog and sunshine filtered through the branches. A stroll among the meadows and woods of Hampstead Heath is like a fall outing to the countryside. Fall is also the nicest time of year to explore Richmond Park, and with luck you might spot a member of the park's resident deer population. The rhythm of the city changes now with the cool weather, a renewed verve after the heat of summer. The first fall showers relent, and the golden days of October are a special gift. On Sunday afternoons, the pubs in Little Venice and along Regent's Canal are a favorite hang-out—why not sit in the sun with a pint of cider, while you still can, or stroll around the elegant residential neighborhoods of Chelsea or Kensington? Come Halloween, it's worthwhile to follow the pumpkin trails that lead through Belgravia so as not to miss any of the creative decorations ranging from the comically gruesome to the nostalgically pumpkin-y.

Right:
*The cafés and restaurants in Belgravia launch themselves completely into fall decorating
and are a feast for the eyes.*

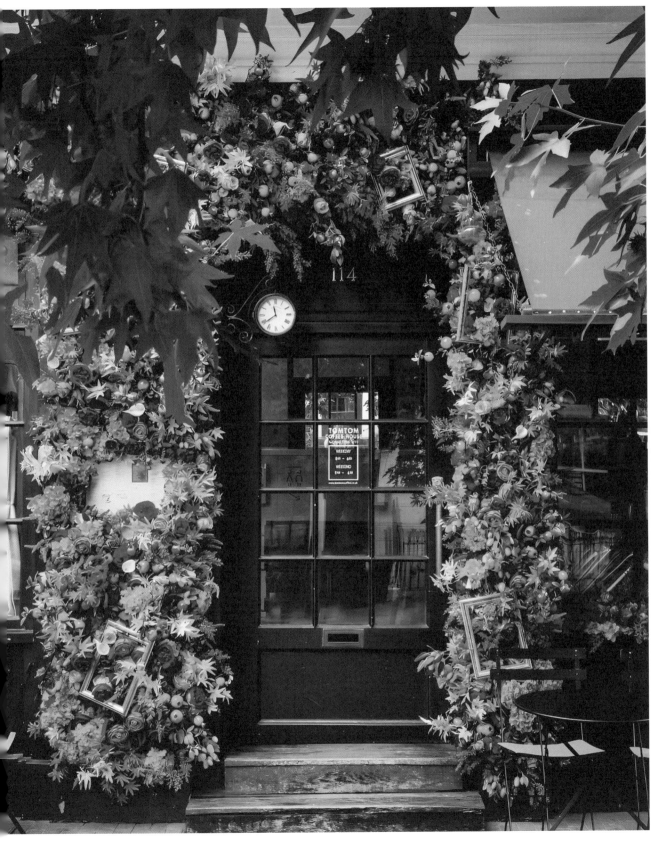

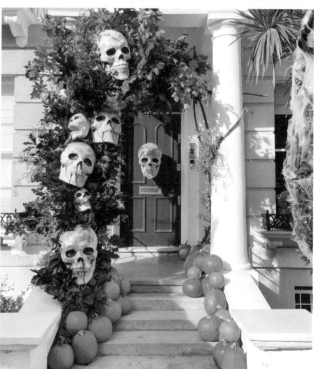

These pages:
London's façades between enchanting fall foliage and Halloween glam: Walls and entrances aglow in warm autumn colors.

NORTH AND SOUTH OF THE THAMES

CITY OF LONDON AND SOUTHWARK

The metropolis sprouted up from the City of London, where Roman invaders settled two thousand years ago. The Great Fire of London of 1666 started (legend has it) because of a careless baker in Pudding Lane, potentiated by inaction on the part of the mayor. It laid half of London in rubble and ash, transforming the face of the medieval city between St Paul's Cathedral and the Tower of London. Over the centuries, the city north of the Thames became a hub of finance and commerce, with skyscrapers rising ever higher, displacing old London. But as if composed by a mad painter, there are still traces of an earlier time. Leadenhall Market, where people gather at trendy wine bars, cafés, and delis beneath the Victorian arches of an old meat market, is certainly such a trace, and one of the most worthwhile sights in the city. Another is the ruin of the Gothic church of St Dunstan-in-the-East. So is old Wharfinger Cottage, tucked between the Tower and the Thames. Southwark, south of the Thames, has always been more rustic. In Shakespeare's day, there were theaters and taverns, possibly of ill repute. But today, a new building has resurrected the Globe Theater and now beckons with a journey back in time to Elizabethan London. Old and new thrive freely and side by side here, each complementing the other, with modern architecture like Norman Foster's City Hall ensemble and the Shard, London's most imposing skyscraper, there next to old half-timbered buildings. The old Bankside Power Station was repurposed as the Tate Modern, a museum that offers free admission—art for everyone, with an expansive view of the Tower Bridge and the Thames. Foodies also flock to Southwark on a pilgrimage to Borough Market, a mecca of theirs ever since Jamie Oliver's cooking show crossed their feeds. Here they can indulge in gourmet food and marvel at the colorful displays.

Right:
Leadenhall Market is magical, and not just for Harry Potter fans. In reality, these passageways, seen in the films, are a lively market and home to cafés and delis.

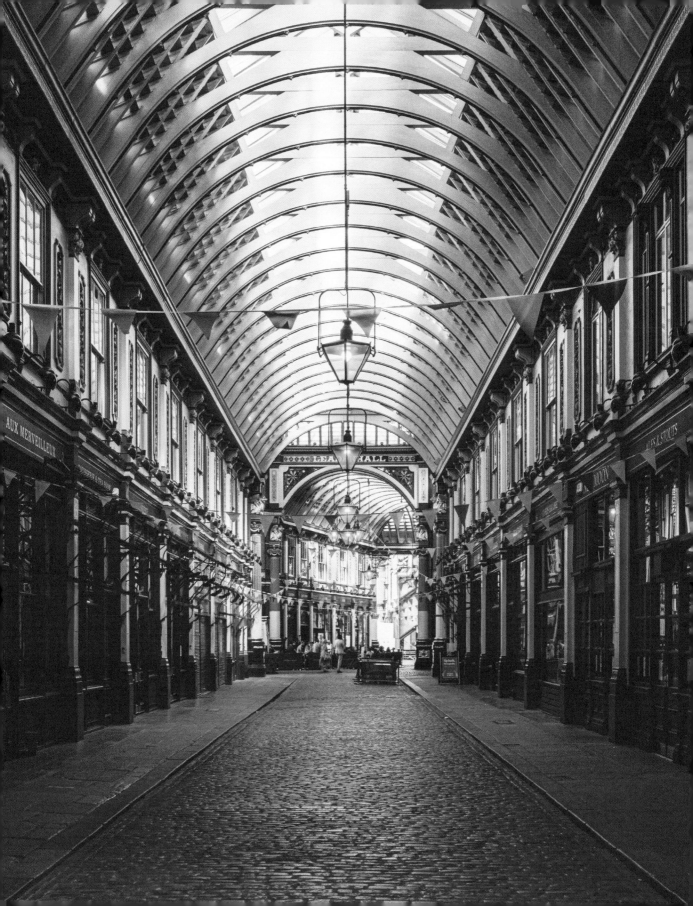

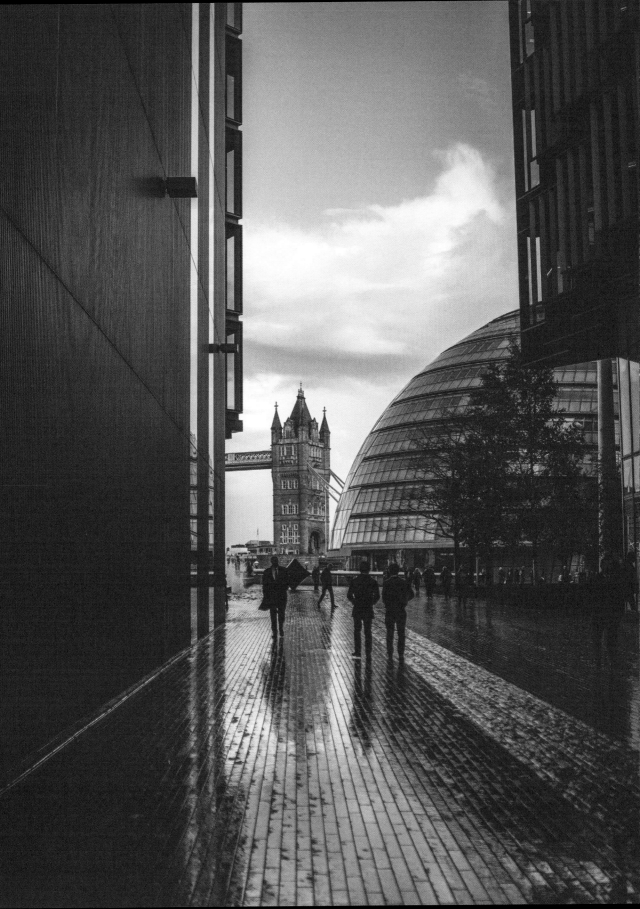

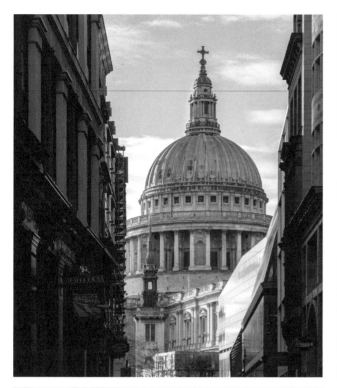

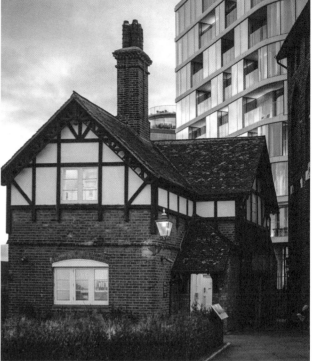

This page:
Giants and small treasures: St Paul's Cathedral and, right next to the Tower, tiny Wharfinger Cottage, formerly the living quarters of the controller of the old wharf on the Thames.

Left:
Majestic and modern: Norman Foster's futuristic architecture by the dome of City Hall orchestrates a view of London's number-one hallmark, the Tower Bridge.

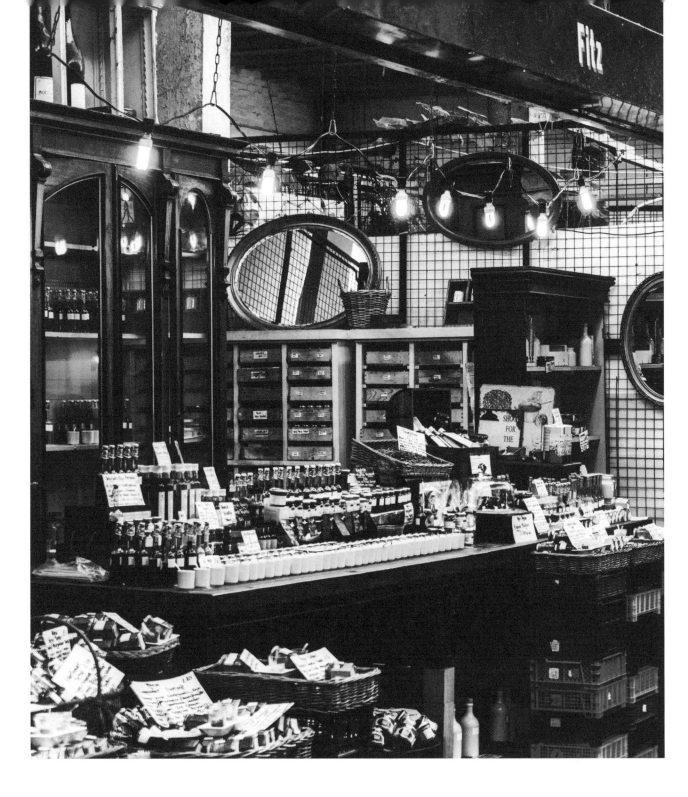

Above and at right:
A must for foodies: A gourmet tour of purveyors of fine foods at Borough Market.
The George Inn, built in 1677, one of London's oldest inns, is tucked away on a quadrangle in Southwark.
With its galleries, the George was also used as a theater.

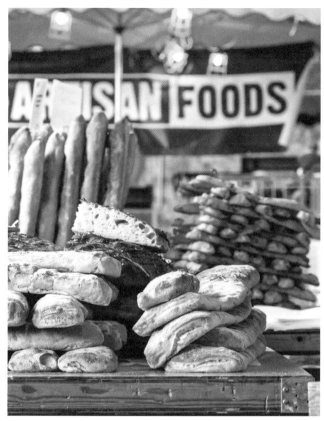
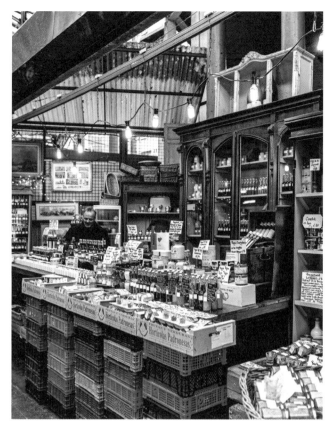
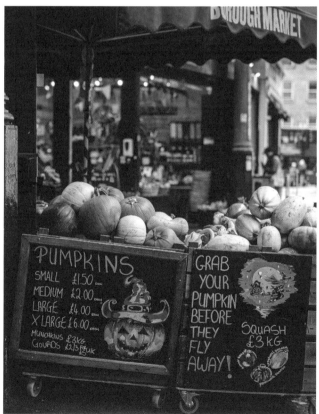
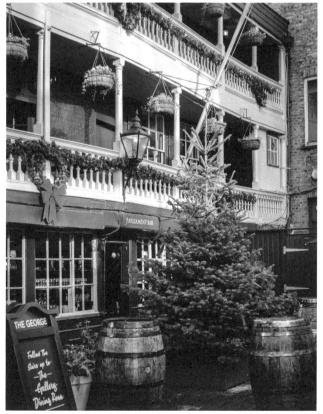

WINTER IN LONDON

DANCING LIGHTS AND GLITTERING FACADES

Visit London in the winter? Yes! Hardly any other city primps and preens itself for Advent and Christmastime like London does, sometimes with an addled intensity. Everywhere there are sparking Christmas baubles, glittering chains of lights, doors hung with wreaths of fragrant fir cuttings, and extravagant Christmas trees. Your eyes will never tire of the spectacle. Even if you have other intentions, the annual event of Christmas shopping begins, and a visit to London's grand shopping streets is intrinsically rewarding. Each year, people eagerly await the moment when they switch on the Christmas lights and decorations around Regent Street and Oxford Street. The pedestrian zone around Carnaby Street in Soho is an annual highlight—ahem!—for people who can't get enough of the magical festival of lights. During Advent, storied department stores like Harrods or Harvey Nichols and the famous toy store Hamleys strive to outdo each other with exorbitant window dressings that are often works of art in themselves. A stroll through Knightsbridge is best taken at dusk, in the glow of what are said to be more than 12,000 light bulbs casting a remarkable glow on and around the Harrods façade. Lovers of the enchanting winter atmosphere and heavenly lights will enjoy the artistic light installations at Kew Gardens. Traditional Advent markets have become a regular seasonal feature in London, too. The air around the stands at the Covent Garden Christmas Market is filled with seasonal scents of cinnamon and mulled wine. Right in front of the market hall, they put up one of the biggest Christmas trees in London. By the way, the Christmas tree tradition did not conquer England until the eighteenth century, when it was introduced by Queen Charlotte, who imported it from her native Prussia. What would London at Christmastime be without the many decked-out trees all around the entrances?

Right:
When Advent knocks, every door and entranceway in London breaks out in festive decorations.

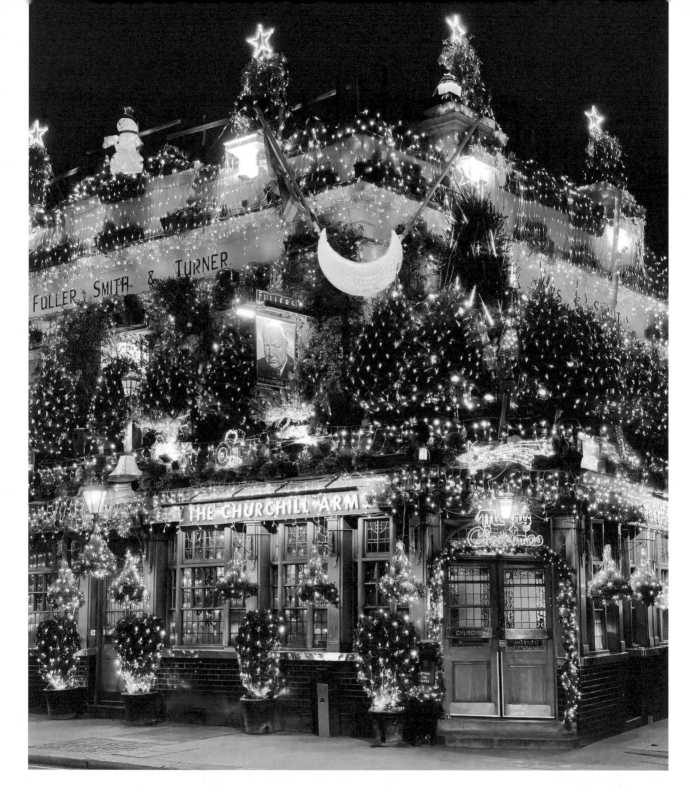

This page:
The Churchill Arms, a pub in Kensington, is famous for its opulent exterior decorating at Christmas.
Right:
*Elegant cafés in Chelsea, the Covent Garden Christmas market, the sparkling lights on the façade
of Harrods in Knightsbridge—London really primps for Christmas shopping season.*

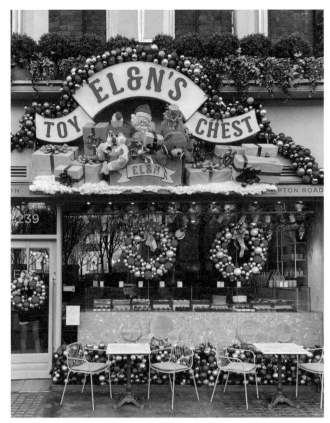

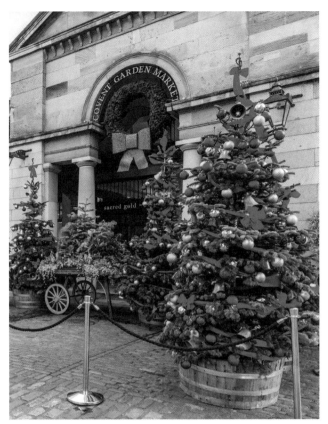

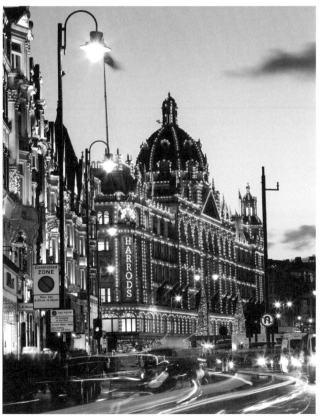

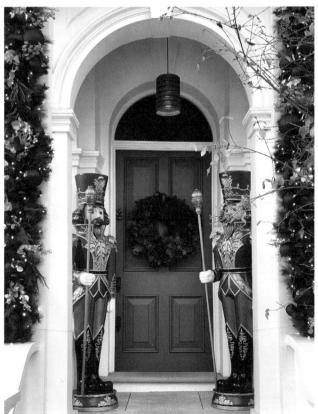

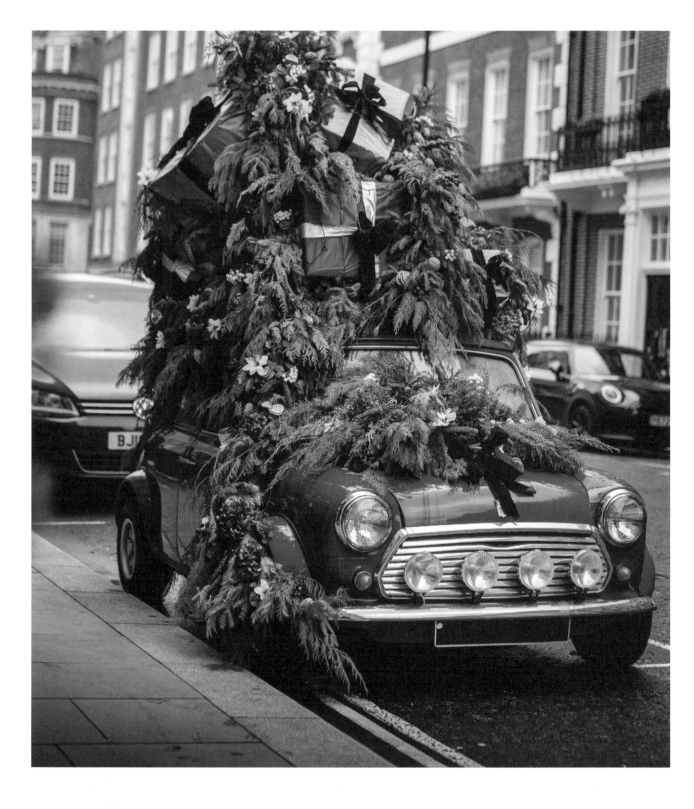

Above and at right:
With whole façades and sometimes even the street decked out in Christmas décor, London goes for a classic look in red, green, and gold—with extravagant tendencies.

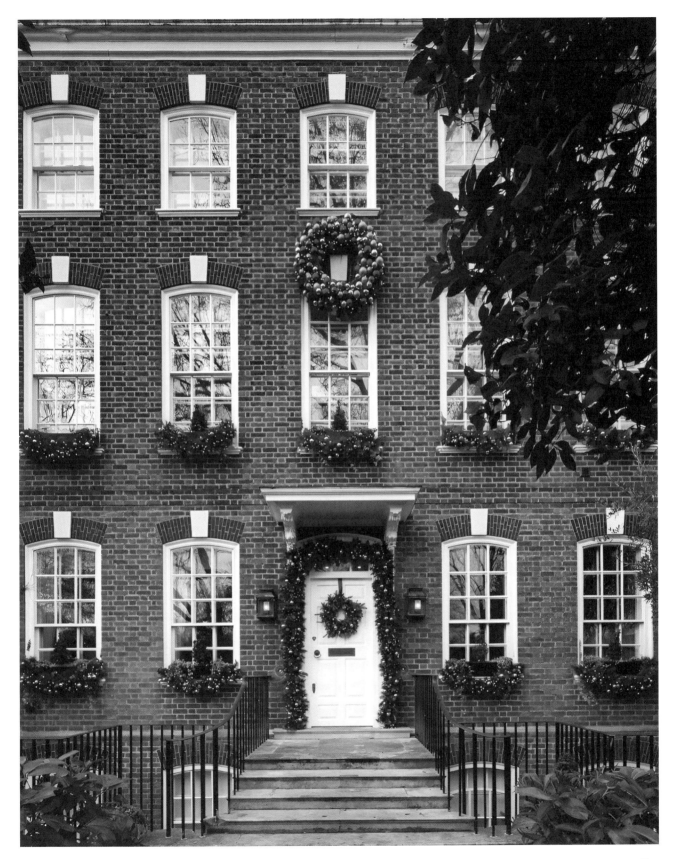

EAST OF HYDE PARK

NOTTING HILL, KENSINGTON, CHELSEA

If you see pastel-colored façades and lilac-blue wisteria and think, "I can't get enough of this," then visit Notting Hill, a coveted residential address that is one of the most colorful neighborhoods in London, where people know how to make a show of their postage-stamp front yards and green façades. Colorful housefronts ranging in tone from light pastel to blaringly loud make for a favorite destination for Sunday viewing. Visitors on weekdays are drawn to the Portobello Road open-air market, brimming with shoppers and stands with merchants and dealers hawking all kinds of things from antiques to vegetables. Wait a sec, was that Hugh Grant? It's not out of the question. Not only was the classic film *Notting Hill* shot here, but the lead seems to have liked the neighborhood so much that he bought a house here. Kensington and Chelsea, southeast of Hyde Park, are also first-rate quarters. The neighborhood on the other side of Kensington Palace is home to several important museums, such as the Victoria and Albert Museum and the cathedral-like Natural History Museum, housed in structures so splendid that they're worthwhile sights besides the collections they hold. Affluent Chelsea also has many attractions. The Chelsea Flower Show, which takes place each May on the grounds of the Royal Hospital, near the Thames, is a magnet for garden afficionados from all over the world and—lest we forget—an upper-crust social event. If the pleasure of attending would be a budget-buster, then you may be commended to Chelsea in Bloom, which takes place at the same time and consists of the shops and cafés in the surrounding streets busting out with creative arrangements, setting you up for a perfect ramble around town for its own show. Typical of Chelsea and Kensington are the mews, which originated as small stables in the back alleys and streets around the noble residences, with servants' quarters above them. Today these small houses and hidden little quadrangles are coveted residences—and idyllic subject matter for photographers.

Right:
No room for dull, urban grey: Notting Hill thrives on bright housefronts and colorful entrances in every color of the rainbow.

Above and at right:
From pure yellow to azure: The brightly colored houses on Portobello Road have a Mediterranean flair.

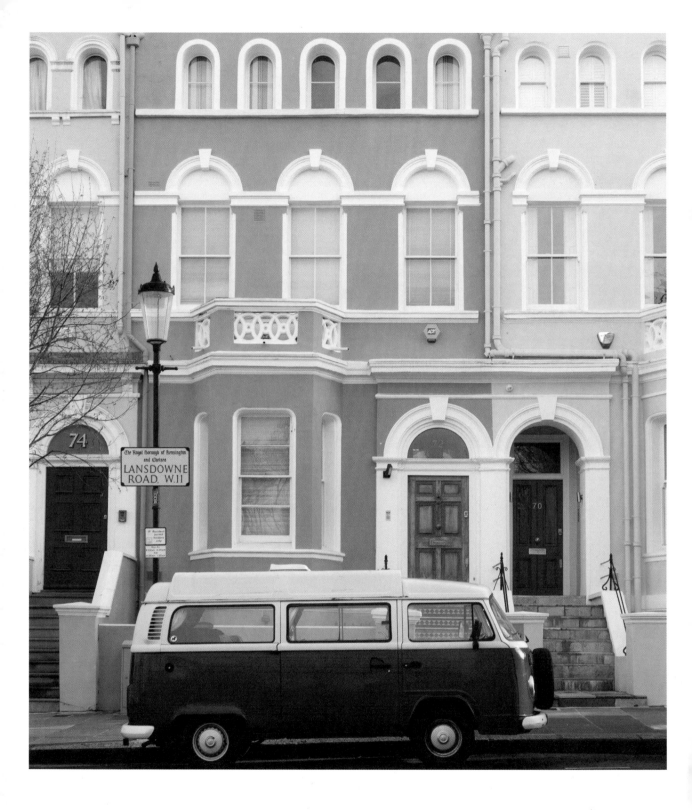

This page:
The pastel houses on Lansdowne Road are Notting Hill at its most elegant.
Right:
Green Notting Hill: Everywhere are spring blooms, façades covered in wisteria, gardens fronting the street.

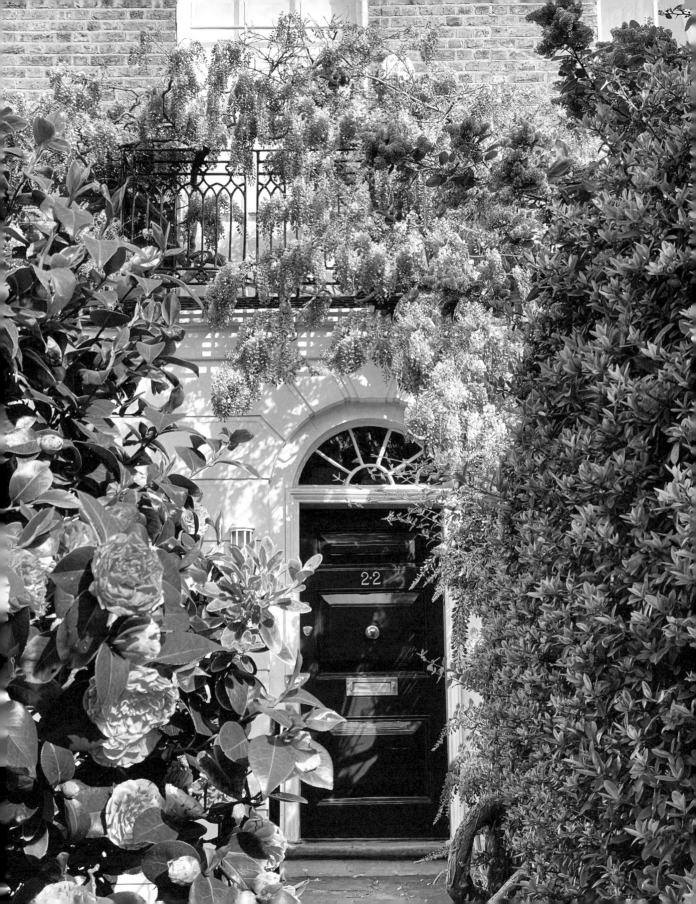

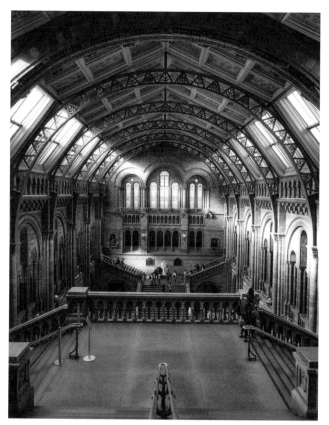
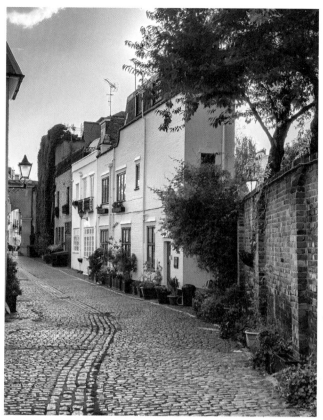
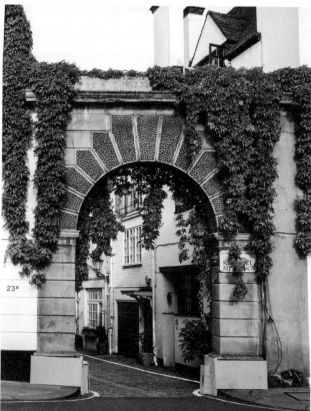
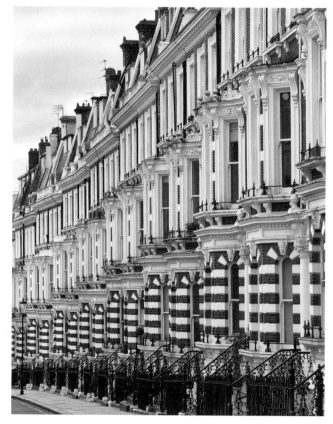

Above and at left:
Kensington in classical garb at the impressive Natural History Museum, while small lanes, like Kynance Mews,
have an almost village-like air.
Following pages:
During the Chelsea Flower Show, the cafés and businesses in the neighborhood don't hold back with the floral
décor for their storefronts.

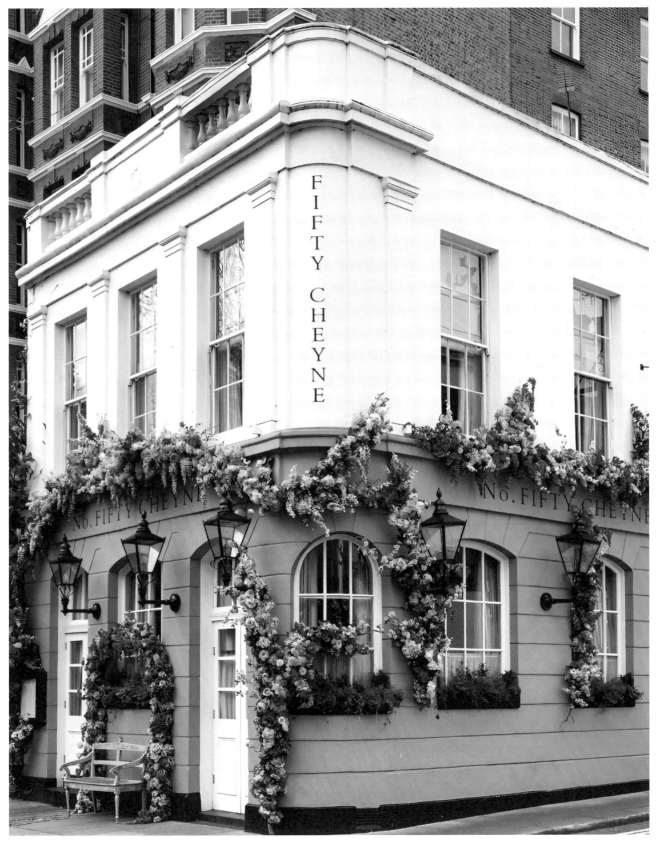

Spring in London

ENCHANTING BLOOMS IN PARKS AND ELITE QUARTERS

It's spring in London, and everything is blooming. No other season is as awaited or lovingly celebrated, with as many rituals, as spring. Fancy a walk?—Let's do some magnolia-spotting in the elegant streets of Notting Hill or Kensington. In the spring, around the affluent neighborhoods, the shops and cafés seem transformed into a single, enormous florist's emporium. Inspired by the Royal Horticultural Society's Chelsea Flower Show, people install floral decorations around the entrances and façades of the nearby shops, drawing in passers-by. All Chelsea and Belgravia are in bloom, the city plunged into a sea of flowers. A floral-inspired afternoon tea in one of the luxury hotels is a real treat and one way to truly celebrate spring in London. The most beautiful place to take in the cherry blossoms is in Greenwich Park. As the season advances, all the plant-lovers and amateur photographers trade speculations about which façade has the dreamiest look, from all the lilac-blue wisteria blossoms. With its melancholy, immanently Instagrammable charm, the Hill Pergola in Hampstead may be among the most favored spots to be doused with such a natural and romantic blue rain. South West London's Richmond Park also has a wonderful speck of greenery to offer, in Isabella Plantation: a small, hidden gem that blossoms in late spring in every nuance of rose and pink, London's most beautiful spot to be engulfed in a sea of splendid azalea blossoms. A cruise on a narrow boat down Regent's Canal to Little Venice offers a green respite in the middle of the city and is the perfect opportunity to grab the first pint of the spring at one of the pubs along the canal.

Right:
A highlight of springtime in London is the magnolia blossom. Nothing looks as elegant as the rose-colored clouds of blossoms framed before the white façades of the Georgian townhouses.

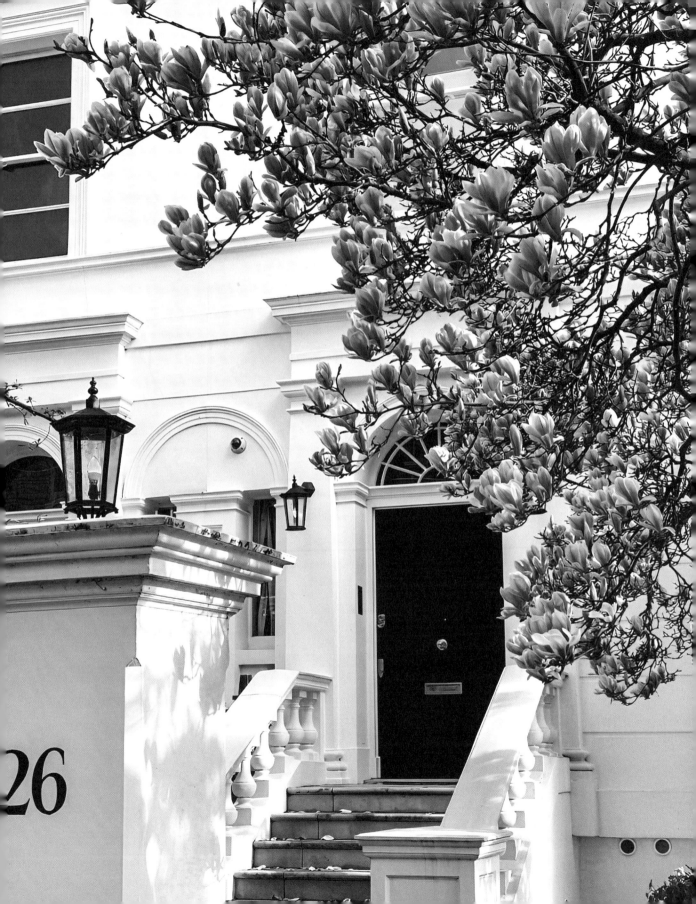

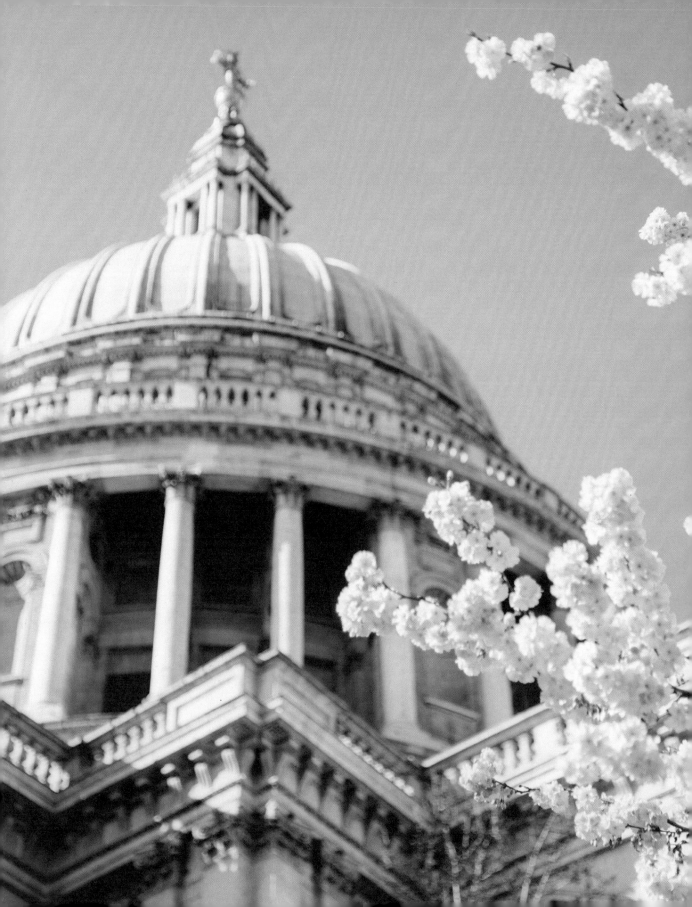

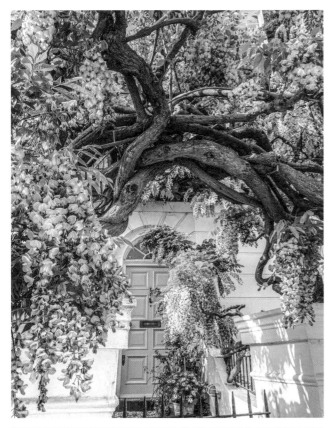
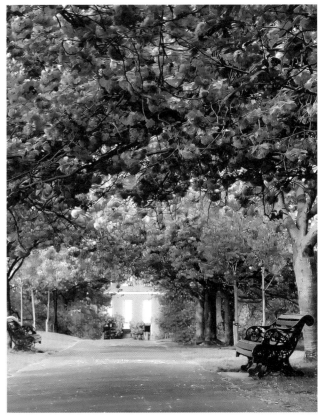
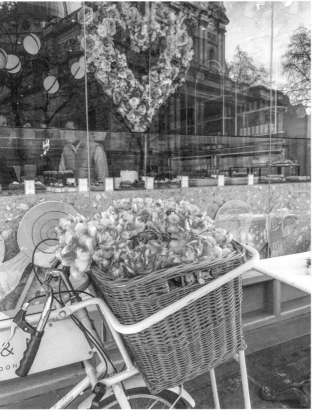

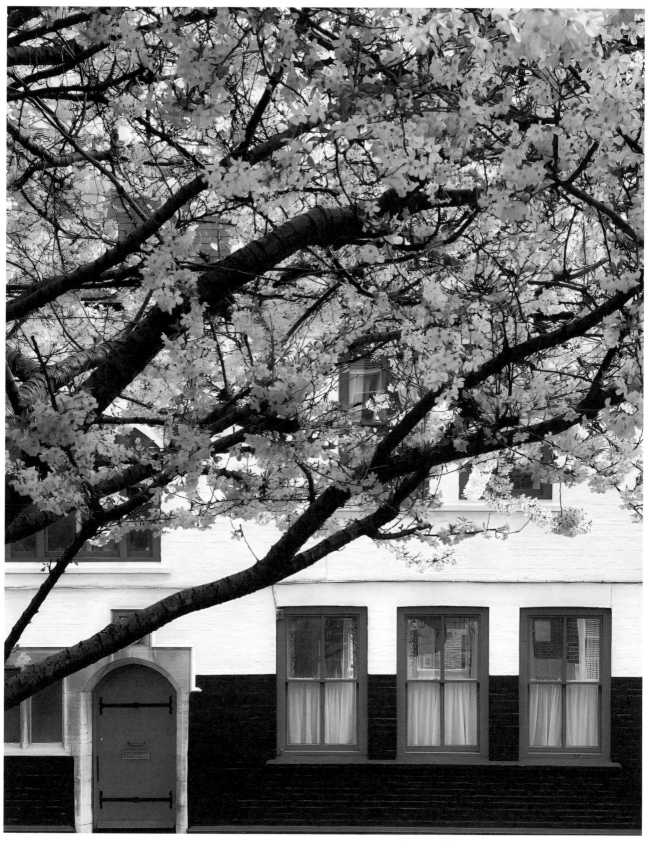

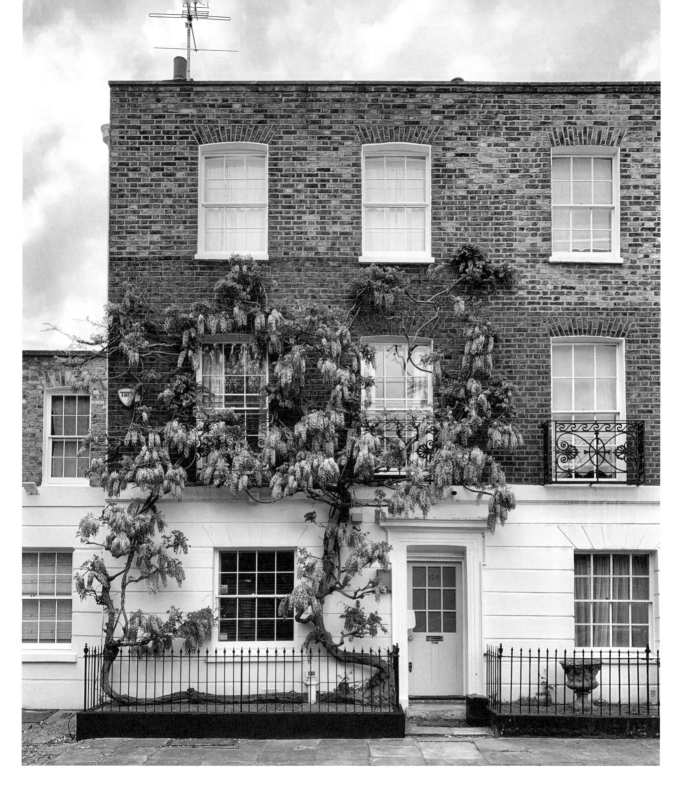

These and the previous pages:
Cherry blossoms and purple rain of wisteria: In the spring, the trees and housefronts of London are plunged into a flowering revery.

NORTH OF REGENT'S PARK

CAMDEN TOWN AND PRIMROSE HILL

A bustling urban center *and* an oasis of calm in the middle of a fast-paced metropolis? That's the trick of Camden Town, London's canal district, behind the major railway stations of St Pancras and King's Cross. It lay in a postindustrial slumber long until life returned to its abandoned industrial sites. And it's been a minute since then. Today the entire quarter around Regent's Canal has developed a unique, unmistakable charm. A sunbeam is all it takes to fill the pubs and cafés along the banks of the canals, and life pulsates through Camden Market 24/7 no matter what. In the 1970s, a small market arose there out of some dilapidated warehouses by the old gin distilleries and saddlers of Camden Lock, and Dingwalls Dancehall became one of punk rock's most legendary venues, its old walls shaking with sounds of The Clash and the Sex Pistols. Now people are drawn to the neighborhood's eclectic mixture of secondhand shops, street food, and alternative culture. But if you're looking for tranquility rather than bustle, just walk a bit farther down to Regent's Canal. At the beginning of the nineteenth century, coal and other cargoes would land here from the port at Limehouse on the Thames. Today's pace is more relaxed. The old towpath along the canal invites visitors to walk and discover Camden Town from another angle. And there's much to see. One highlight is the countless, slender-hulled launches remade into houseboats, charming and much-sought-after abodes in London's pulsating metropolis. Primrose Hill offers another perspective and a perfect spot for a summer picnic from this park on higher ground. It has the most beautiful views of the breathtaking City of London skyline. On the way there, the colorful houses along Chalcot Crescent catch your eye, setting a fair-weather tone for a summer's day.

Right:
Indie culture, an alternative market, small cafés and street food: The market at Camden Lock is an experience at any time of day. Ramble, enjoy, gather impressions—before soaking up the evening light around Regent's Canal.

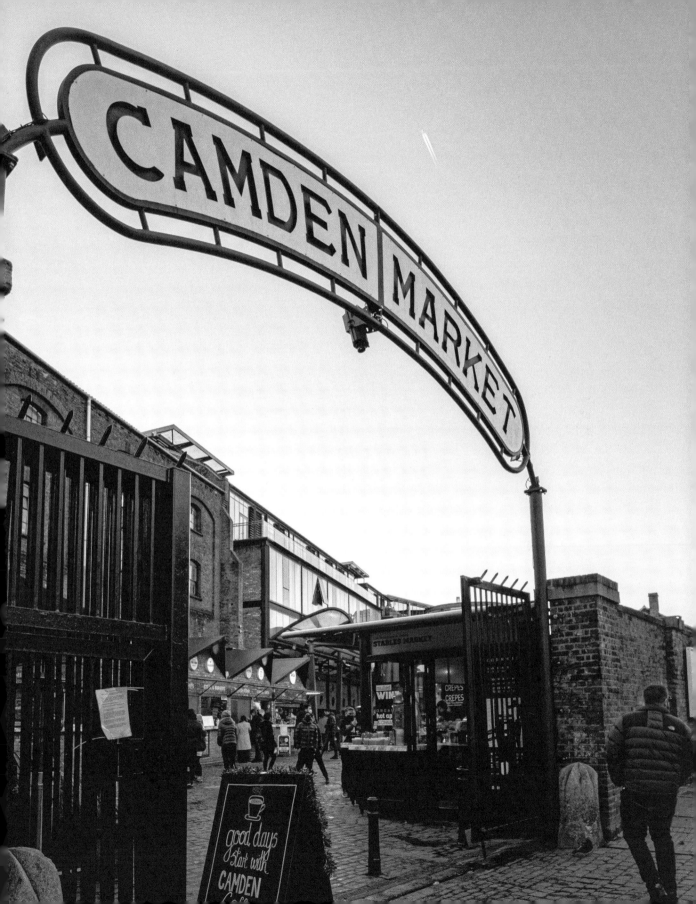

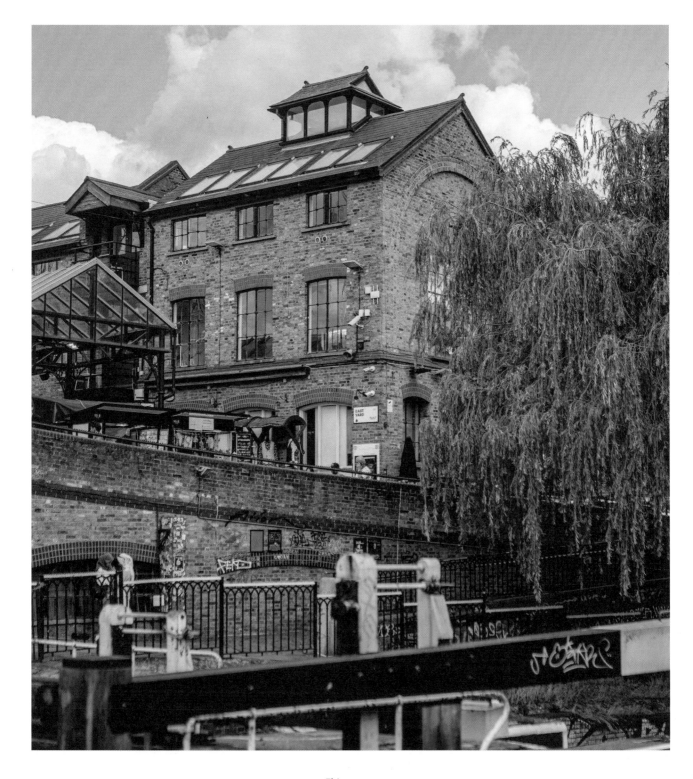

This page:
Camden Lock Market has developed a lively cultural scene with fashion and other purveyors manning the stalls. Dingwalls is a musical hotspot.
Right:
Barges loaded with coal were once pulled down the old towpath along Regent's Canal, which today offers one of the best walks in London.

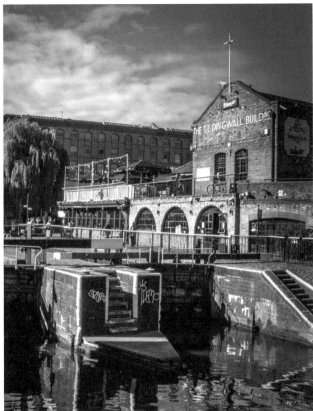

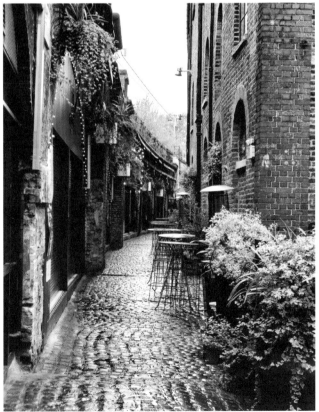

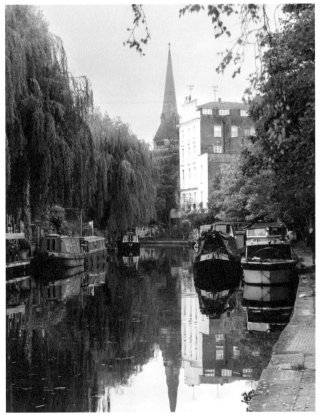

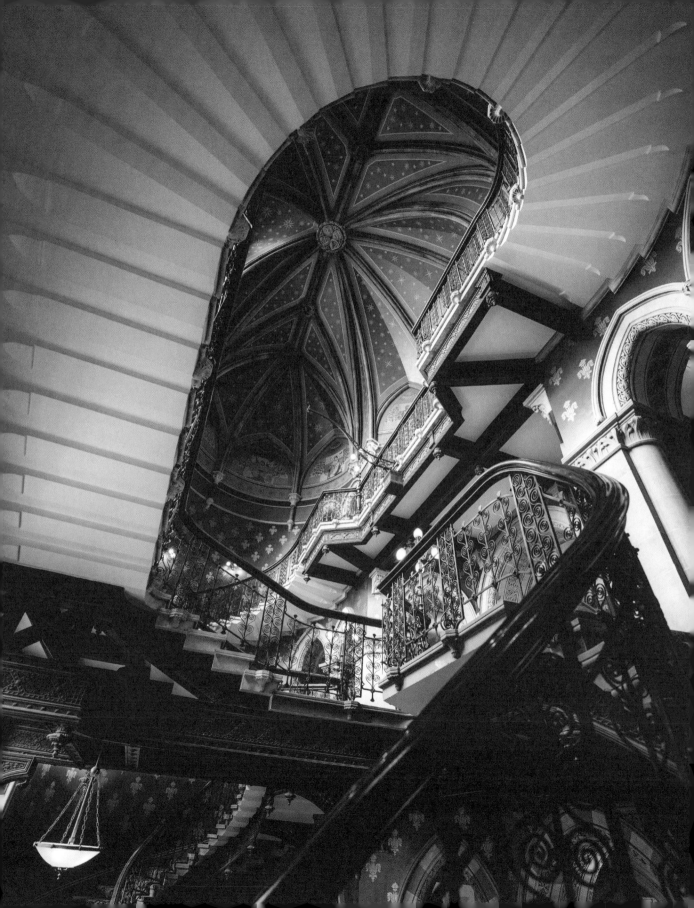

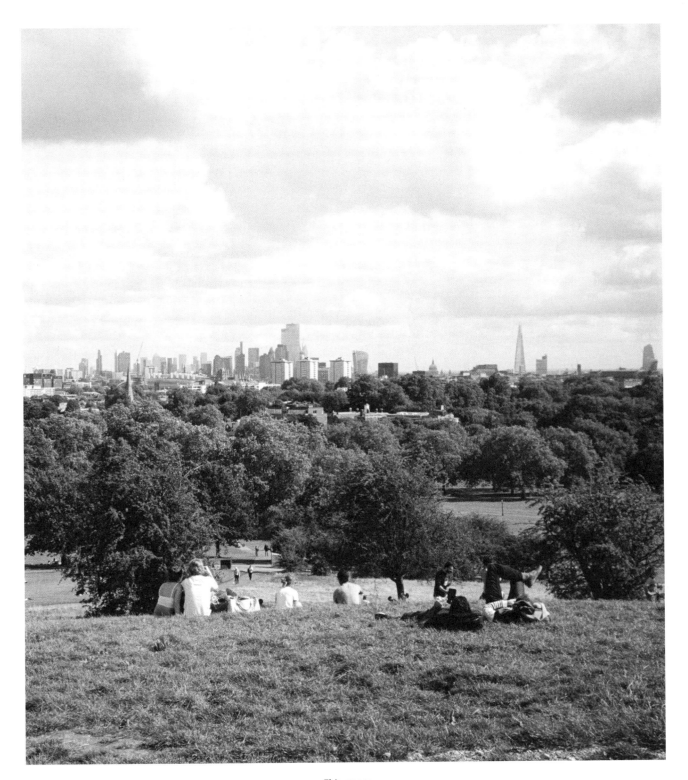

This page:
The park at Primrose Hill provides one of the best views of the London skyline and is a fantastic spot for a leisurely Sunday picnic.

Left:
The St Pancras Renaissance Hotel is a wonderful, Victorian-era relic. It almost feels like a cathedral with its neo-Gothic architecture.

Worth the Trip

HAMPSTEAD, CHISWICK, RICHMOND, GREENWICH PARK

They say some people don't know that London even exists beyond Zone 2 of the Tube. Well, they're missing out on charming locations that are definitely worth visiting. If you want to know what it really feels like to be a Londoner far removed from the buzzing metropolis, I can recommend an outing to the outlying districts, which are tinged with countryside. In north London, streets are lined with well-maintained, Victorian brick houses. They wind uphill toward Hampstead Heath, a vast park dotted with idyllic ponds that offers wide-open views of London's skyline, though the park itself has a rural feel. It's no wonder the picturesque residential district of Hampstead has enjoyed enduring popularity, including among many artists and actors. And it's only a half-hour ride from the center of London to idyllic, almost village-like Chiswick, a world nestled into a bend in the Thames and beyond the rush of the city. Exploring the beautiful gardens surrounding magnificent Chiswick House is a pleasure at any time of the year. Go a bit farther to Richmond, and there's more to see than the day is long: the wonderful, Victorian greenhouses at Kew Gardens; the journey through time that is Hampton Court Palace; or even, just a ramble along the banks of the Thames, for a great view across the water over a pint at the pub. Sprawling Richmond Park is pure heaven, too. Once a hunting preserve for the royals, it's now a refuge for a wild deer population. If you're lucky you might catch a glimpse of a regal red-deer buck. Royal Greenwich Park also awaits with great views. One Tree Hill, just a few steps from the Royal Observatory and the Greenwich prime meridian, offers eye-level remote inspections of the imposing skyscrapers of Canary Wharf.

Right:
The streets of Hampstead in North London wind steeply uphill, lined by brick Georgian and Victorian buildings set cozily amid lush gardens.

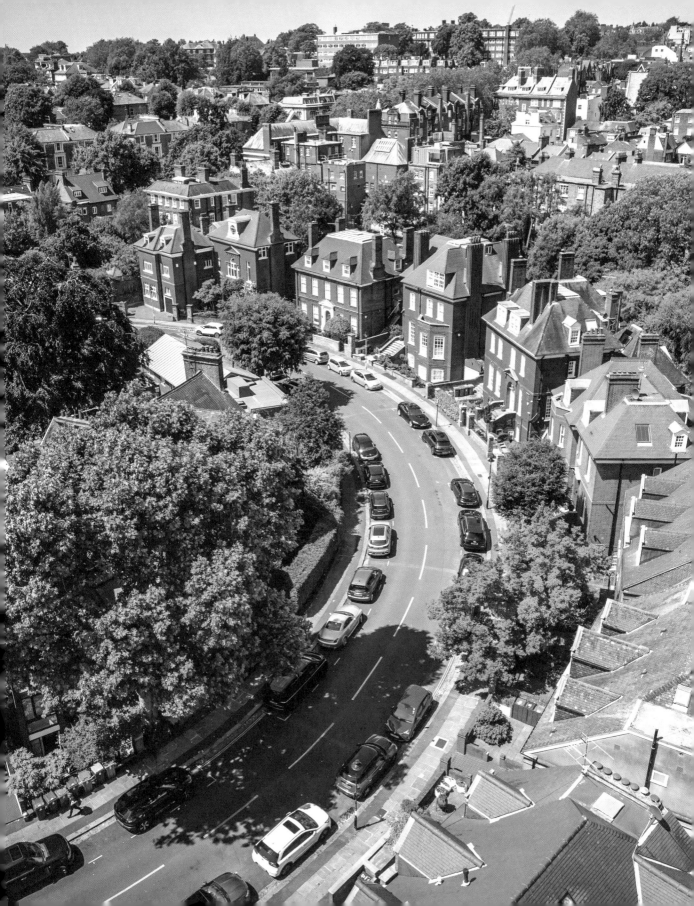

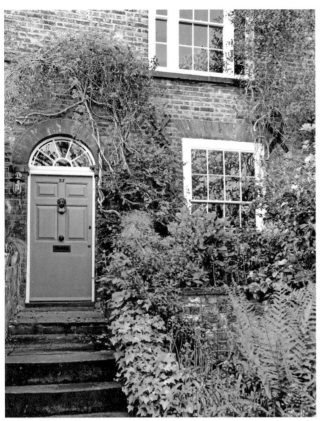

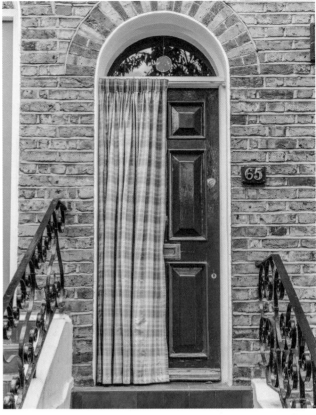

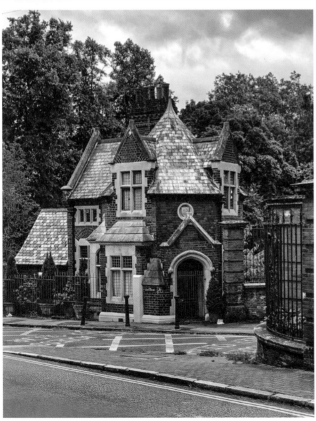

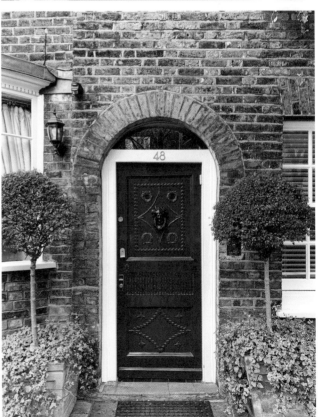

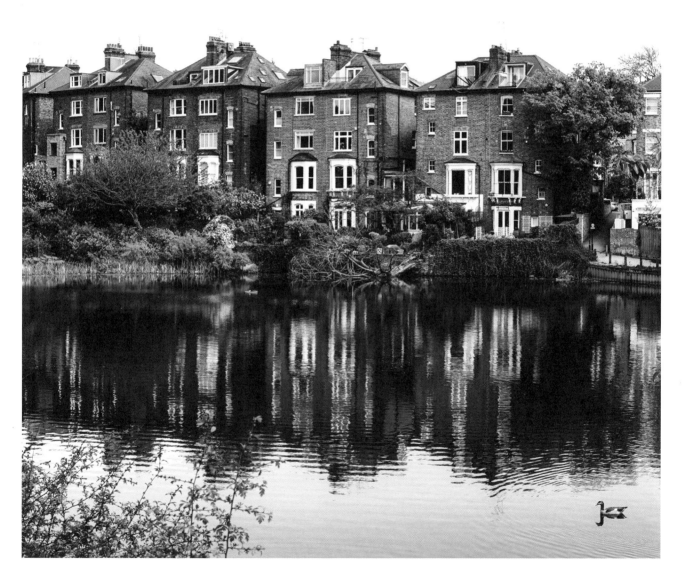

This page:
Coveted homes at Hampstead Heath look out onto the park's idyllic ponds.
Left:
No shortage of colorful, charming doors on old, brick Victorians in Hampstead.

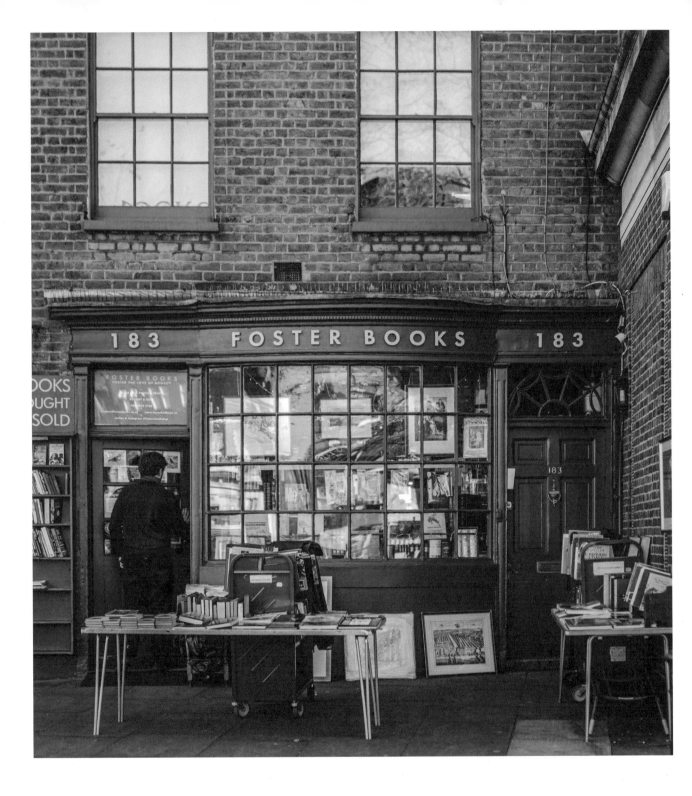

This page:
If you cannot resist the magical draw of old bookstores, pay a visit to Foster Books, a fixture in Chiswick.
Right:
Chiswick House with its wonderful garden is a major factor in this charming, green quarter by the Thames.

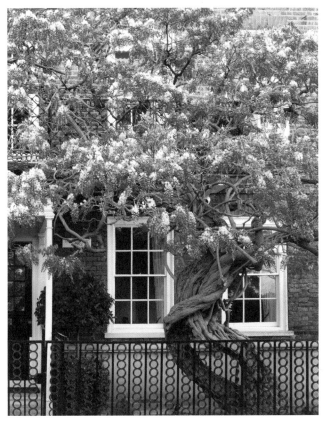

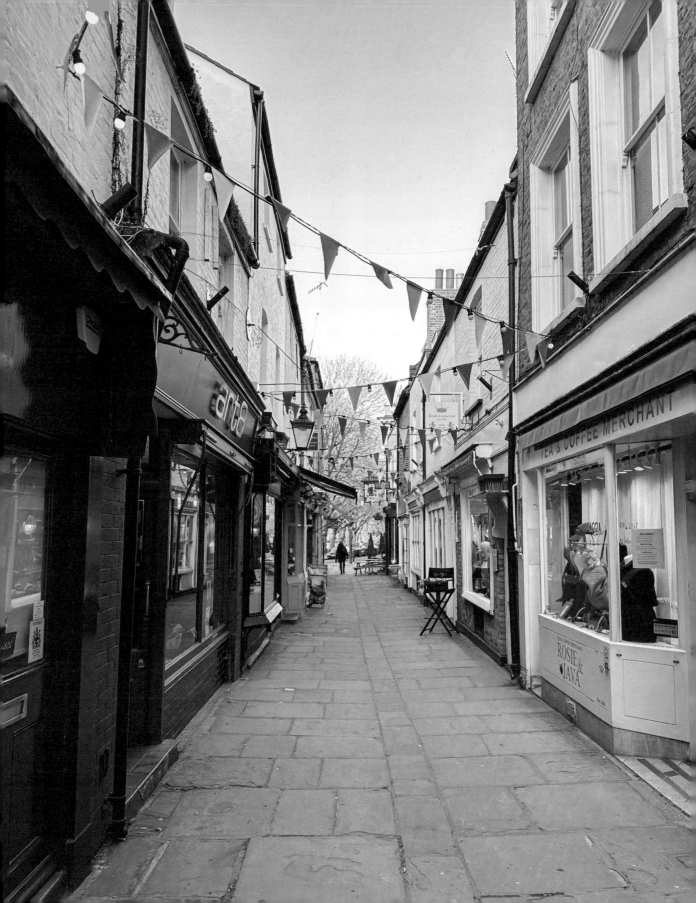

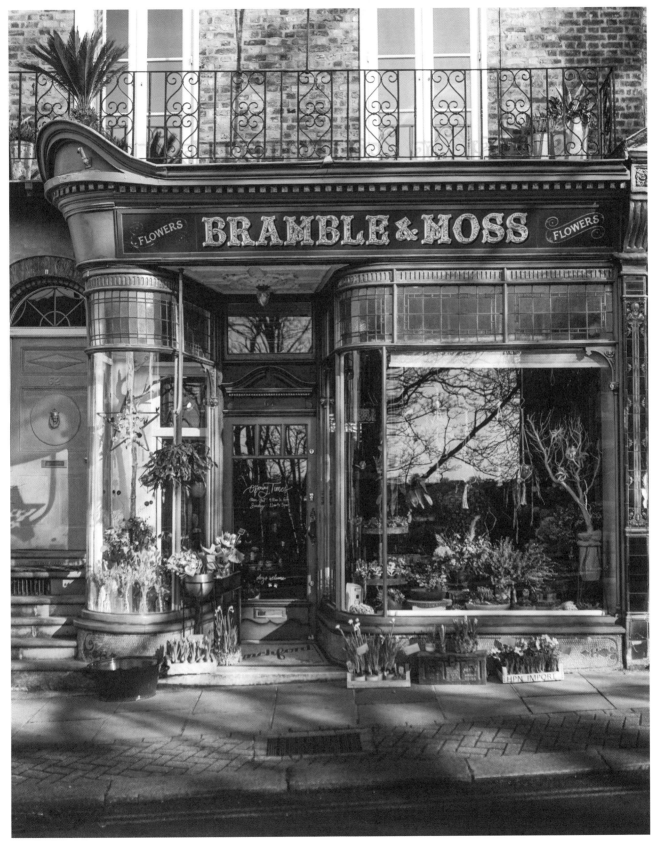

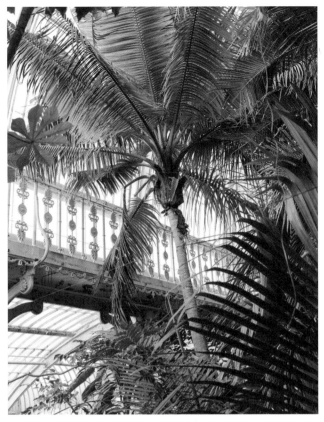
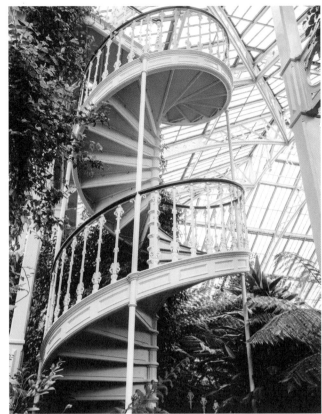
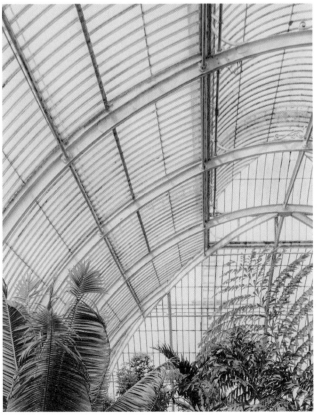

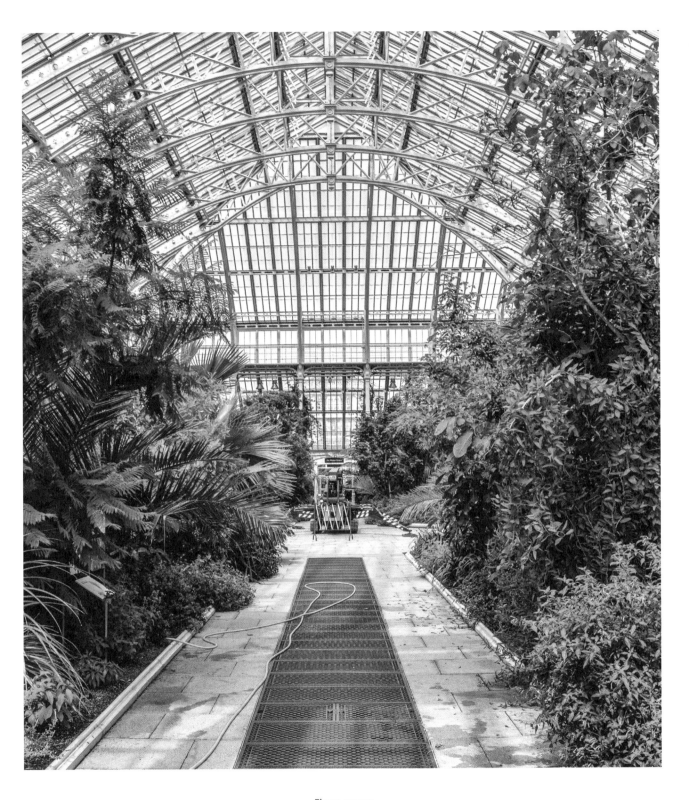

These pages:
The centerpiece of Kew Gardens is a set of elegant Victorian-era greenhouses. Their ornate architecture is as impressive as the botanical wealth they shelter.

Previous pages:
Quaint Richmond is full of surprises, with little alleys and charming old shops.

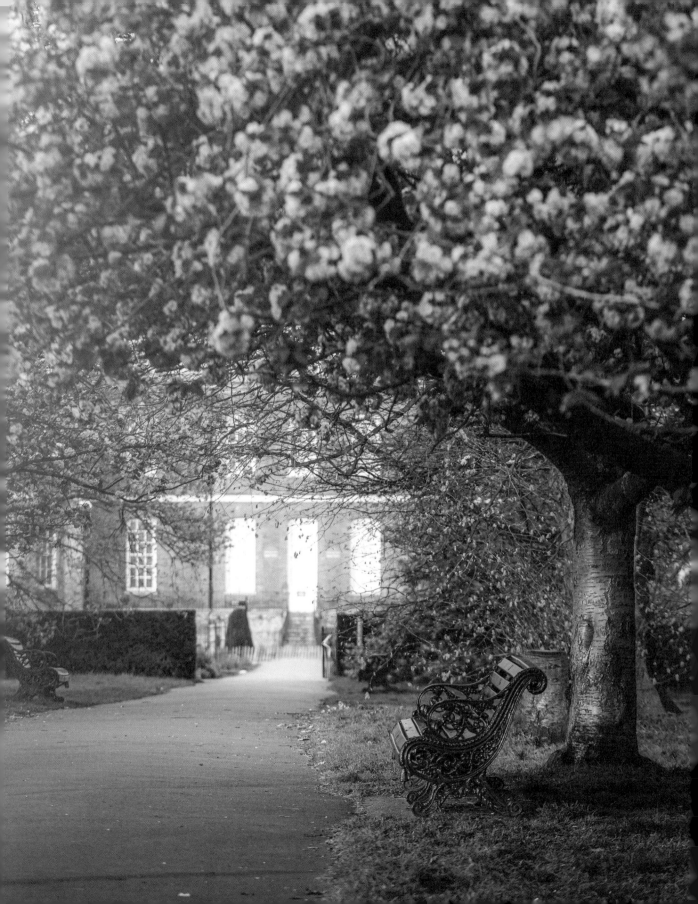

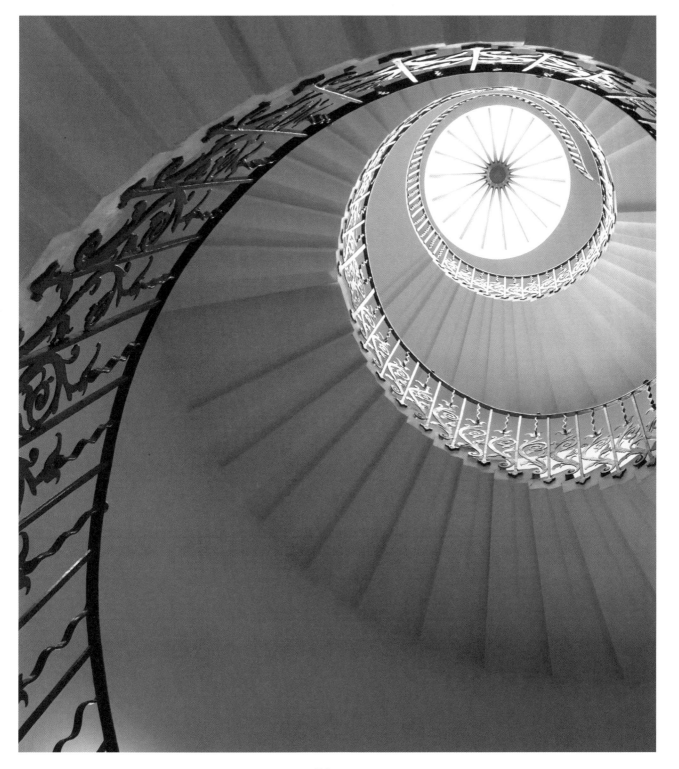

This page:
The harmonious spiral of Tulip Staircase appears to defy gravity at the former royal residence of Queen's House, Greenwich.
Left:
The cherry blossom in Greenwich Park is especially magical, and fans of the Netflix series Bridgerton *may think picturesque Ranger's House looks familiar.*

NORTHERN ENGLAND

FROM NORTHUMBERLAND TO YORKSHIRE

There's a peculiar magic to the ruggedness of Northern England, where storms off the North Sea lash at the sand dunes. More than a few abandoned old stone buildings along the coasts of Northumberland seem poised for erasure by the elements. A bit inland sits stately Alnwick Castle, which has survived nearly a thousand years of turbulent history only to nowadays provide the photogenic backdrop for many a film. An archaic atmosphere also permeates Hexham on the River Tyne, near the ancient Roman defensive barrier of Hadrian's Wall. Visitors can catch great views of imposing Hexham Abbey as they walk the narrow streets of the old town. Hikers along the ancient remnants of Hadrian's Wall are enthralled by a majestic sense of reverence, undiminished by the recent loss of one of its hallmarks: a two-hundred-year-old sycamore tree at eponymous Sycamore Gap was felled by vandals. Northern England in general is a celebrated destination where visitors come away with unforgettable impressions of well-preserved natural landscapes. The rugged ridges of the Yorkshire Dales and the high, breathtaking North York Moors possess a character utterly unlike the idyllic lakes and wild-flower-strewn slopes of the Lake District. Out on the trails, hikers may encounter more sheep than people—a good sign of a comfortable pace. To the south lies the eternal city of York, which was founded during the Roman period. The lively old town within the city's medieval walls has these captivating little streets the locals call "snickelways" that snake their way in a tangled confusion past motley, assorted old brick and half-timbered buildings. Small shops alternate with tiny cafés, making for a bright, colorful vibe, and several idiosyncratic, old-style pubs are probably of the same vintage as the countless churches strewn all over the old town.

Right:
On an endless walk on one of the beaches near Alnwick on the coast of Northumberland, a chance to reflect.

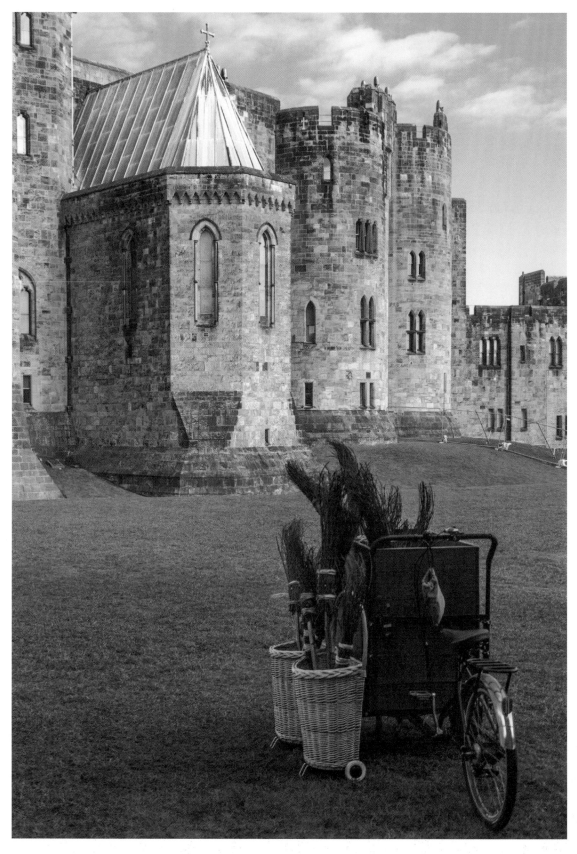

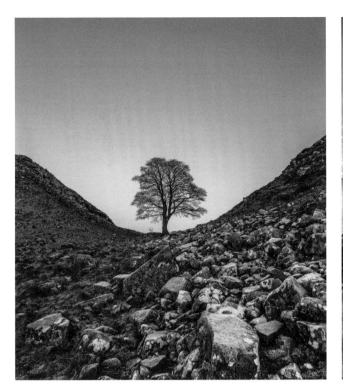
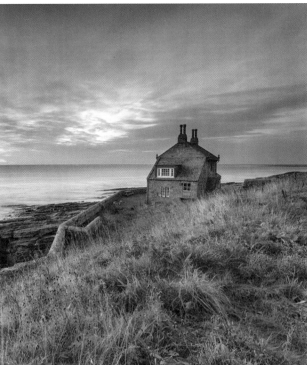

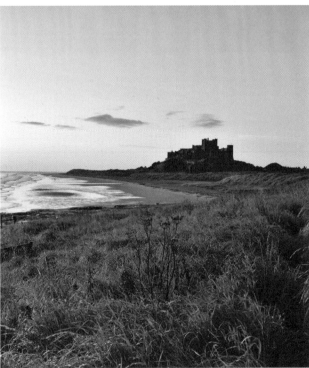

This page:
Wild and picturesque: The archaic beauty of Northumberland, from Hadrian's Wall to Norman-era Bamburgh Castle, a stronghold against the North Sea.

Left:
Not only is Alnwick Castle one of the biggest castles in England that someone still lives in, but in the Harry Potter *movies it also doubled as Hogwarts.*

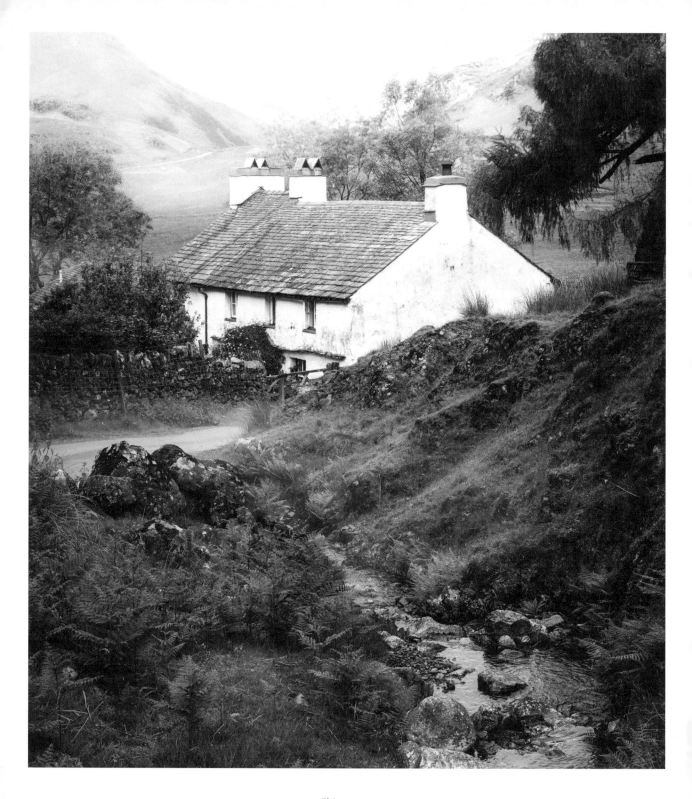

This page:
The melancholy lonesomeness of Blea Tarn House in the high valleys of the Lake District, near Ambleside, is said to have inspired the Romantic poet William Wordsworth.
Right:
Around Coniston Water, the Lake District can look bleak and picturesque at the same time.

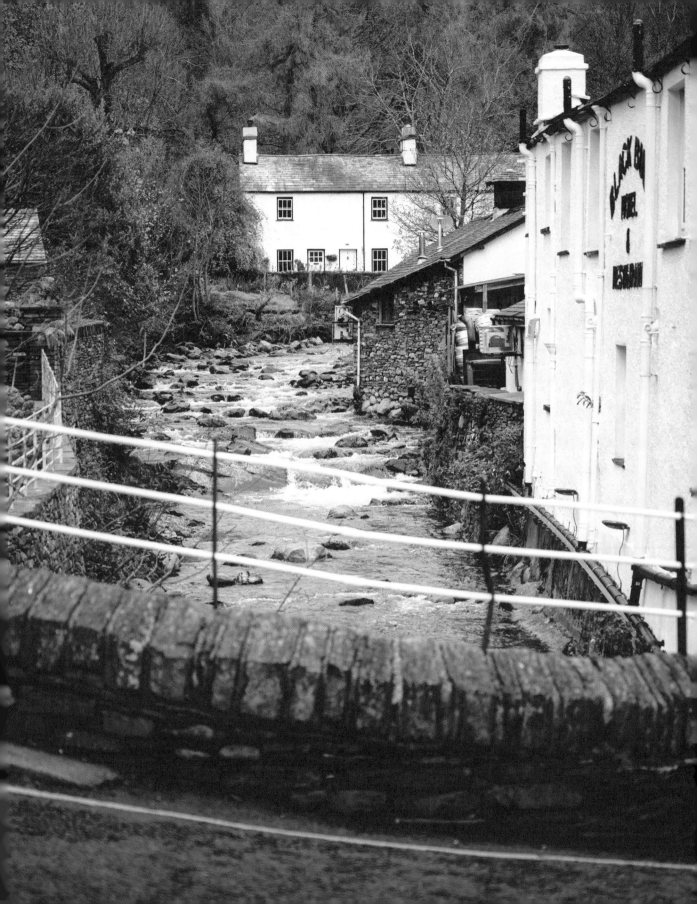

This page:
The city of Hexham on the River Tyne, near Hadrian's Wall, exudes an almost archaic charm.
Right:
Many people don't notice that the sheep in front of Hexham Abbey aren't real until they see them illuminated at night. They're part of an arts project.

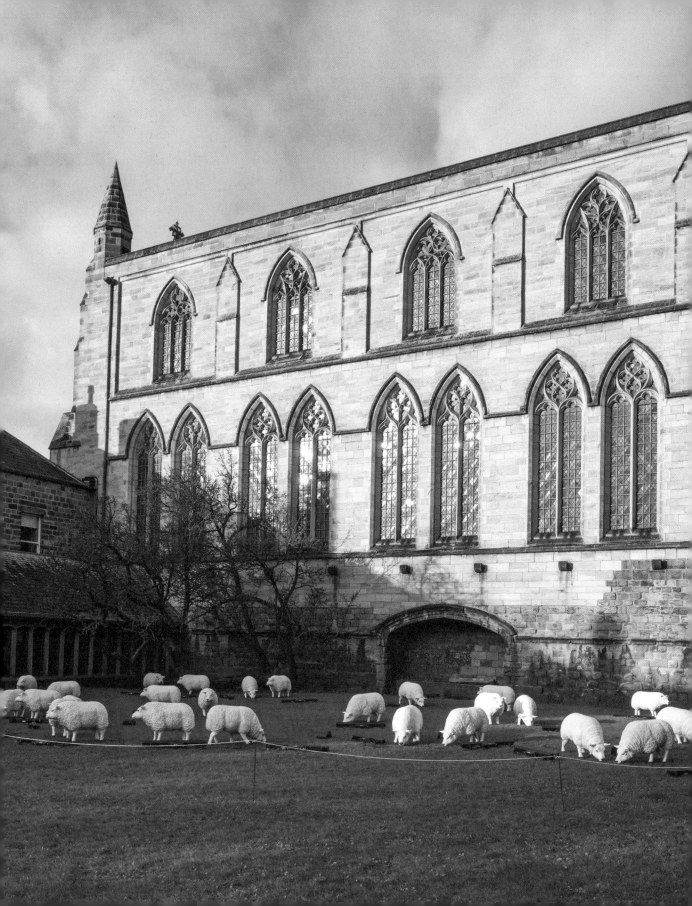

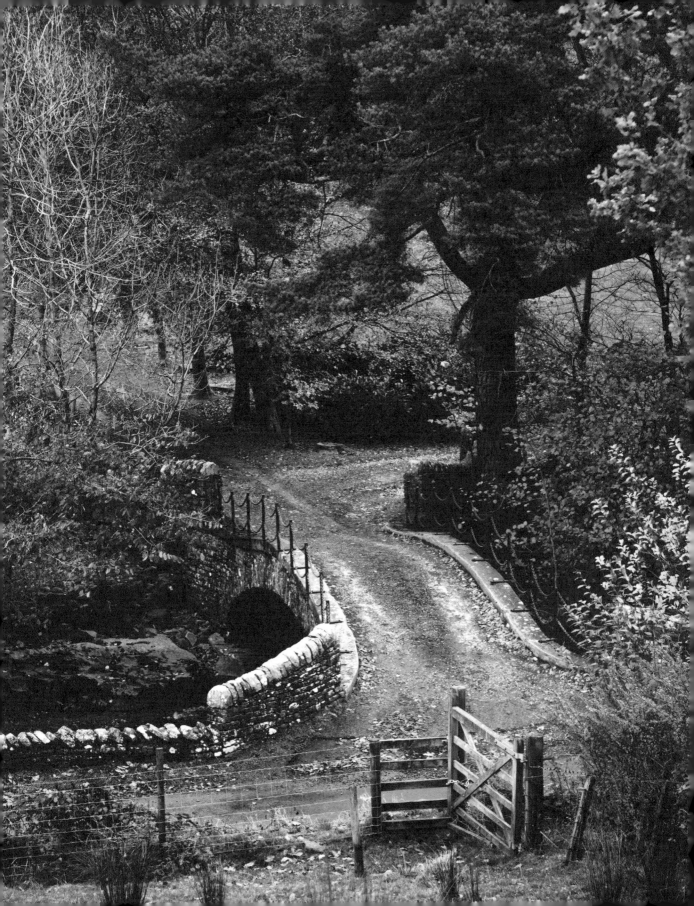

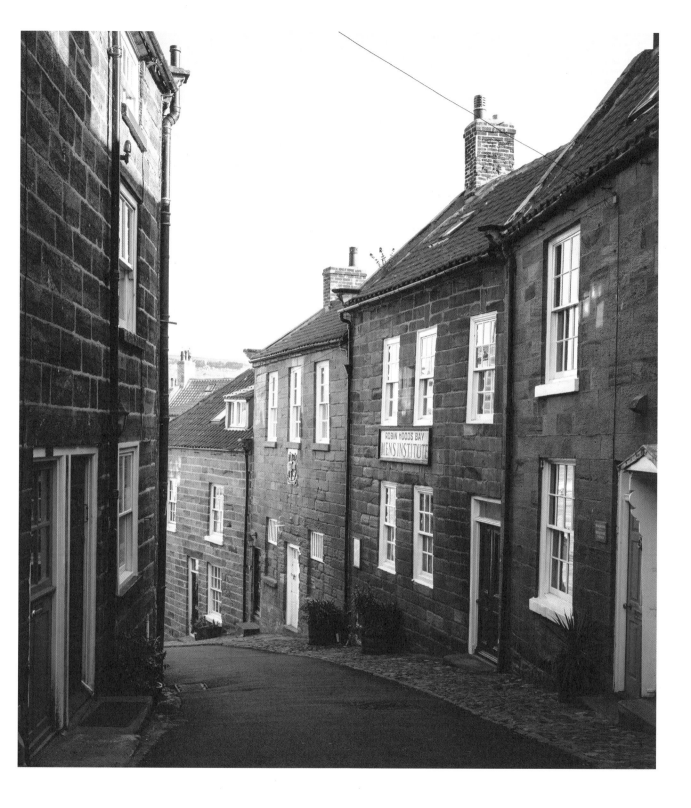

This page:
Steep, narrow streets descend to a small harbor in the idyllic old fishing village of Robin Hood's Bay.
Left:
Typical: Hikers in remote areas in Northwest England cross more than a few old stone bridges like this.

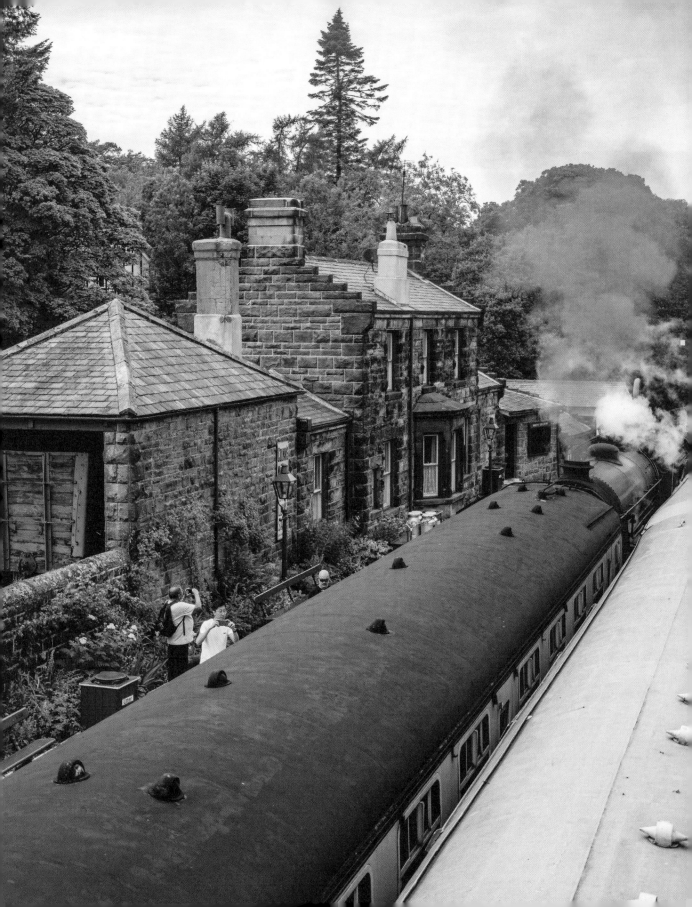

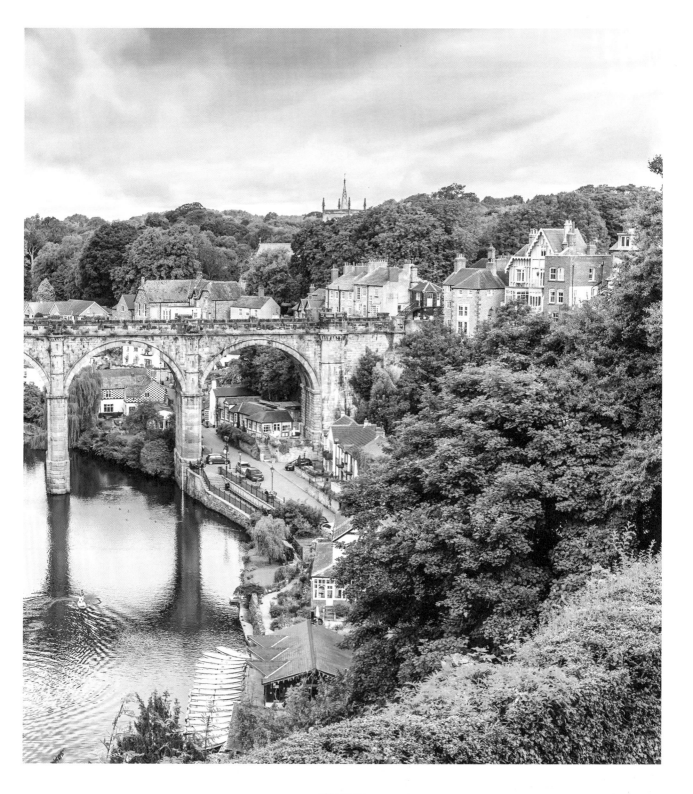

This page:
The best view of the impressive railroad viaduct is from the footpath to the ruins of Knaresborough Castle.
Left:
The quaint Hogwarts train station is a real place. Fans of Harry Potter *can pilgrimage in style, drawn by steam locomotive to Goathland Station in North Yorkshire.*

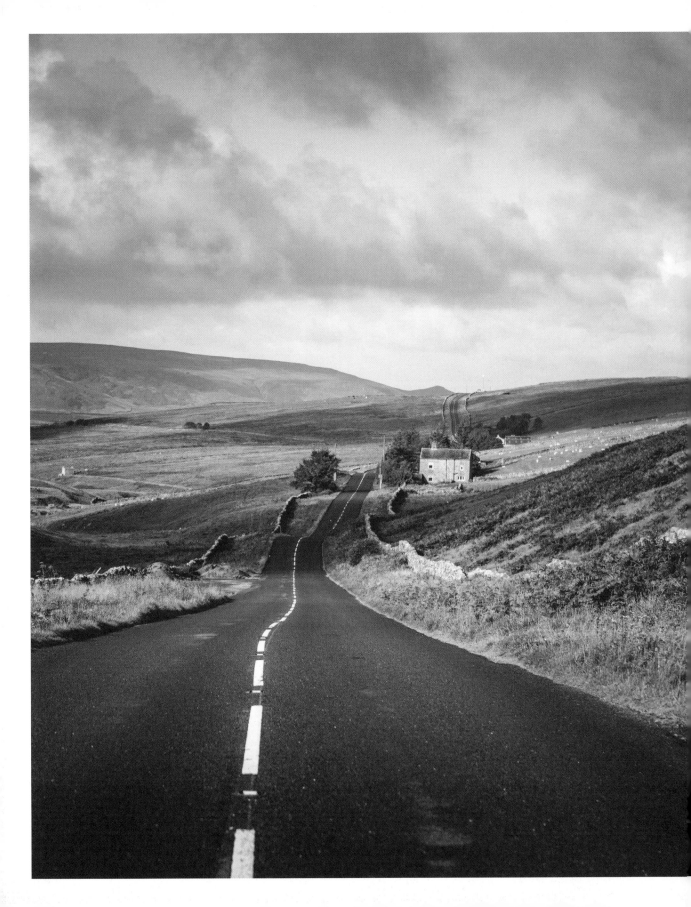

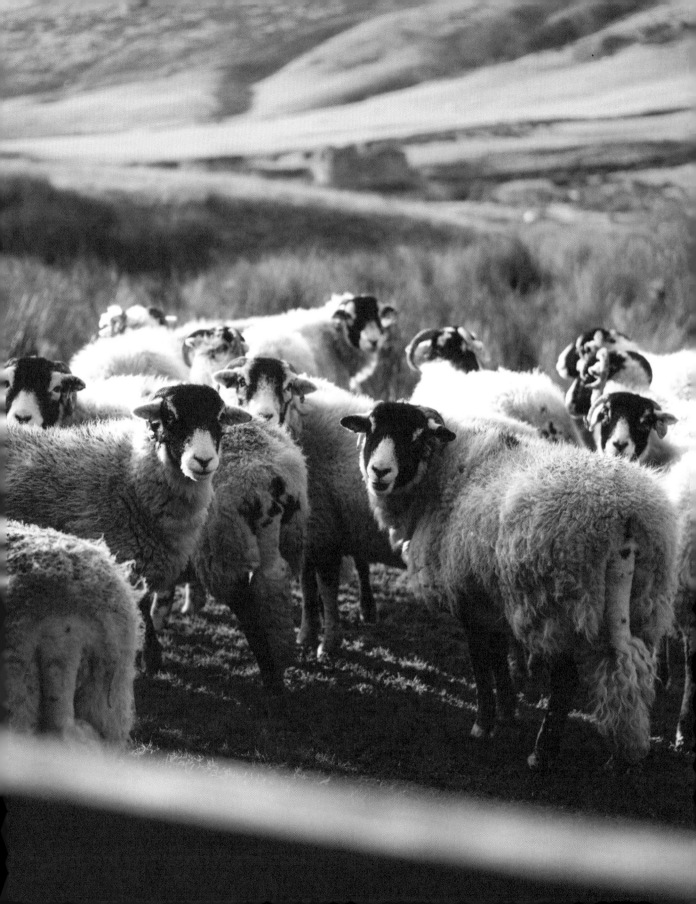

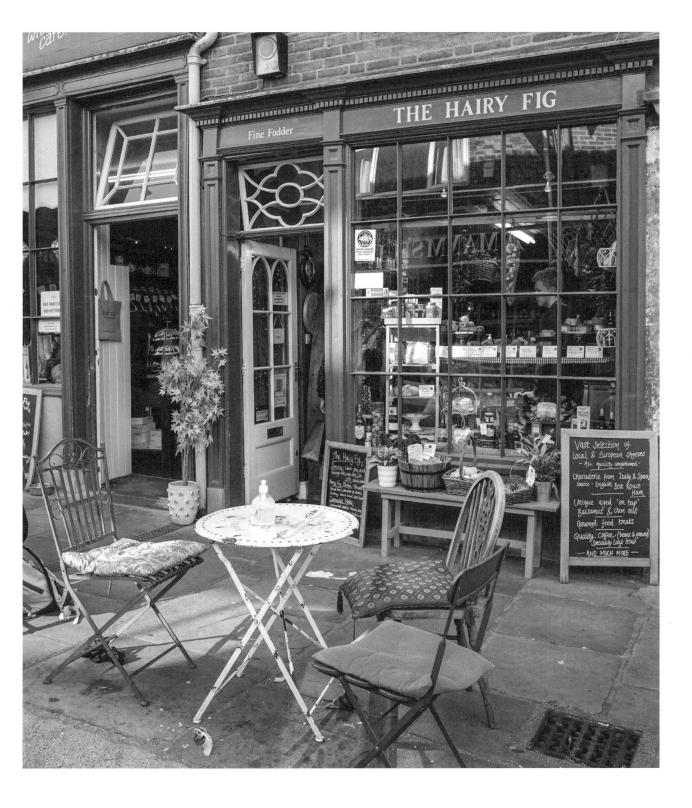

These and the previous pages:
Counterpoint to the barren, lonesome Yorkshire Dales (previous) is the old town of York, which offers color, flowers, and a laid-back charm. Epicureans are yo-yoed between afternoon tea at The Ivy or a dainty snack at The Hairy Fig.

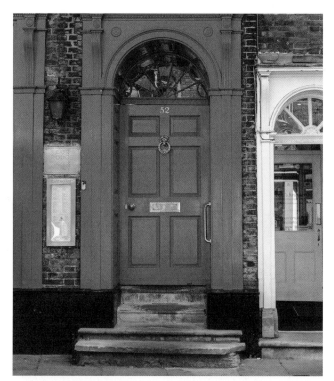

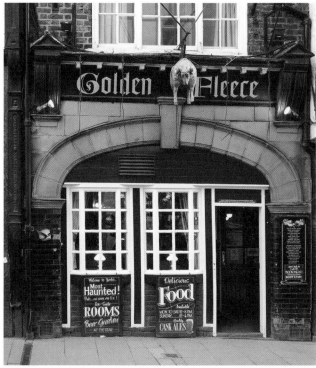

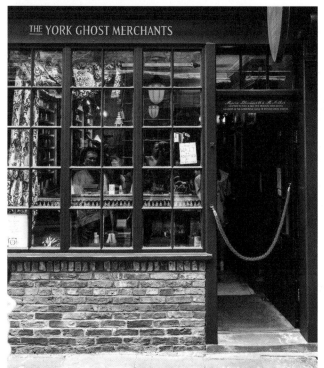

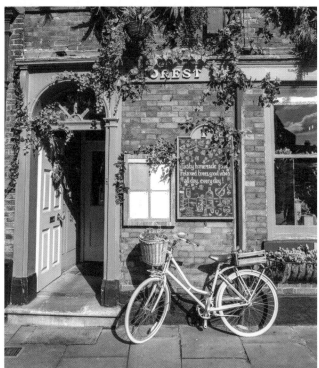

This page:
In doorways and shop windows around The Shambles, York's old town persists with its rich character and bold tones.
Right:
Downtown York is permeated by old-style, medieval streets, such as Grape Lane, that are interconnected via hidden alleys called "snickelways".

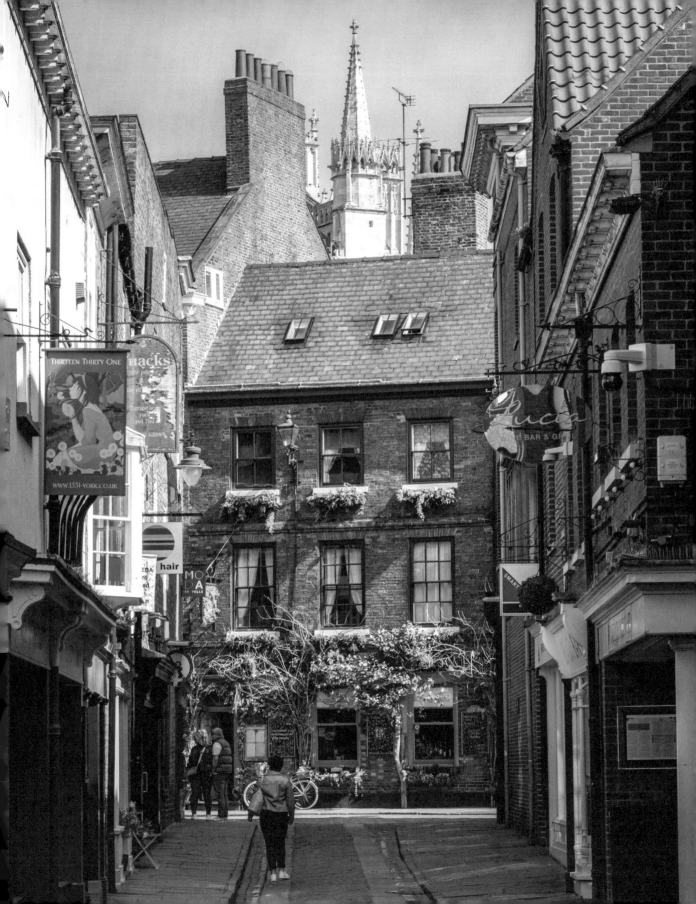

MIDLANDS AND EAST ENGLAND

FROM THE PEAK DISTRICT TO NORFOLK

An august landscape, wild and untamable, where autumn mists rise up, and the melancholy atmosphere transports the observer across the barren hills and directly into Emily Brontë's Romantic classic *Wuthering Heights*. Derbyshire's foggy high moors and storm-lashed hills offer dramatic scenery for those yearning to simply walk across the landscape and let their thoughts wander. Enticed into a traditional pub or café for a rest, a traveler could almost expect to find herself at the bar beside some depressive-romantic hero straight out of a novel by Jane Austen or the Brontë sisters. Picturesque scenes are also found in Shropshire. Head to Ludlow to enjoy the flair of an earlier time while browsing the small shops in the old town at the foot of the ruins of an old castle. Crooked half-timbered buildings jut into the alleys like a cry from the Middle Ages amid the Georgian homes of the burgesses. Farther west lies Stratford-upon-Avon, which— drawing huge numbers of visitors—is the birthplace of William Shakespeare. The idyllic gardens around Anne Hathaway's Cottage (she was the Bard's wife) are enough to enchant even those who don't care about literature. Stamford is also worth a visit: a small but complex town with honey-yellow stone buildings that easily compares to the idyllic villages of the Cotswolds. Stamford, with its small shops, tea rooms, and old-fashioned, colorful storefronts, regularly ranks on a list of the UK's most lovable and livable places. On to Norfolk and Suffolk, where, conveying a sense of bygone times, are not just plenty of old palaces set amid enormous estates, but also the exalted university town of Cambridge. To ramble through one of the small, charming villages like Lavenham and see the gnarled stock of half-timbered Tudor buildings recalls a scene or three from *Harry Potter*.

Right:
There's always a novel, fascinating view in store from the rocky, wind-swept hills of the Peak District.

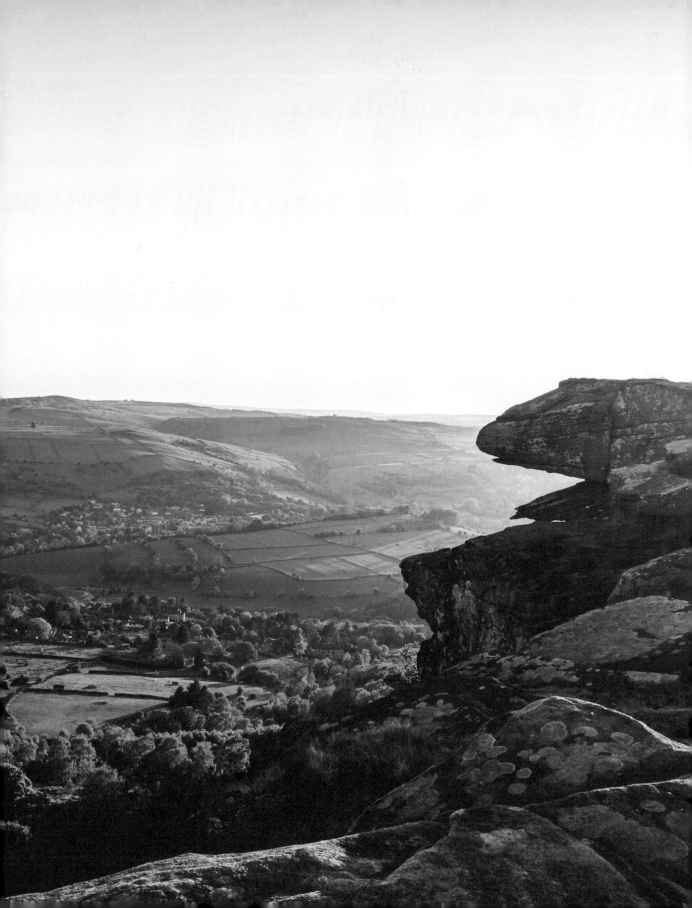

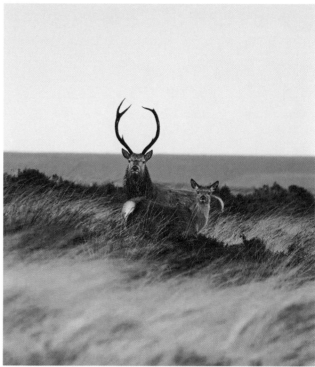

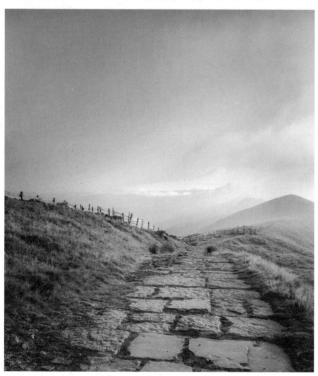

Above and at right:
*The Peak District offers many attractive places to hike for those in search of solitude. The Mam Tor Trail is very
well maintained and passable, so you can look up at the stunning scenery as you go.*

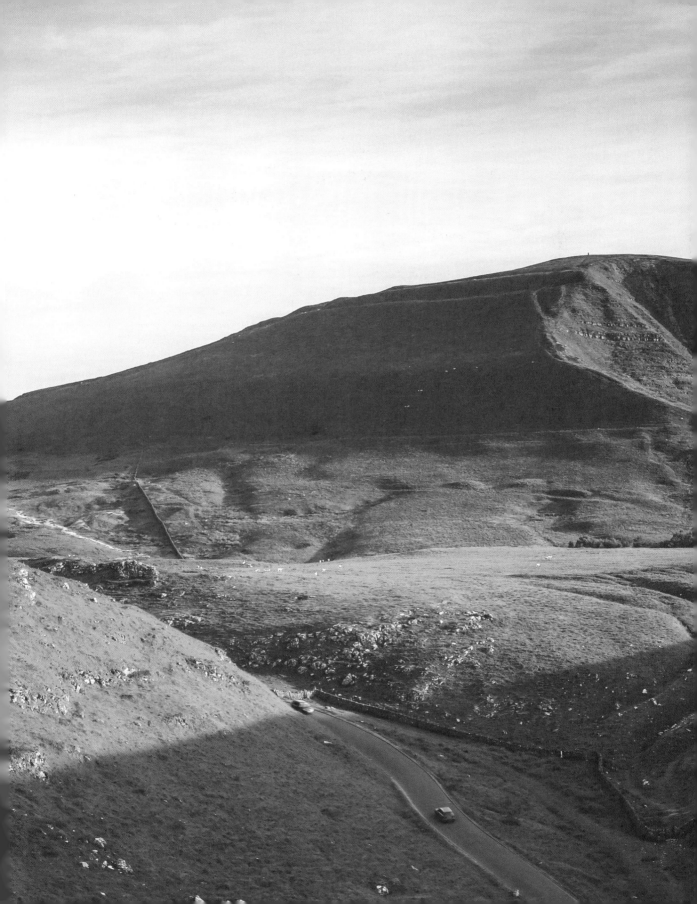

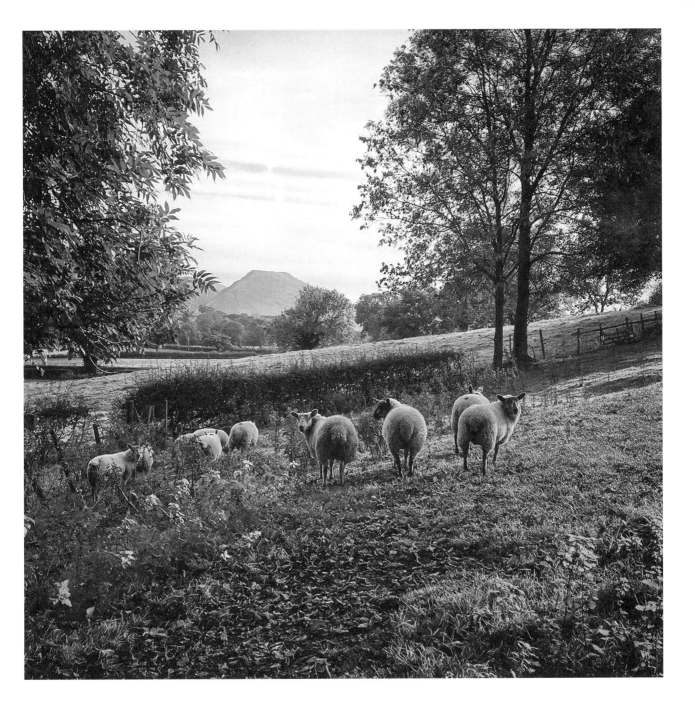

Above and at left:
Tranquil Peak District: You might encounter more sheep than people on some of the remote trails.
Following pages:
For a stroll beneath lush, delicate lilac wisteria, don't miss Trentham Gardens (left) in Stoke-on-Trent.
Ruins of a medieval castle and a quaint gatehouse: Stokesay Castle (right), north of Ludlow.

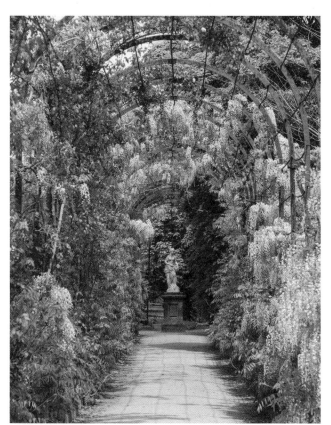

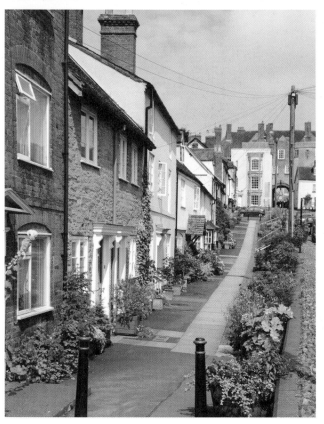
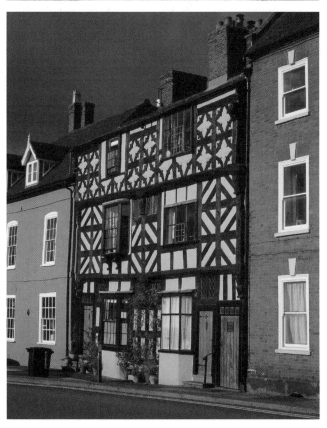

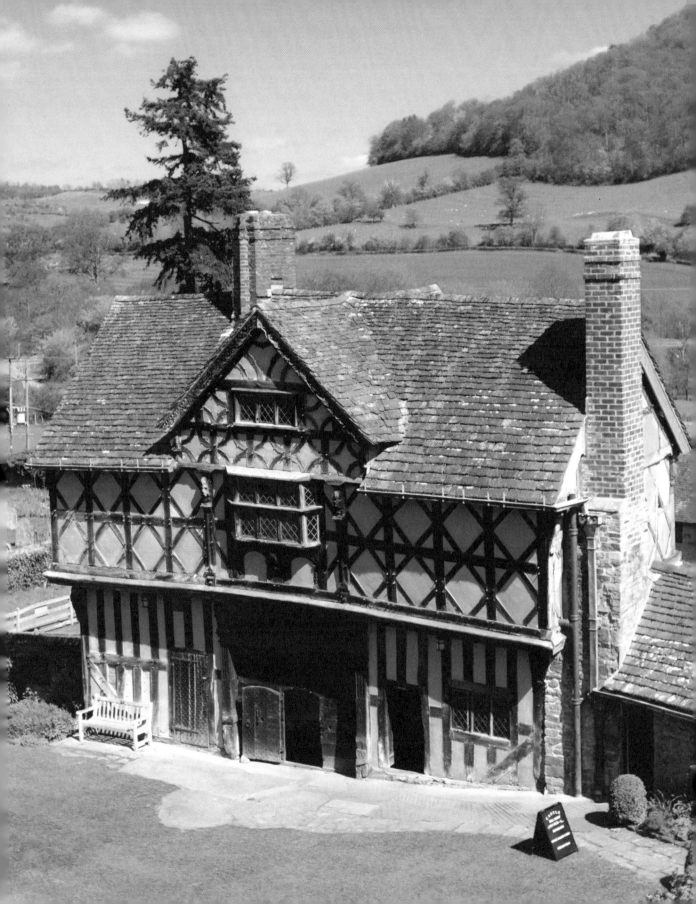

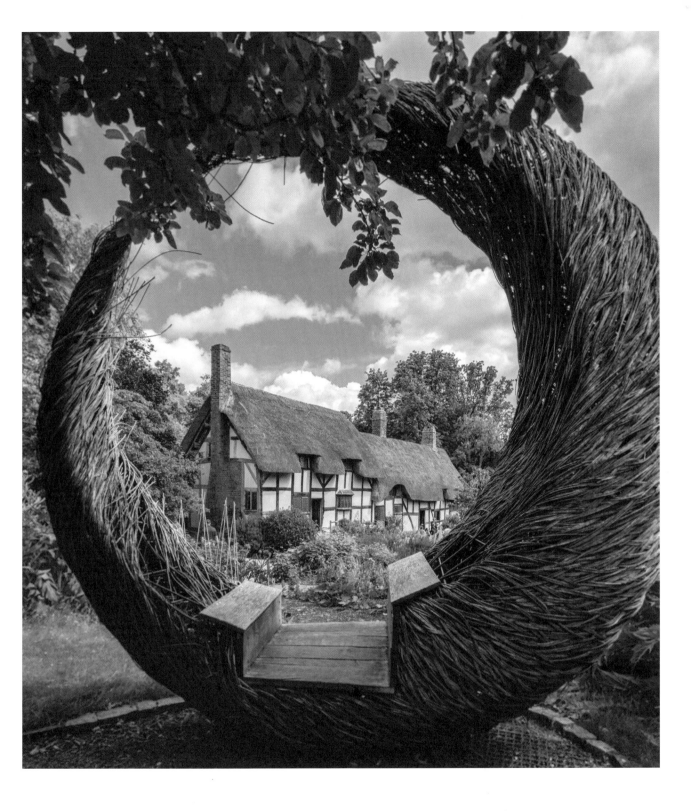

Above and at left:
Witnesses of Shakespeare's day, paintings come to life: The oldest pub in Stratford-upon-Avon and Anne Hathaway's Cottage keep the Elizabethan era alive.

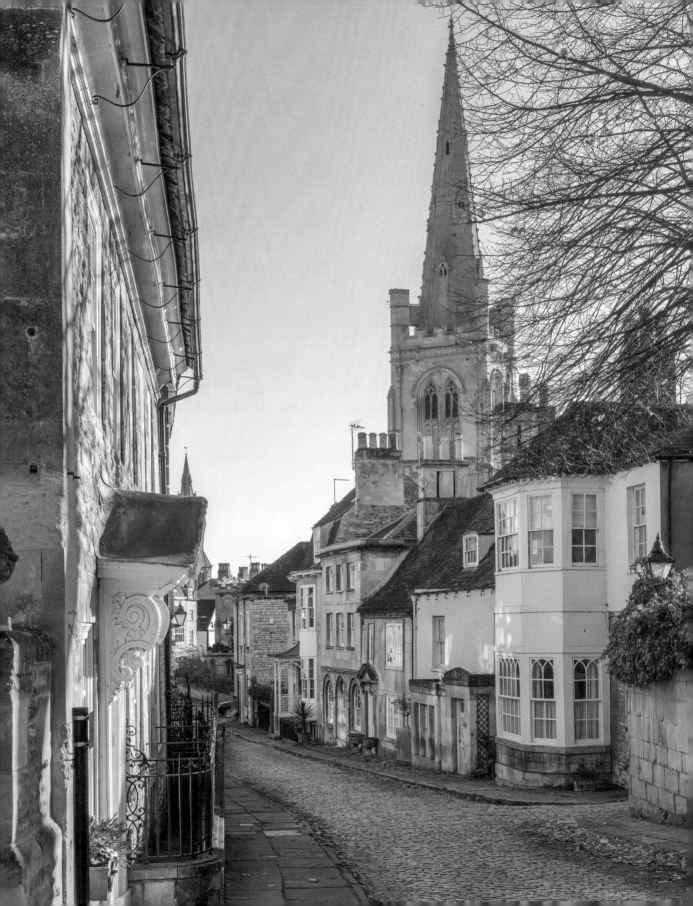

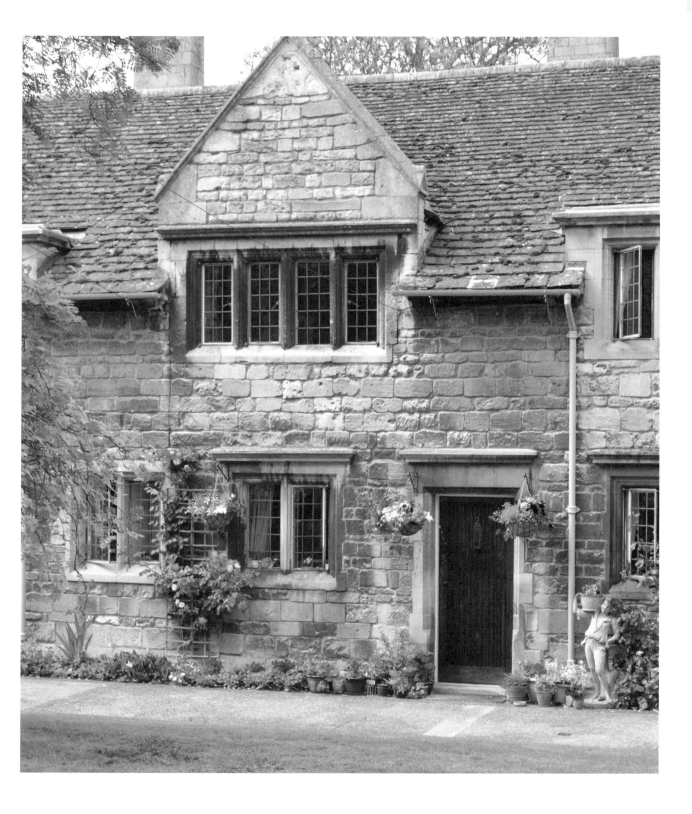

Above and at left:
Scouted for film adaptations of novels from Middlemarch *to* Pride and Prejudice: *Stone houses in charming Stamford.*

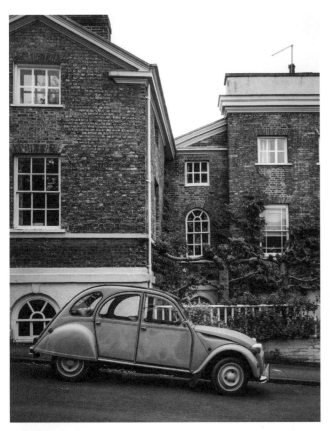
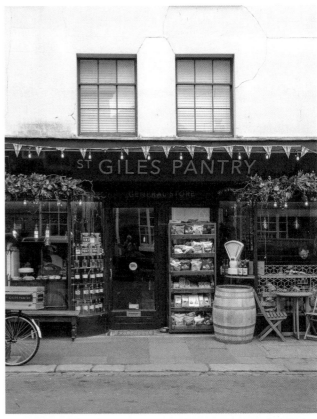
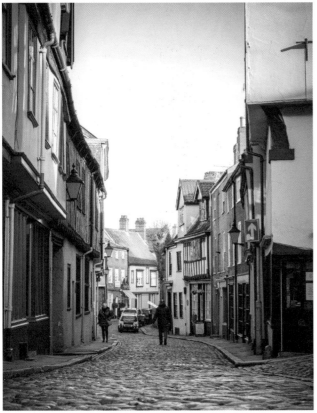

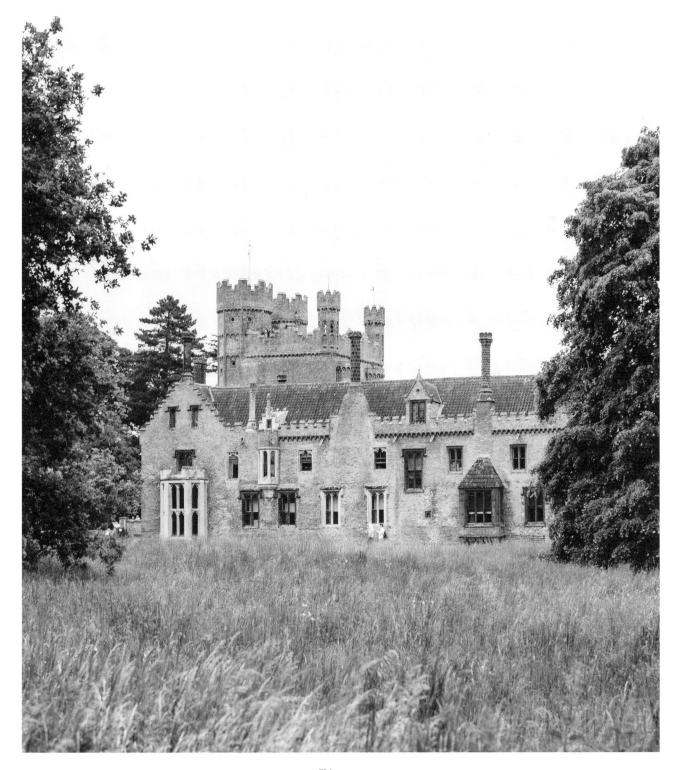

This page:
Oxburgh Estate in King's Lynn, built in 1482, is one of the oldest and most impressive country houses in all of Norfolk.
Left:
For old half-timbered houses and attractive shops, walk down Elm Hill and the other meandering streets in Norwich's old town.

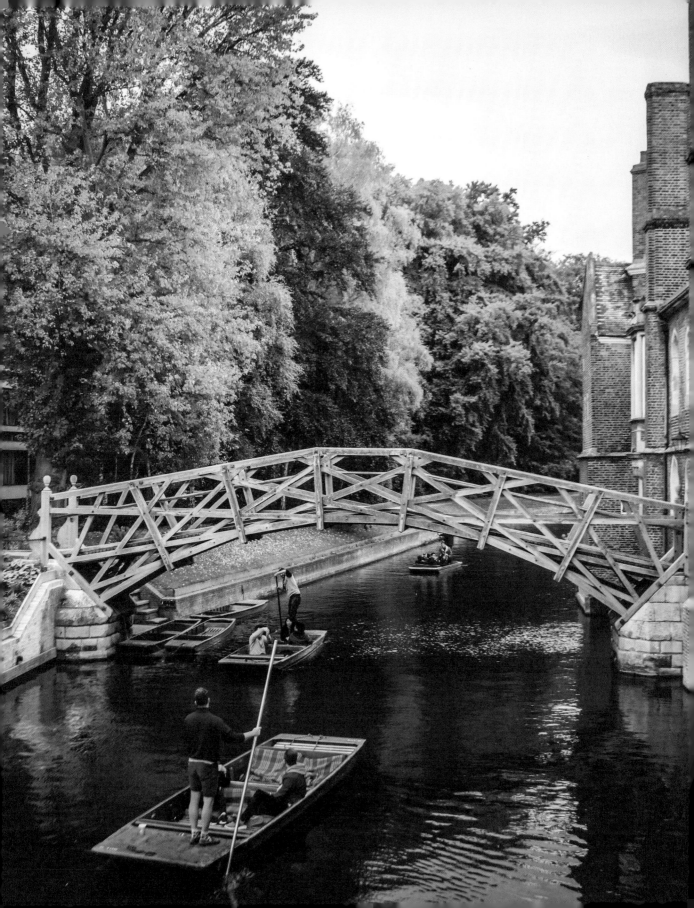

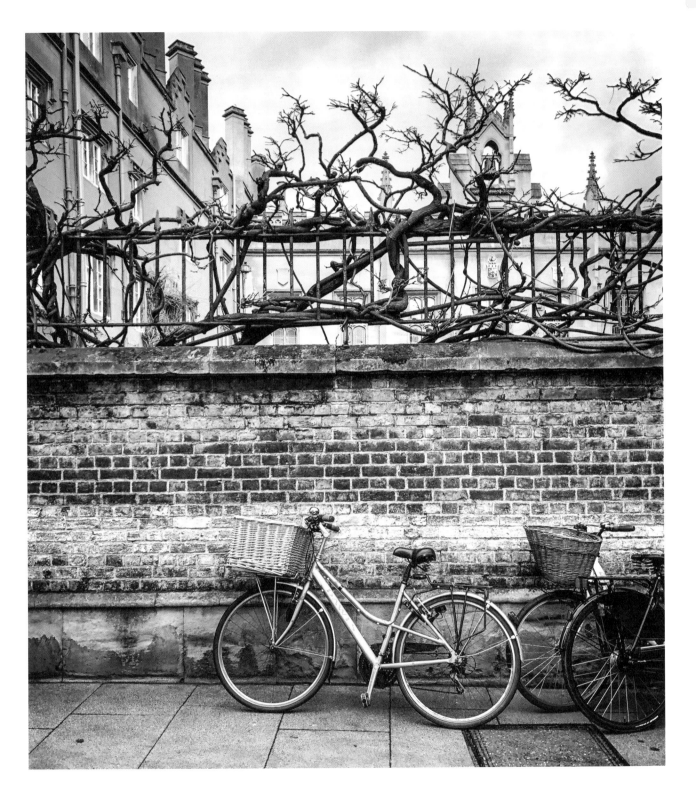

Above and at left:
Cambridge: Mathematical Bridge, an impressive 18th-century engineering triumph, leads to Queen's College.

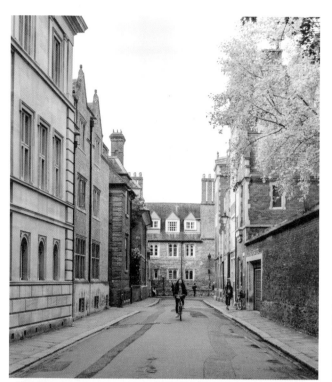
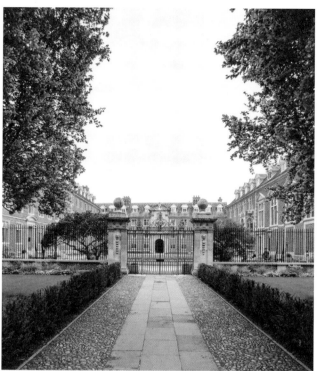

Above and at right:
No visitor to one of the distinguished colleges in the university town of Cambridge can escape at least one poling ride along the romantic meanders of the River Cam in one of these flat-bottomed boats, called punts.

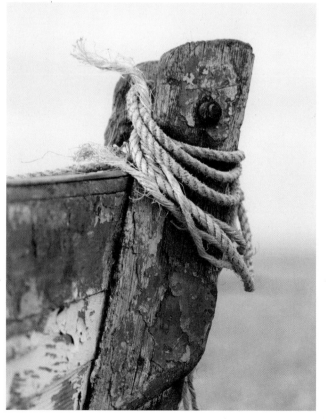
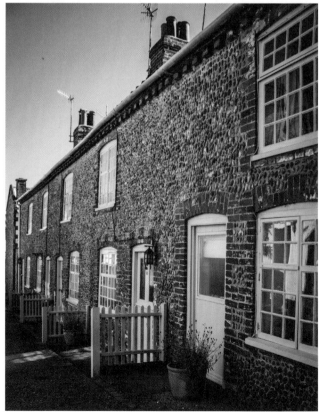

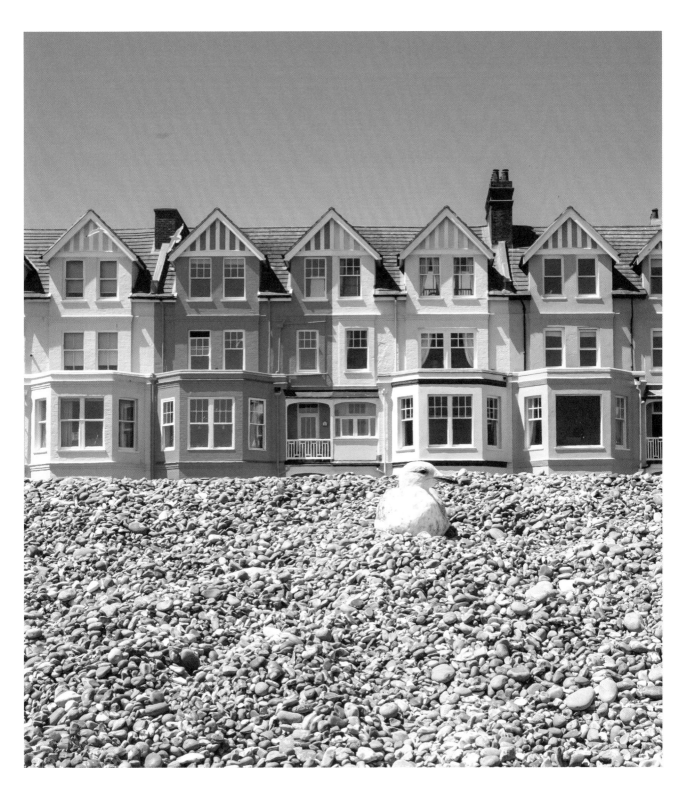

Above and at left:
Laid-back, not to say torpid Aldeburgh, on the Suffolk coast, has kept its original charm. The pastel houses along the seaside promenade longingly conjure Aldeburgh's earlier incarnation as a fishing town.

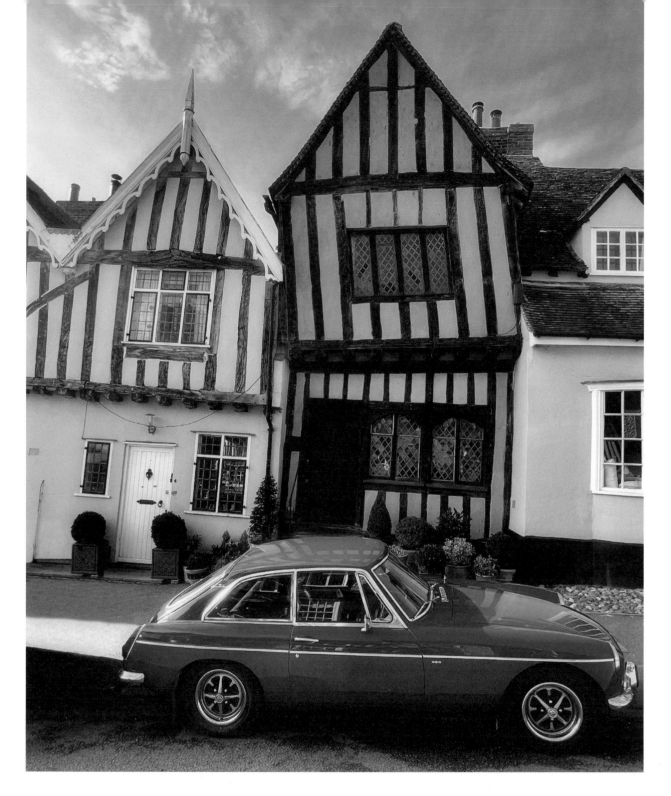

This page:
They say the nursery rhyme "The Crooked Man" tells of the Crooked House in Lavenham.
Right:
Ramble through towns in Suffolk like Lavenham, Kersey, or Bury St Edmunds to see so many Tudor-era half-timbered buildings, with so much personality, you won't know where to look.

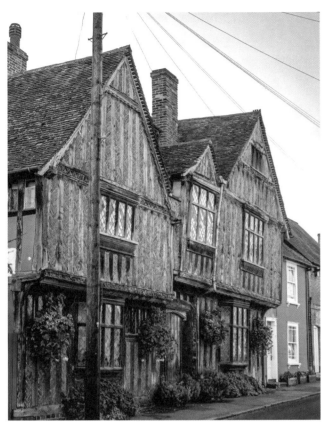
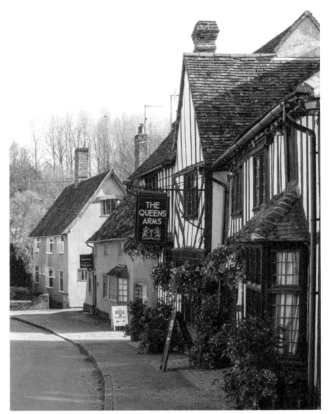
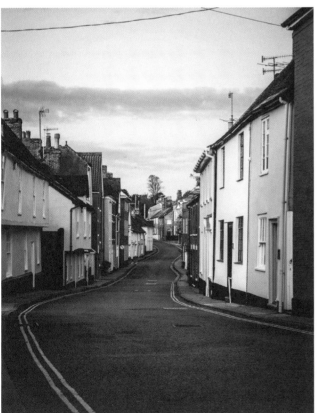

COTTAGES

QUINTESSENTIAL ENGLISH COUNTRY LIVING

True gems are found mostly when one isn't looking for them. If you love charming traces of bygone eras, then strike out clear across the country: you'll be rounding the bend into some sleepy hamlet when a gently curving, thatched roof comes into view, atop a squat, stone house, with little casement windows, with flowerbeds on either side of the path from a wooden gate to a front door beneath an ornate little portico. Here's your gem: a charming cottage, sprung from the pages of a book. Cottages are so typically English that there's practically no word for them in any other language. Today, so many aristocrats and high-society types own these little houses. What to them is a country residence will have once been the home of a small farmer or day laborer, who will have lived in it modestly, space-limited, and growing their own vegetables. Over time, these cottage gardens have blossomed into lush oases, with wisteria and rosebushes all over the place—wildly romantic subject matter for photography—not to mention that there's no single, typical cottage style. Rural homes were wrought from whatever local materials were available. The idyllic villages in the Cotswolds are full of traditional, thatch-roofed cottages built of honey-colored stone. Houses in other rural counties, from Surrey to Warwickshire, are of clay and timbers, or of brick, which is everywhere. And who wouldn't fall in love immediately with one of the small, whitewashed fisherman's cottages along the coasts of Dorset or Cornwall? Their pastoral former occupants are a vision of the past, for many of these small, painstakingly restored houses are now luxury rentals whose allure is the promise of a relaxed, rural retreat. So, the dream of an idyllic rural lifestyle can still come true—temporarily, anyway.

Right:
No English cottage is complete without a romantic English garden,
where everything is allowed to grow and blossom.

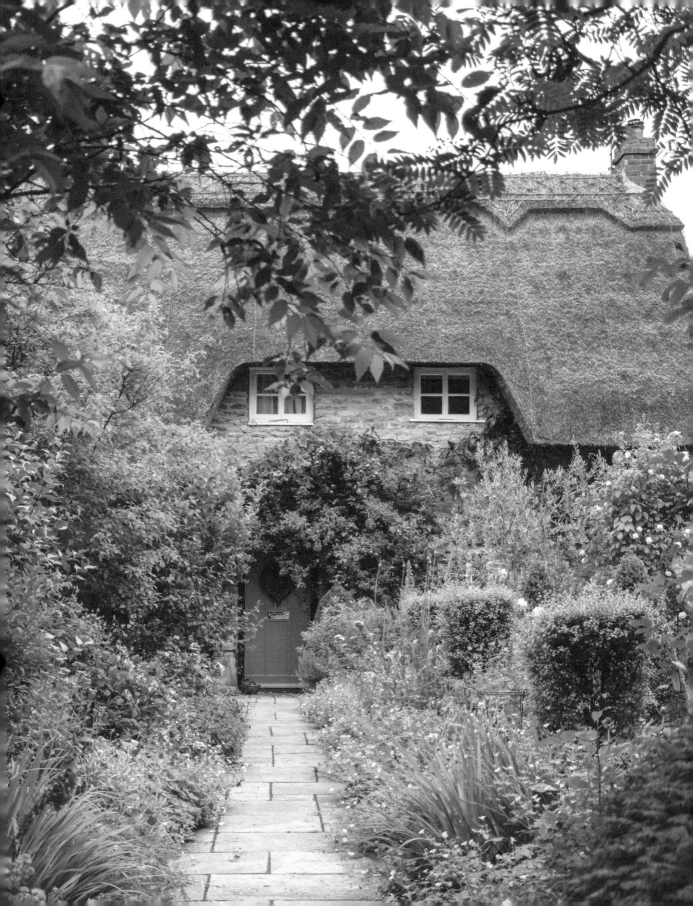

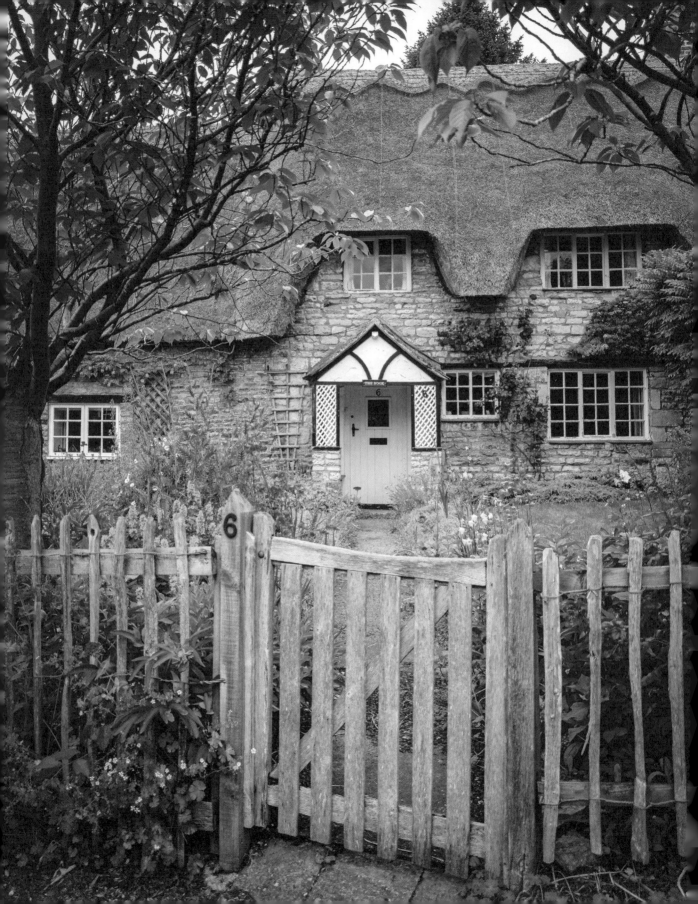

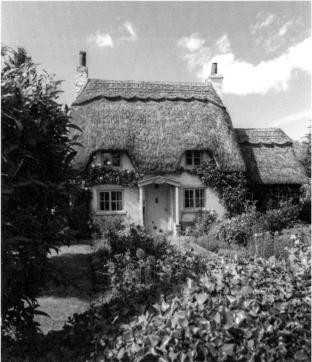
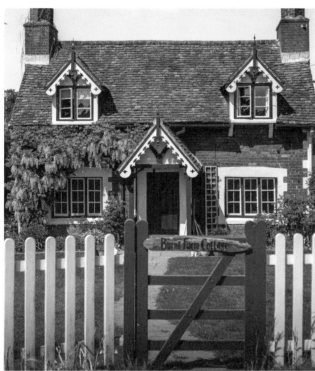
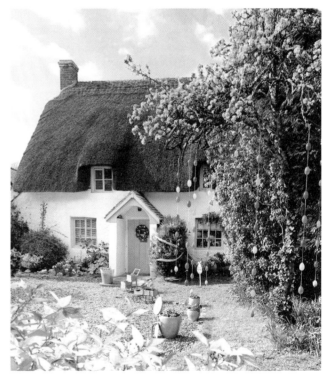

This page:

So different, but all so charming. Clockwise from top left: Polesden Garden Cottage in Surrey, Rose Cottage in Warwickshire, maritime West Lulworth Cottage in Dorset, and Burnt Farm Cottage in Hertfordshire.

Left:

The Nook Cottage, in the hamlet of Exton in Rutland, is a wonderfully preserved gem from the early eighteenth century.

THE SOUTH WEST

A JOURNEY THROUGH 5000 YEARS OF HISTORY

Touring southwestern England is like speed-dating with the past. Five thousand years of history go by, embedded in a nostalgic, picture-book country setting. Begin in rural Wiltshire, where lies Stonehenge, august, mystical, and continuing to mystify, especially around the summer solstice, when the light streams through the dark megaliths. Fast-forwarding three thousand years from Stonehenge, we continue to Bath, where, on cool days, mysterious mists still rise up from the hot springs at the shimmering, blue-green Roman Baths, just as they did in Roman times. Up above, we are greeted by Regecy-era Bath, which is arrayed all around the ancient thermals. Strolling down the magnificent streets, past one masonry building after another, one senses how positively hopping life must have been in this exclusive eighteenth-century spa. Standing before the golden-yellow facades is like stepping into a Jane Austen novel, or perhaps into the glamourous world of *Bridgerton*, a Netflix series that has brought record numbers of visitors to this UNESCO world cultural heritage site. Onward to Bristol, an old port city that's now a cultural hotspot, where street art and graffiti (and works by Banksy) mingle with legacy objects like the fine glass arcade at St Nicholas Market. Travelling across the countryside, one stumbles across England's storied past at just about every corner—Celts, Romans, Saxons, and Vikings. Time is holding its breath in the high street of the village of Lacock; the stone and half-timbered cottages set moods as if for a scene from *Harry Potter* or *Downton Abbey*. Continuing south to Lyme Regis, Weymouth, and Lulworth Cove, Dorset's picturesque coastal locales, we can feast our eyes on pastel façades and enjoy the salt air and the gulls' cries as our gaze reaches past sandstone cliffs and quiet coves and farther, out to sea.

Right:
The wonderful charm of old quadrangles: There's always an unfussy wildflower blooming in the tiniest crack in the wall, enlivening the old stone stairs.

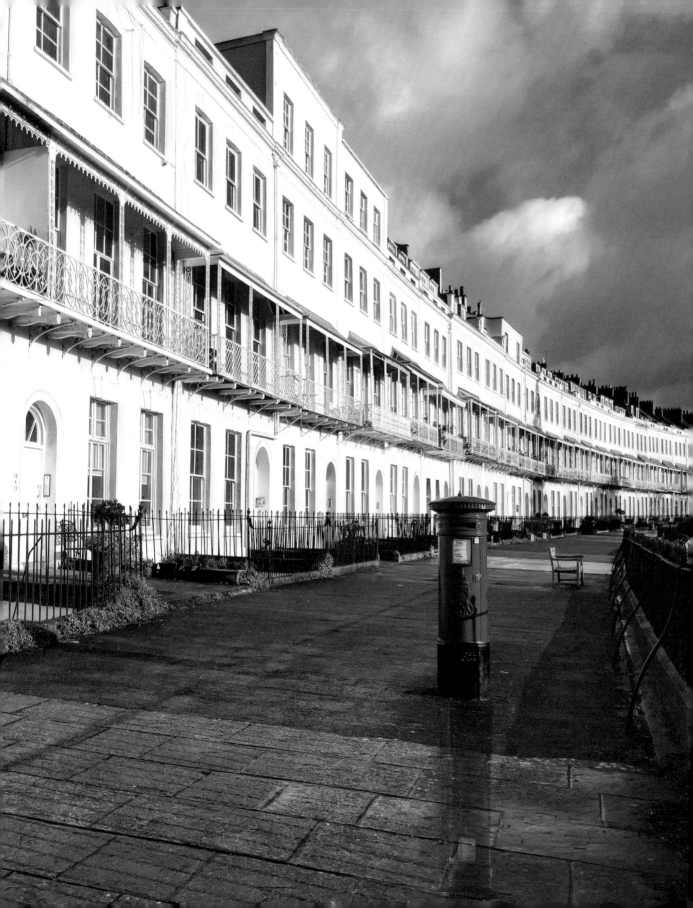

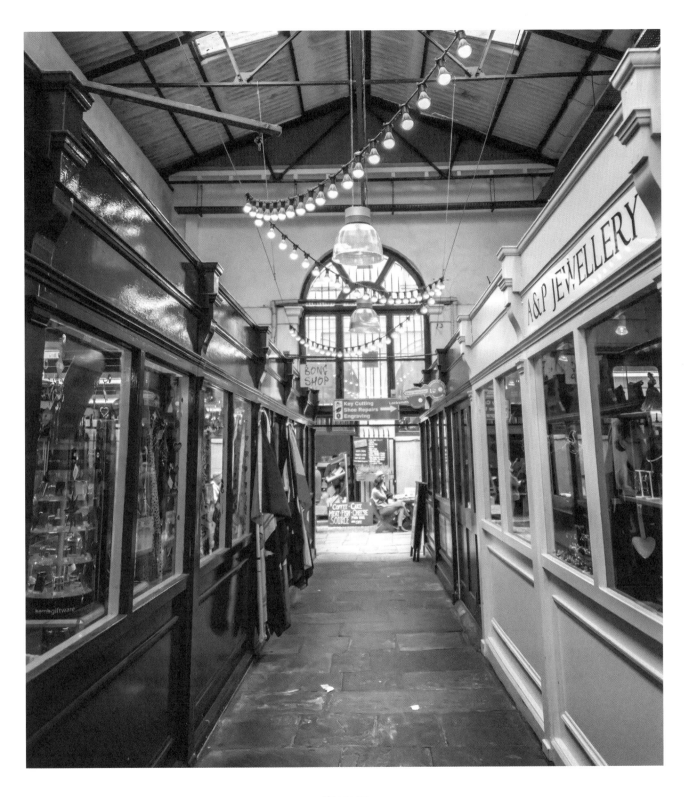

This page:
St Nicholas Market in Bristol is one of the oldest markets in England. A lively mix of market stalls and small shops has persisted here since 1743.
Left:
Apparently endless, the semicircle of Georgian townhouses at Royal York Crescent in Bristol recedes into the distance.

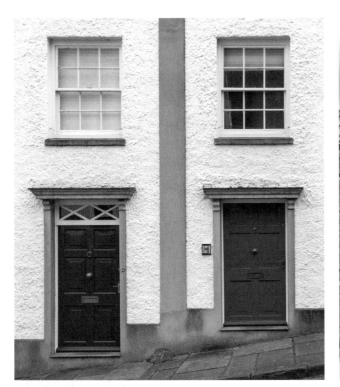

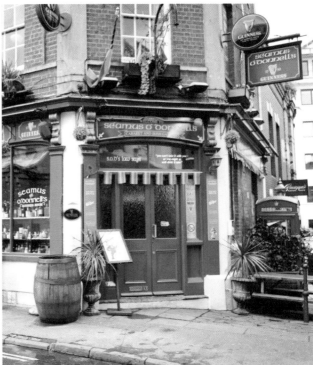

This page:
No shortage of museums, traditional pubs, and stately architecture in Bristol.
Right:
*A close look at the clock at the Corn Exchange reveals two minute-hands. One is a relic of a time
when it wasn't the same time in Bristol as it was in London.*

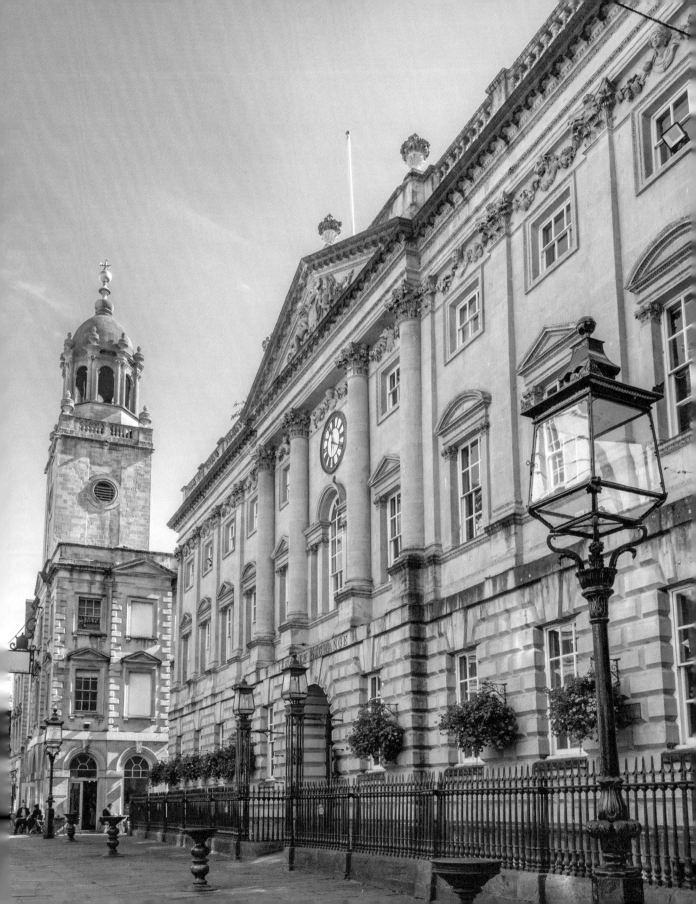

This page:
Many buildings in Bath are constructed from golden-yellow, slow-weathering and thus highly durable Bath Stone.

Right:
Walking through the streets of Bath with its wonderfully old-fashioned storefronts is like a compact form of time travel.

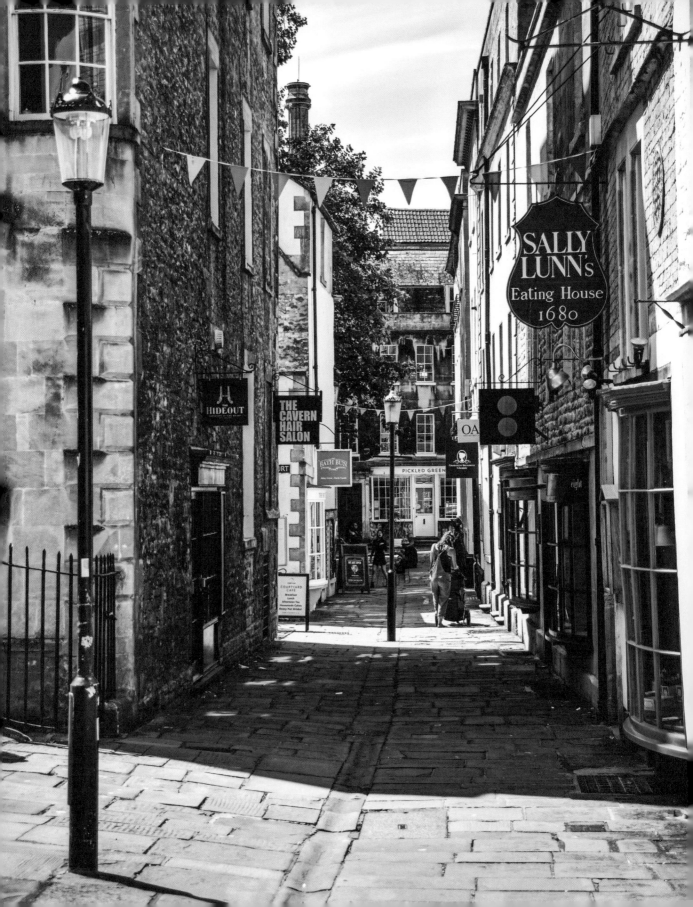

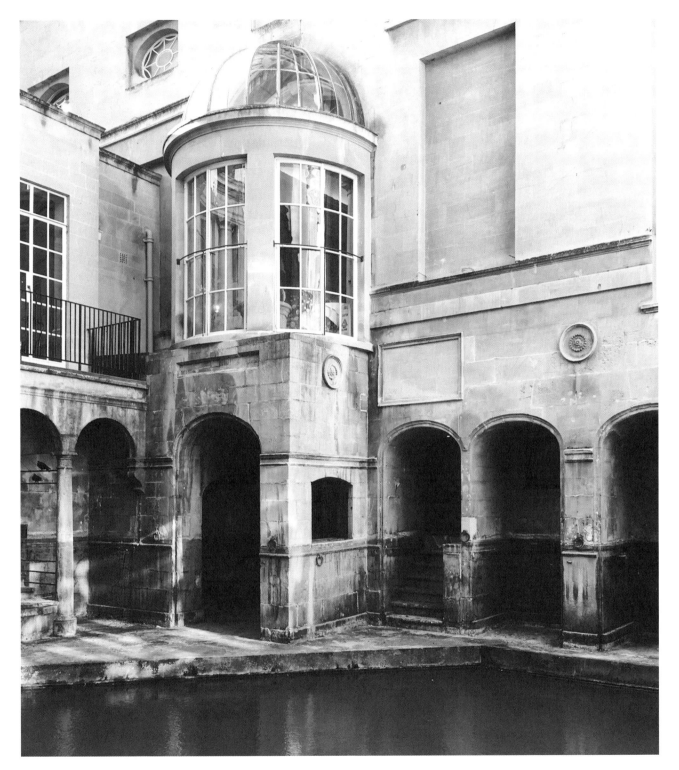

This page:
Two thousand years ago, the Romans erected a temple to Minerva and built thermae over the hot springs at Aquae Sulis, thus laying the foundations of today's Bath.
Left:
One of Bath's oldest buildings, from 1482, houses Sally Lunn's, where you can indulge in a sweet, delectable Bath bun.

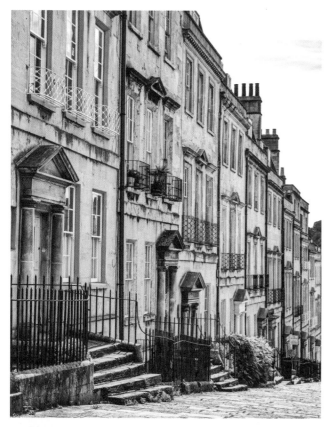

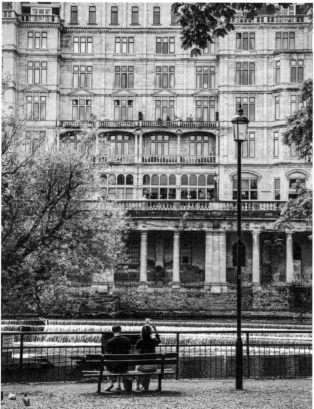
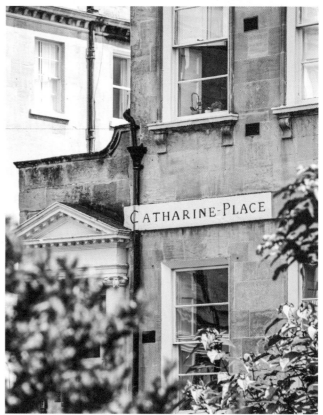

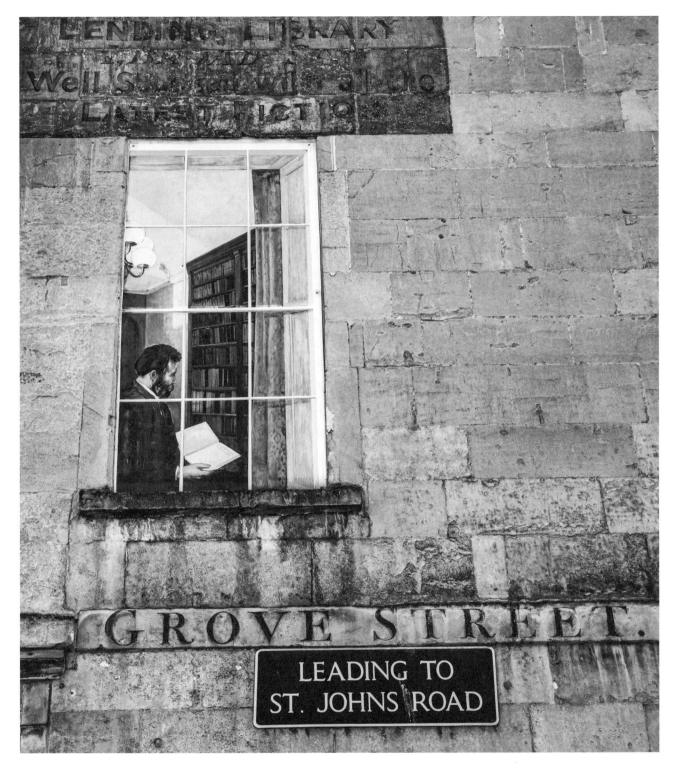

This page:
One of the most famous windows in Bath that isn't: A mural on Grove Street looks onto a literary past, commemorating a book seller that used to operate here.

Left:
Excursion to the eighteenth century: More than 5,000 buildings, many in the Georgian architectural style, qualify Bath as a UNESCO world heritage site.

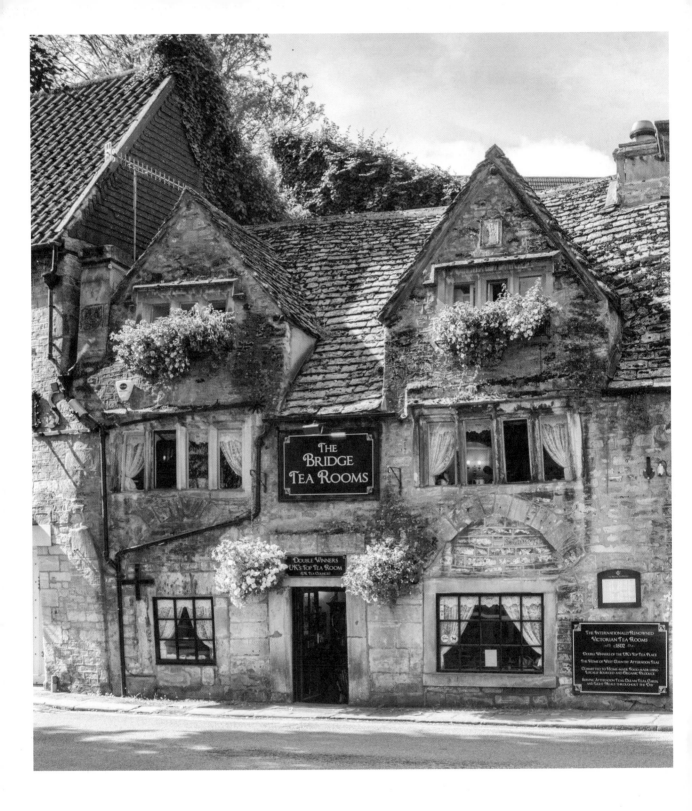

This page:
Quintessential England: Afternoon tea, true to style, in one of the oldest cottages in Bradford-on-Avon, built in 1502.

Right:
Scene from the river: Bradford-on-Avon at its most beautiful.

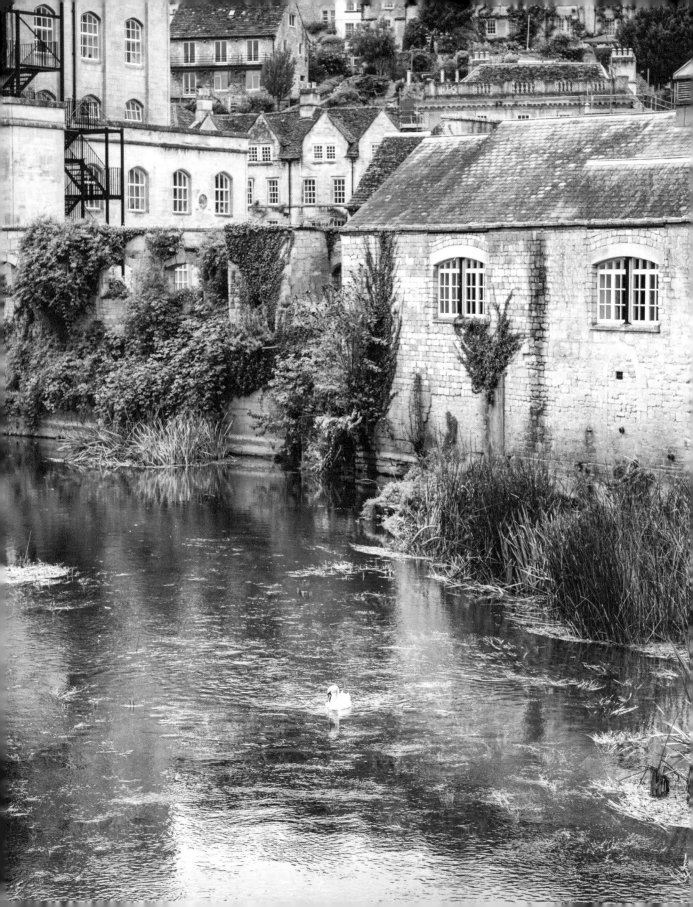

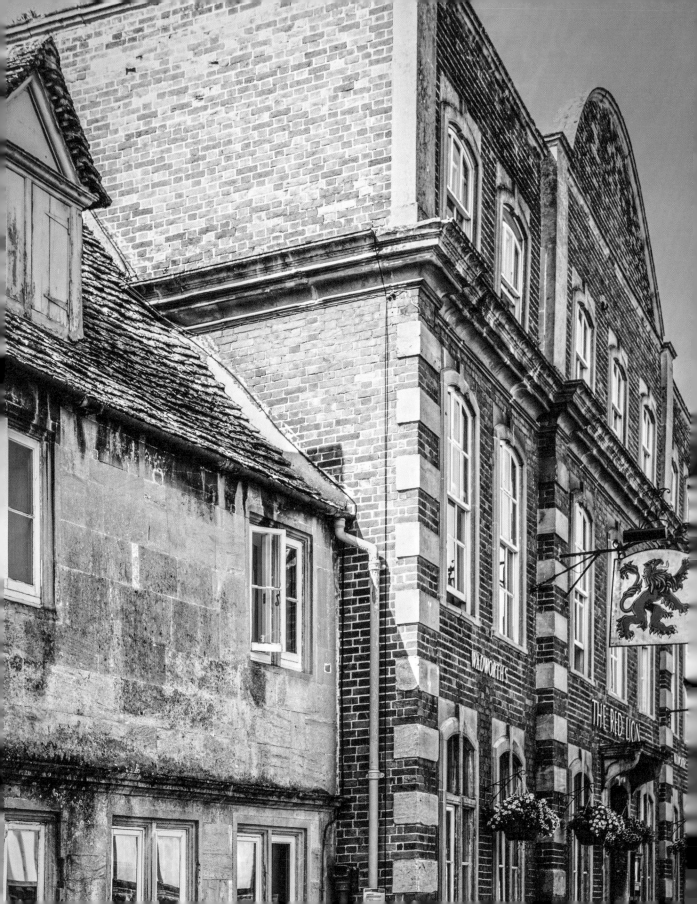

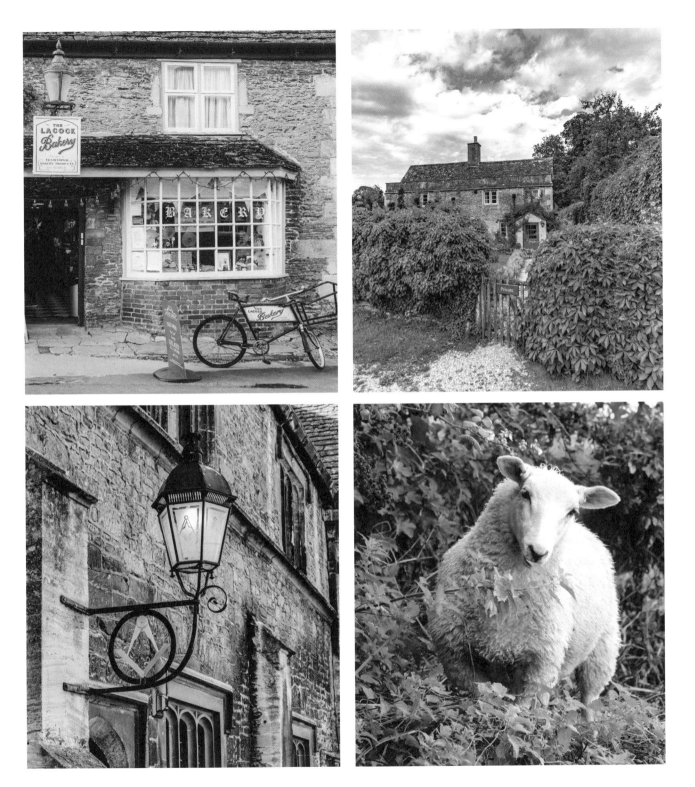

Above and at left:
With four village streets and a charming blend of stone and half-timbered buildings, Lacock in Wiltshire looks today like it did 200 years ago, the perfect setting for grand cinema as well as small, individual memories.

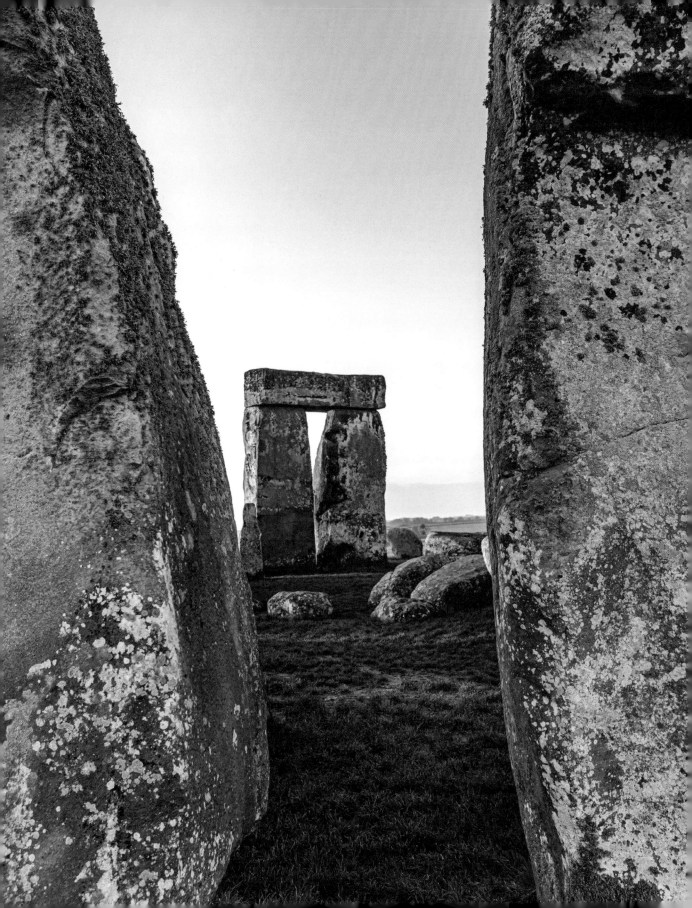

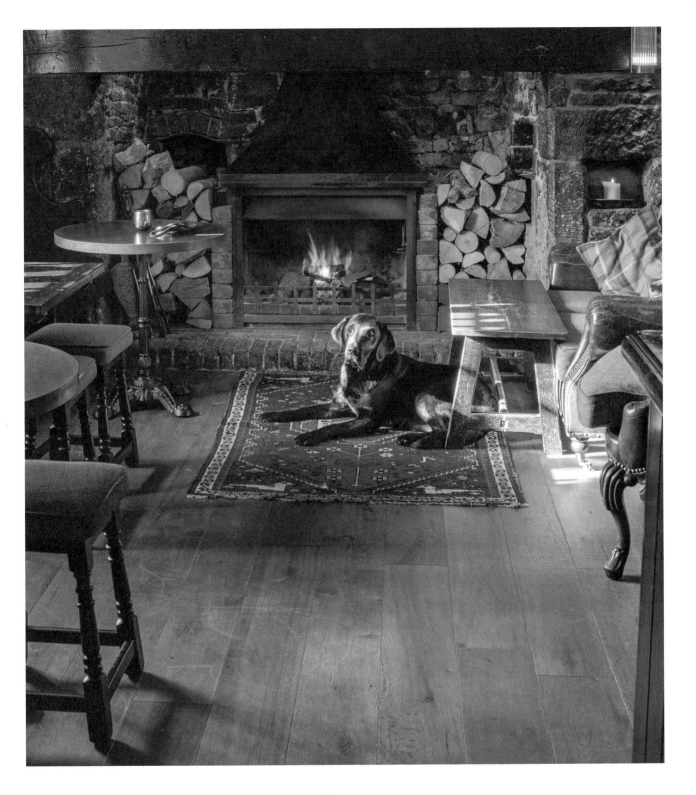

This page:
Cozy pubs and country inns are baked into the culture, an ideal place to go and reflect in front of the fireplace over an ale or a cider...
Left:
Ancient and mysterious: The five-thousand-year-old stone circle of Stonehenge.

This page:
On the Dorset coast, as here in Lulworth Cove, old cottages painted in ice-cream colors furnish
a cheerful, sunny atmosphere.
Right:
The sheer nostalgia of these shops lends so much charm to the old harbor town of Lyme Regis.

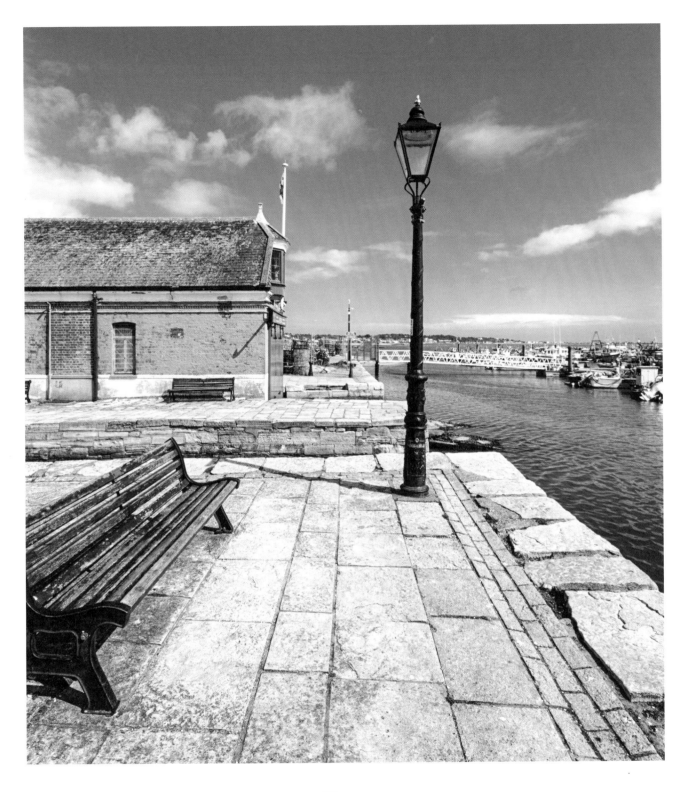

This page:
The Poole Old Lifeboat Museum, idyllically housed in the old RNLI station by the harbor in Poole Quay.
Left:
As far as charming old seaside resorts go, Weymouth has it all: candy-colored little fisherman's huts, lively harborside promenade—and of course, fish & chips.

The South East

FROM OXFORDSHIRE TO SURREY AND KENT

You can catch surprising glimpses inside the dignified walls of Oxford's approximately 40 colleges as you walk through the stately old university city of Oxford, with arcades and turrets everywhere, full of secrets. Radcliffe Camera (the rotunda) and the cathedral-like Divinity School, formerly a lecture hall, give off an air of Hogwarts—perfect for Harry Potter fans looking for something to take a picture of. As you leave Oxfordshire and descend down the valley of the Thames, exploring the south-eastern counties of Sussex, Surrey, and Kent, a wildly romantic paradise unfolds, old manor houses and historic castles, like Scotney Castle and Bodiam Castle, amid estates and parklands and surrounded by moats. Nature is the main event and grandly on display in the true "Garden of England" between London and the coast of the English Channel. Here in Kent—rather than in the eponymous city in the north of England—lies the majestic water castle of Leeds Castle. Fairy-tale views of its thousand-year-old walls open up from all over the sprawling parklands adjacent to it. And then the pilgrimage to the most photogenic sites arrives in Canterbury. For some charming new impressions of this city of bishops, leave the busy alleys of the old town and take a cruise on the River Stour after visiting Canterbury's Norman cathedral. And now, off to Brighton, because the coasts of South-East England also have a lot to offer. On a sunny day, it'll be you and about half of London crowding the pier and up and down the promenade. Still, it's easy to find charming, photogenic angles in the old town by the sea. The brightly colored cabins on the beach in Hove or the motley houses on Blaker Street are definitely very Instagrammable. The medieval town of Rye also invites visitors for an idle stroll up and down its steep cobblestone streets and small alleys, exploring charming scenes with your eyes and your camera lens.

Right:
What are we now, in a land of tea drinkers, enjoying coffee for four hundred years? Credible historical sources have it that the Grand Café on High Street, Oxford, which opened in 1650, may stake its claim as England's oldest coffee house, still serving fine coffees—perhaps with traditional afternoon tea.

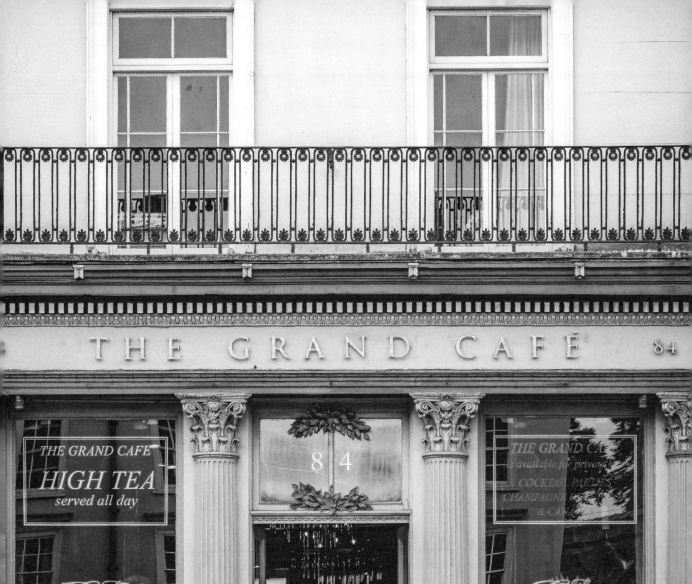

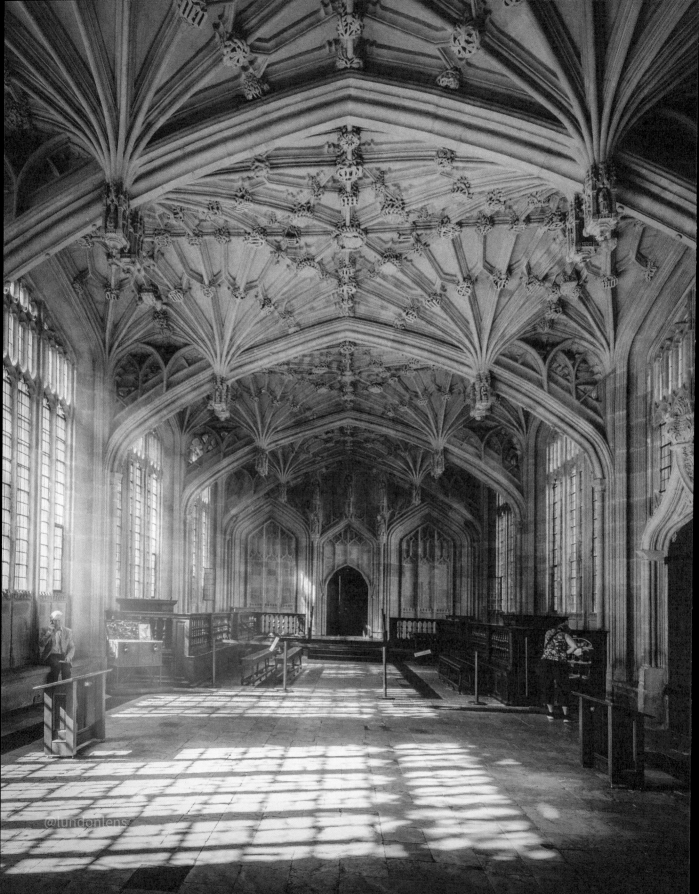

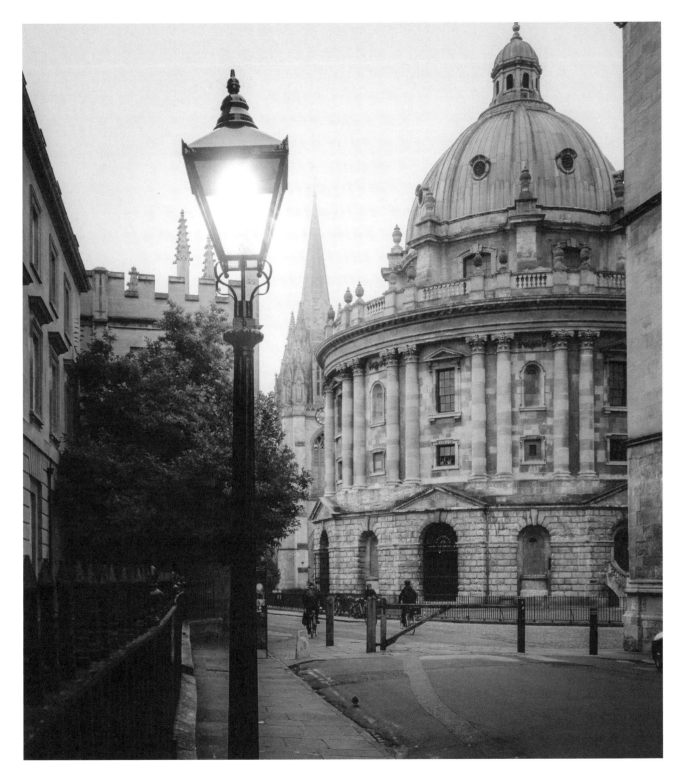

This page:
In the evening, an atmosphere of gnawing secrecy seems to surround Radcliffe Camera, the stately old library building and Oxford's hallmark.

Left:
The posh lecture hall of Oxford Divinity School seems almost enchanted as sunlight slants through the high windows, striking delicate patterns where it falls.

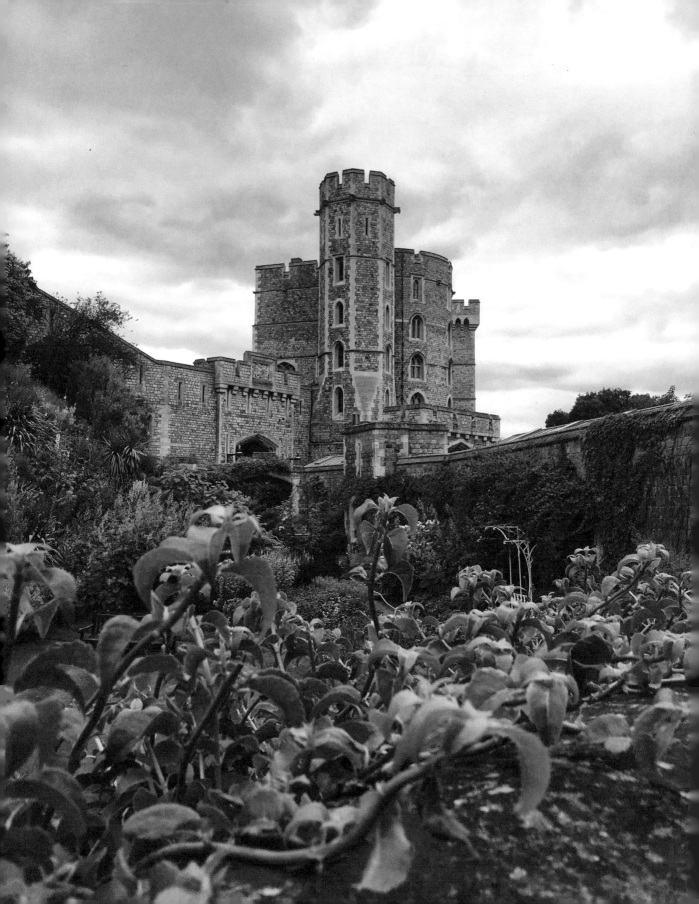

This page:
Many old country homes in the south of England have a secretive, romantic feel.
Left:
Majestic Windsor Castle is one of the chief residences of the British Royal Family.

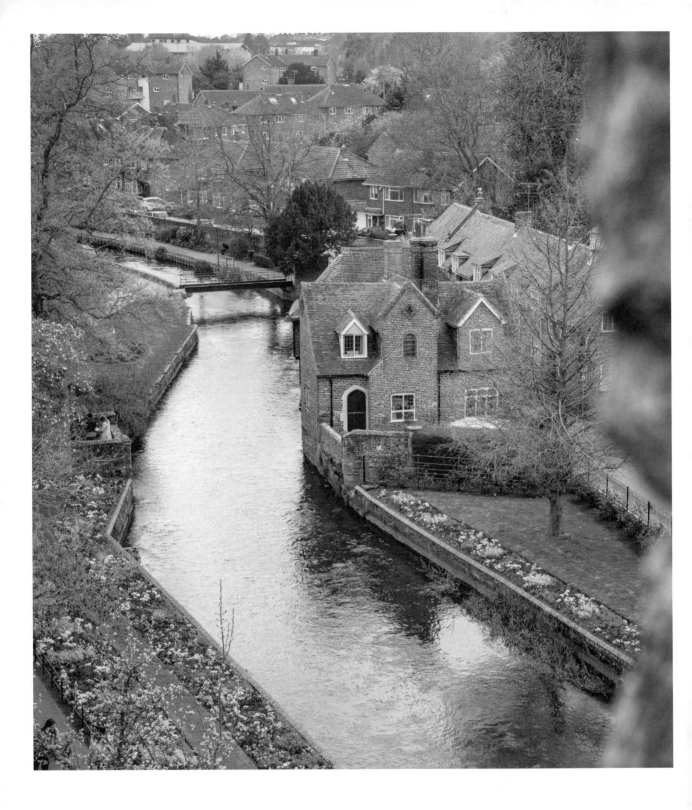

This page:
Picturesque scenes of Canterbury await at Westgate Gardens along the River Stour.
Right:
Drifting across the water while taking in the old town of Canterbury from a new angle.

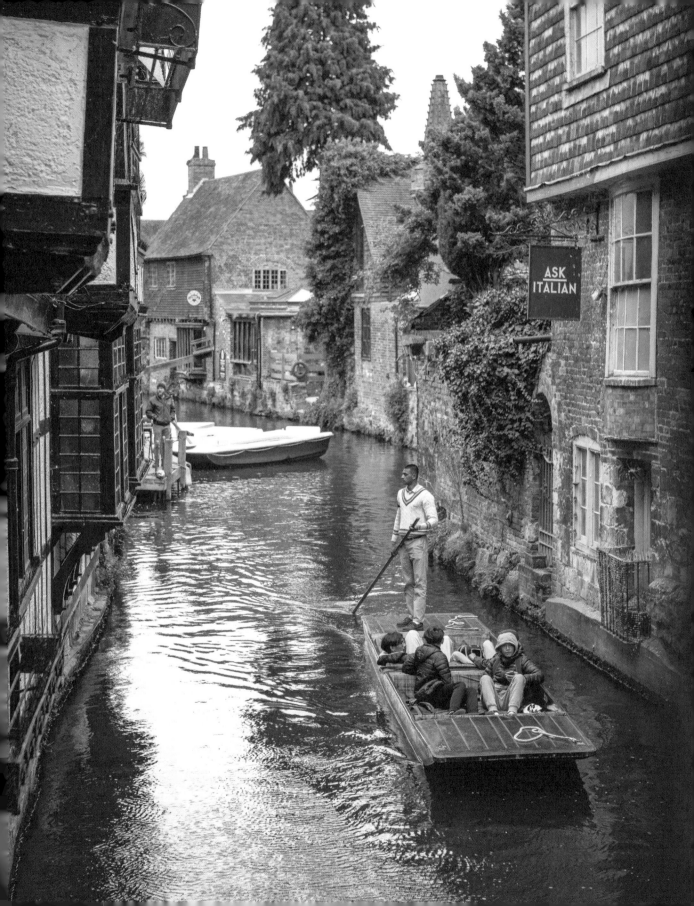

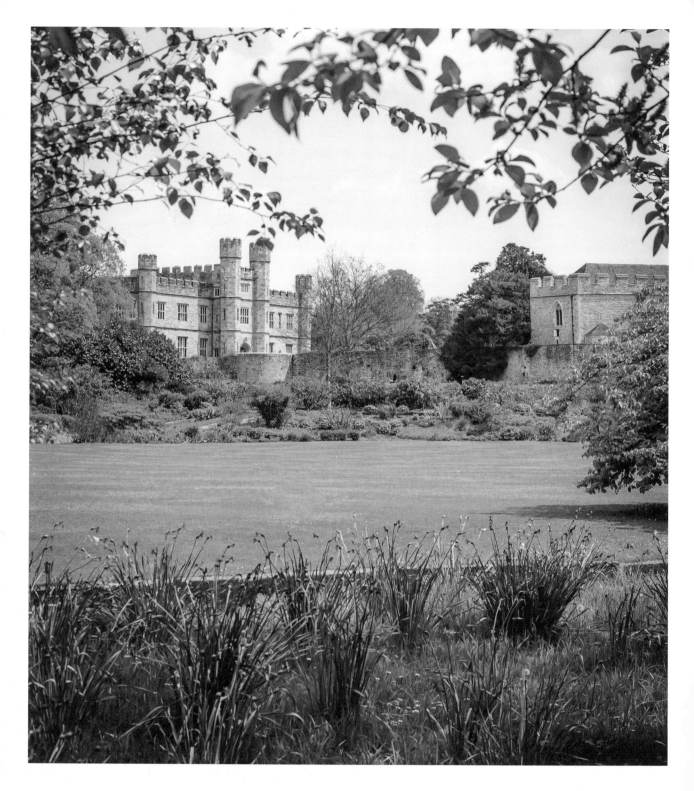

This page:
Leeds Castle in rural Kent became famous as a water castle, but it's also worth a visit just to see the gardens.
Right:
*History runs backwards at Chiddingstone Castle. The Tudor-era castle was remodeled in the style
of the Middle Ages—in the 19th century.*

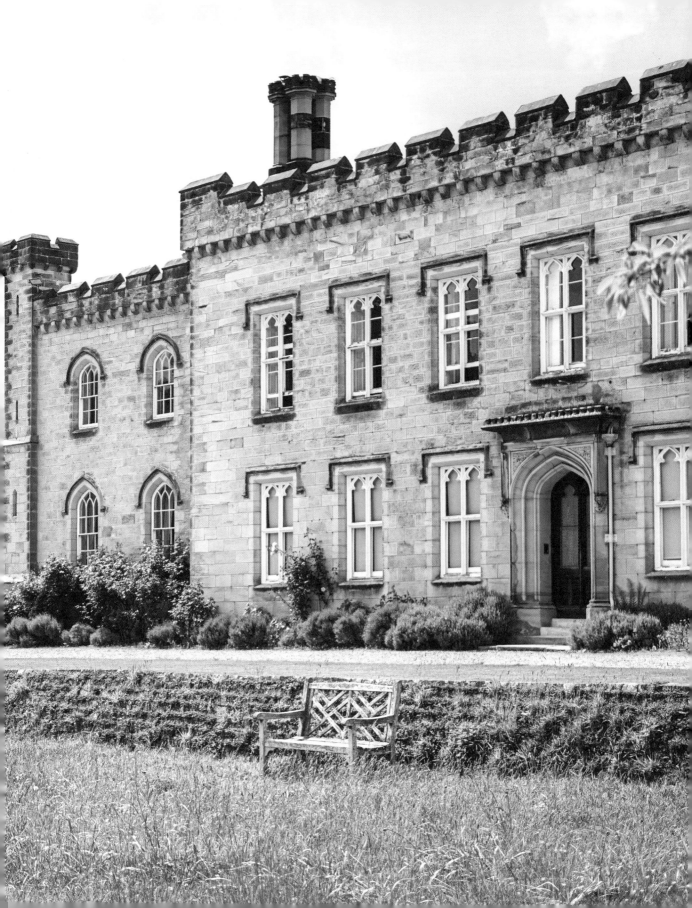

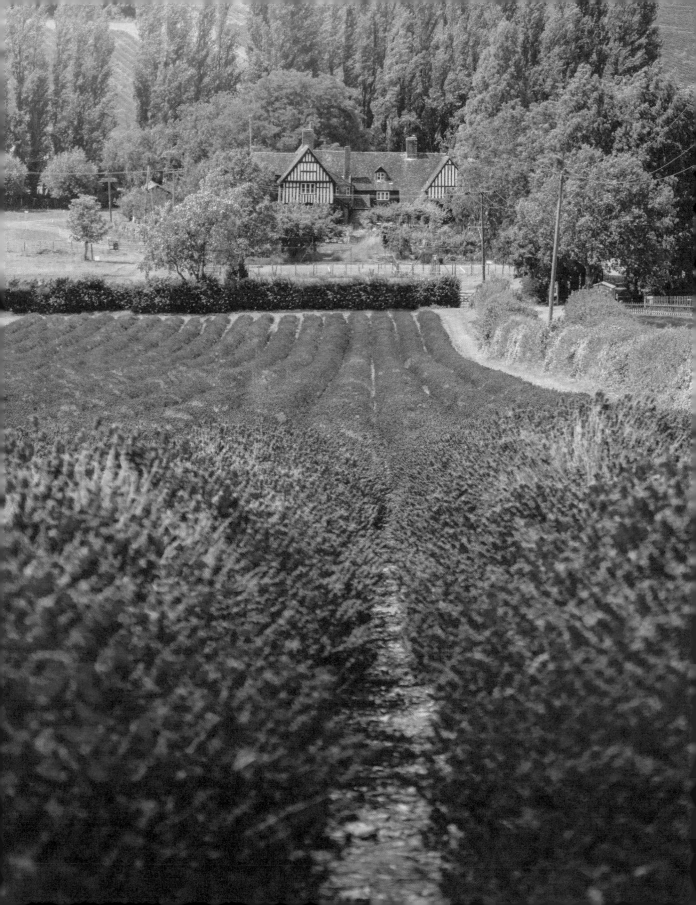

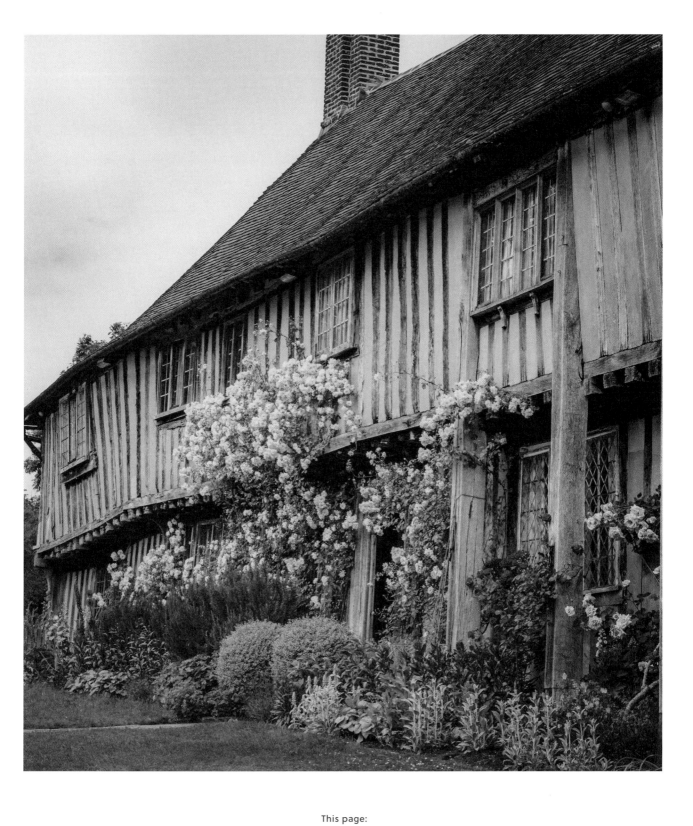

This page:
Smallhythe Place in Kent has an enchanting and decidedly crooked charm, typical of half-timbered buildings from the Tudor period.
Left:
South of France or South England? The lavender at Castle Farm in Kent blooms at least as beautifully as it does in Provence.

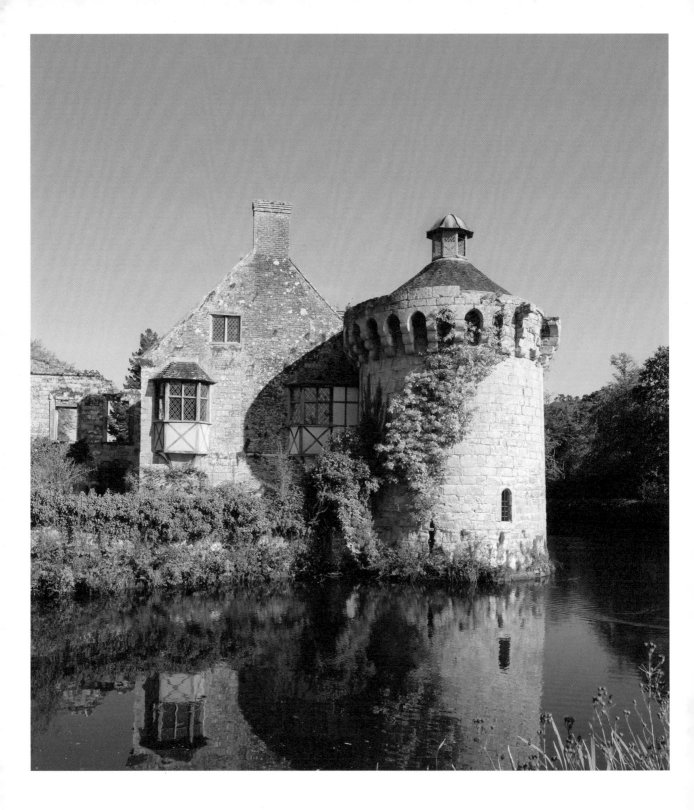

This page:
Ruins of a medieval castle and water lilies on the pond: Scotney Castle in Kent looks sprung from a fairy tale.
Right:
Wonderfully idyllic scenes crop up all over as the Thames flows through Oxfordshire.

HAMPSHIRE CHRONICLE

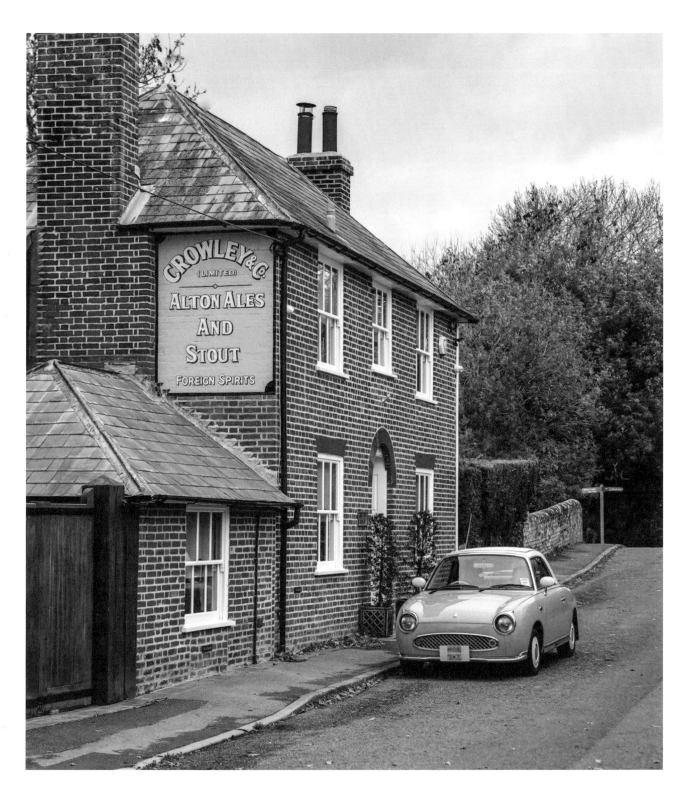

Above and at left:
Now rural, now urban, always full of history: Many discoveries await in the county of Hampshire.

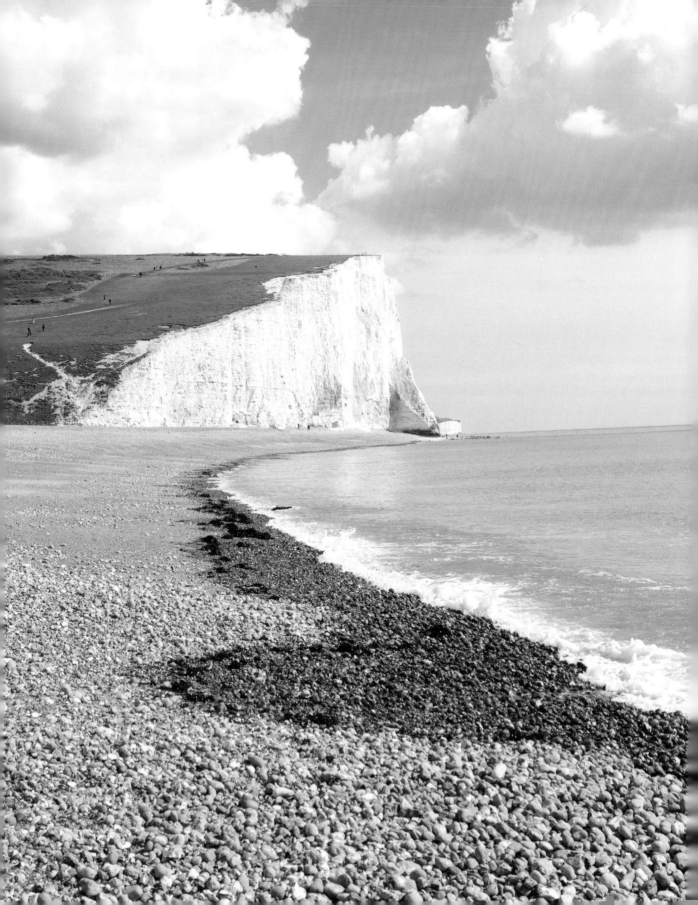

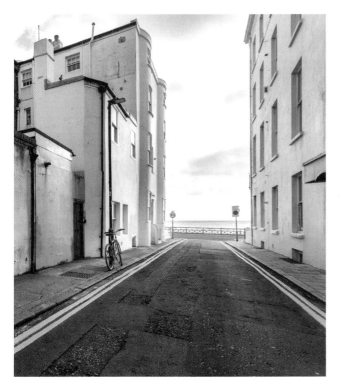

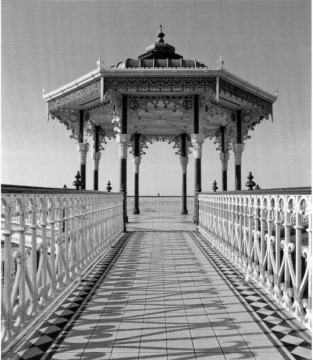

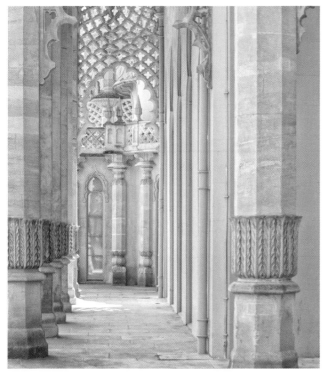

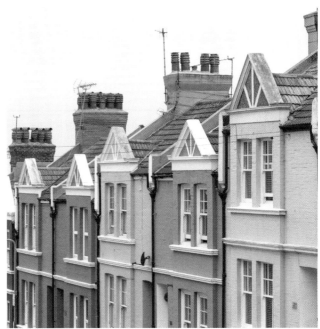

These pages:
The Seven Sisters are chalk sea-cliffs on the English Channel between Brighton (above) and Eastbourne.
Following pages:
Steep cobblestone streets, half-timbered houses with no 90-degree angles, and enchanting glimpses into idyllic
front yards keep coming up in the old inland port town of Rye.

Cover: Michael Sparrow

Backcover: see p. 25, 67 (a.r.), 135

p. 2, 3 Annie Spratt/unsplash, p. 4 Mark/Adobe Stock, p. 5 t-s-v6eWCssM8yE/unsplash, p. 6 Fineas Anton S/unsplash, p. 7 Magdanatka/Shutterstock, p. 9 Alla/Adobe Stock, p. 11 Chris Lawrence/Adobe Stock, p. 15 Liam Pearson, p. 16 Laura/Adobe Stock, p. 17 Liv Cashmann/unsplash, p. 18 Bill/Adobe Stock (a.r.), Stephen/Adobe Stock (b.r), Milosz Maslanka/Shutterstock (a.l) (Andrew Roland/Shutterstock(b.l.), p. 19 Alla/Adobe Stock, p. 20 N000065/unsplash, p. 21 Chris Lawrence/Adobe Stock(a.l.), Alena Veasey/Shutterstock (a.r.), Steven/Adobe Stock (b.l.), Laura/Adobe Stock (b.r.), p.22, 23 Jacob Rossi, p. 24 Nickos/Adobe Stock (a.l.), A/Adobe Stock (a.r.), Alla/Adobe Stock (b.l.), Chris Lawrence/Adobe Stock (b.r.), p. 25 Laura/Adobe Stock, p. 26 William/Adobe Stock, p. 27 Daviddionut/Adobe Stock, p. 28 Liam/Adobe Stock (a.l.), Apisot(Adobe Stock (a.r.), Stephen/Adobe Stock (b.l.), Jo Jones/Shutterstock (b.r.), p. 29 David Hughes/Adobe Stock, p. 30 Joyce Nelson/Shutterstock, p. 31 Jackie Davies/Adobe Stock, p. 32 Ipivorje/Adobe Stock, p. 33 Roserunn/Shutterstock (a.l.), Alena Veasey/Shutterstock (a.r.), Benjamin Elliot/unsplash (2), p. 34 Laura/Adobe Stock, p. 35 Jacob Rossi, p. 36 Colin & Linda McKie/Adobe Stock (a.l.), Benjamin Elliot/unsplash (a.r.), SRSImages/Adobe Stock (b.l.), Bossa Art/Adobe Stock (b.r.), p. 37 Bossa Art/Adobe Stock, p. 38 Matt Letek/unsplash, p. 39 Benjamin Elliot/unsplash, p. 40 Helen Brittain/unsplash, p. 41 Jacob Rossi, p. 42 Antonel/Adobe Stock, p. 43 Jenifoto/Adobe Stock, p. 44 Ray Harrington/unsplash, p. 45 Otto Dan/unsplash p. 46 Roserunn/Adobe Stock (a.l.), Laura/Adobe Stock (r.l.), Josh/Adobe Stock (b.l.), Roserunn/Adobe Stock (b.r.), p. 47 Kay Ransom/shutterstock, p. 48 Suchan/Adobe Stock, p. 49 Lois GoBe/Shutterstock (a.l.), iRStone/Adobe Stock (a.r.), iPics/Adobe Stock (b.l.), IRStone/Adobe Stock (b.r.), p. 50, 51 Liam Pearson, p. 53 Maciek Wróblewski/unsplash, p. 54 Harrison Mitchel/unsplash, p. 55 Luke Raggett (a.l., a.r.), Packshot/Adobe Stock (b.l.), Luke Raggett (b.r.), p. 57 Pxl.store/Adobe Stock, p. 58 Courtesy of The Chesterfield Mayfair (2), Hannah Reding/unsplash (b.l.), James Frewin/unsplash (b.r.), p. 59 Chris Lawrence/Adobe Stock, p. 60 Lenscap50/Adobe Stock, p. 61 Courtesy of Soho House DS Townhouse, p. 62 Lana/Adobe Stock (a.l.), Luke Raggett (a,r,) Aaina Sharma/unsplash (b.l.), Ruben Hannssen/unsplash (b.r.), p. 63 Lana/Adobe Stock, p. 64, 65 Liam Pearson, p. 66 Kristina Blokhin/Adobe Stock, p. 67 Andriy Blokhin/Adobe Stock (a.l.), Sabrina Mazzeo/unsplash (a.r., b.l.), m4x1mvs/unsplash (b.r.), p. 68 Chalres Postiaux/unsplash, p. 69 Courtesy of Jikoni (a.l.), Liam Pearson/Lundonlens/unsplash (b.l.), Samuel Regan Asante/unsplash (b.r.), p. 71, 72, 73 Luke Raggett, p. 75 Samuel Regan Asante/unsplash, p. 76 Normal Rajendharkumar/unsplash, p. 77 Num/Adobe Stock (a.l.), Liam Pearson (3), p. 78 Artiom Vallat/unsplash, p. 79 IWei/Adobe Stock (a.l.), Hulki Okan Tabak/unsplash (a.r.), Liam Pearson (2), p. 81 Annie Spratt/unsplash, p. 82 Luke Raggett, p. 83 Luke Raggett (a.l.), Beataaldridge/Adobe Stock (a.r.), Sampajano-Anizza/Adobe Stock (b.l.), Luke Raggett (b.r.), p. 84 Liam Pearson, p. 85 Luke Raggett, p. 87 Axp-photography/unsplash, p. 88-91Luke Raggett, p.92 Claudio Testa/unsplash (a.l.), Luke Raggett (a.r.), Robert Bye/unsplash (b.l.), Luke Raggett (b.r.), p. 93 Tomas Anton Escobar/unsplash, p. 94 Alex Yeung/Adobe Stock, p. 95, 97 Luke Raggett, p. 98 Nik Guiney/unsplash, p. 99 A-s/unsplash (a.l.), Luke Raggett (a.r.), Raquel Afugu Caliz/Wirestock/Adobe Stock (b.l.), Luke Raggett (b.r.), p.100 Luke Raggett, p. 101 Alla/Adobe Stock, p. 103 Samuel Regan Asante/unsplash, p. 104 Liam Pearson, p.105 OkFoto.it/Adobe Stock (a.l.), Kippis/Adobe Stock (a.r.), Julien/Adobe Stock (b.l.), McoBra89/Adobe Stock (b.r.), p. 106 Charlie Harris/unsplash, p. 107 Timur Valiev/unsplash, p. 109 Alexey Fedorenko/Adobe Stock, p. 110 Chris/Adobe Stock (a.l.), Packshot/Adobe Stock (a.r.), Luke Raggett (b.l.), Alla/Adobe Stock (b.r.), p. 111 Amadeusz Misiak/unsplash, p. 112 Liam Pearson, p. 113 Picturesque/Adobe Stock (a.l.), Alla/Adobe Stock (a.r.), Dbrnhrj/Adobe Stock (b.l.), Luke Raggett (b.r.), p. 114 Alla/Adobe Stock, p. 115 Liam Pearson, p. 116 Yomex Owo/unsplash (a.l.), Max Letek/unsplash 8a.r.), Chris Johnson/unsplash (b.l.), Wren/unsplash (b.r.), p. 117 Tom Podmore/unsplash, p.118 Liam Pearson, p. 119 Chikashi Miyamoto/unsplash, p. 121 Darren Richardson/unsplash, p. 122 Jeffrey Zhang/unsplash, p. 123 Mark Mc Neill/unsplash (a.l.), Helen Hotson/Adobe Stock (a.r.), Andrew Ridley/unsplash (b.l.), Bruce Edwars/unsplash (b.r.), p. 124 Jacob Rossi, p. 125 Eranjan/unsplash, p. 126 Swan Liu/Adobe Stock (a.l.), Jonny Gios/unsplash (a.r.), Victor Lord Denovan/Adobe Stock (b.l.), Joe888/Adobe Stock (b.r.), p. 127 Joe888/Adobe Stock, p. 128 Illiya-Vjestica/unsplash, p. 129 Jacob Rossi, p. 130 Liam Pearson, p. 131 Nicola/Adobe Stock, p. 132 Illiya-Vjestica/unsplash, p. 133 Illiya-Vjestica/unsplash, p. 134 Sarah Hpn/unsplash, p. 135 cktravels.com/shutterstock, p. 136 Anton Ivanov/Shutterstock (a.l.), Chris Lawrence/Shutterstock (a.r.), Mike Workman/Shutterstock (b.l.), cktravels.com/Shutterstock (b.r.), p. 137 Clare Louise Jackson/Shutterstock, p. 139 Stephen Kidd/unsplash, p. 140 Rob Potter/unsplash (a.l.), Stephen Kidd/unsplash (a.r.), Michael Cummins/unsplash (b.l.), Eranjan/unsplash (b.r.). p. 141 Roxxie Blackham/unsplash, p. 142 Nicky King, p. 143 Nicky King, p. 144 Lois GoBe/Shutterstock (a.l.), Sue Burton Photography/Shutterstock (a.r.), Christine Dodd/Shutterstock (b.l.), Andy Millard/Adobe Stock (b.r.), p. 145 David Hughes/Adobe Stock, p. 146 Christopher Eden/unsplash, p. 147 Liam Pearson, p. 148 Gb27photo/Adobe Stock, p. 149 Inga/Adobe Stock, p. 150 Liam Pearson (a.l.), Anna Mould/unsplash (a.r.), Tom Juggins/unsplash (b.l.), Anna Mould/unsplash (b.r.), p. 151 Katarzyna Korobczuk/unsplash, p. 152 Bogdan Todoran/unsplash, p. 153 Fatih/unsplash, p. 154 Samuel Regan Asante/unsplash (a.l.), Samuel Regan Asante/unsplash (a.r.), Colin Watts/unsplash (b.l.), K Mitch Hodge/unsplash (b.r.), p. 155 Arthur Tseng/unsplash, p. 156 David Calvert/Adobe Stock (a.l.), Derek/Adobe Stock (a.r.), David Calvert/Shutterstock (b.l.), Bobby Allen/unsplash (b.r.), p. 157 KimJane1/Shutterstock, p. 158 Angela Giovanna/Lensereflection, p. 159 Liam Pearson (3), Bobby Allen/unsplash (b.l.), p. 161,162 Liam Pearson, p. 163 Angela Giovanna/Lensereflection (a.l.), Jacob Rossi (a.r.), Liam Pearson (b.l.), Angela Giovanna/Lensereflection (b.r.), p. 165 Richard Semik/Shutterstock, p. 166 Andy Newton/unsplash, p. 167 Delphotostock/Adobe Stock, p. 168 I-Wei Hung/Adobe Stock (a.l.), Hector/Adobe Stock (a.r.), Electric Egg Ltd/Adobe Stock (b.l.), Sonia Bonet/Adobe Stock (b.r.), p.169 Dudlajzow/Adobe Stock, p. 170 Liv Cashmann/unsplash, p. 171 Lucy Claire/unsplash, p. 172 Liv Cashmann/unsplash, p. 173 Eleanor Brooke/unsplash, p. 174 Liv Cashmann/unsplash (4), p. 175 Liv Cashmann/unsplash, p. 176 Travellight/Shutterstock, p. 177 Kathy Huddle/Adobe Stock, p. 178 Susan Vineyard/Adobe Stock, p. 179 Eleanor Brooke/unsplash (a.l.), Rpbmedia/Adobe Stock (a.r.), Nina/Adobe Stock (b.l.), hal_pand_108/Adobe Stock (b.r.), p. 180 Hulki Okan Tabak/unsplash, p. 181 Michael Cummins/unsplash, p. 182 Alla Tsyganova/Shutterstock, p. 183 Georgethefourth/Shutterstock, 184 Naffarts/Shutterstock (3), Neil Lang/Shutterstock (b.l.), p. 185 Helen Hotson/Shutterstock, p. 187-189 Liam Pearson, p. 190 Laura Lugaresi/unsplash, p. 191 Alicia Slough/unsplash, p. 192,193 Liam Pearson, p.194 Hardyuno/Adobe Stock, p. 195 Yanny Mishchuk/unsplash, p. 196,197 Liam Pearson, p. 198 Steve Payne/unsplash, p. 199 Benjamin Elliot/unsplash, p. 200 Chris Dorney/Adobe Stock, p. 201 Luke Raggett, p. 202 alice_photo/Adobe Stock, p. 203 SearchingForSatori/Adobe Stock (a.l.), sammyone/Adobe Stock (a.r.), Eyewave/Adobe Stock (b.l.), Chopard Photography/Adobe Stock (b.r.), p. 205 Alla Tsyganova/Shutterstock (a.l.), Cyberian94/Adobe Stock (a.r.), Helen Hotson/Adobe Stock (b.l.), Alena Veasey/Shutterstock (b.r.), p. 207 Alexey Fedorenko/Shutterstock.

Illustrations map p. 12-13: Morphart Creation/Shutterstock, Olesya Neverova/Shutterstock, canicula/Shutterstock, Roman Ya/Shutterstock

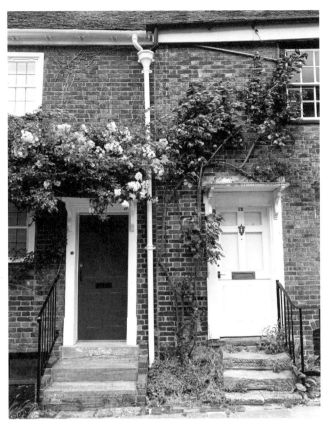

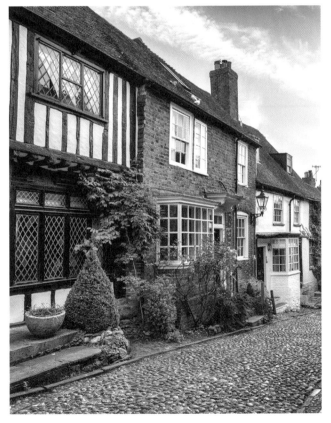

GUINNESS
IS GOOD
FOR YOU

GIVES YOU STRENGTH

THANK YOU, FOLKS!

A book is never created in isolation; it always requires one essential element: the right people. I would like to extend a special thank you to Anja Klaffenbach for her inspiring texts, which form the heart of this work. I am grateful to Eva Stadler for her keen eye in layout and design, which gives the book its distinctive charm. I also thank John A. Foulks for his excellent translation, which has allowed me to bring my thoughts and ideas to life in a new language.

I hold deep admiration for the photographers whose works give this book its visual depth. My particular thanks go to Liam Pearson (@lundonlens), Luke Raggett (@luke_through_my_lens), Nicola King (@peakdistrict_lady), Angela Giovanna/AJ Photography (@lensereflection), and Jacob Rossi (@jacobxrossi).

Additionally, I would like to extend my gratitude to the following image contributors (see previous page).

Your support and creativity have made this book possible. It is always something special to work with the fantastic team at teNeues. Thank you, folks!

Heide Christiansen began her career as a photo editor at a renowned travel magazine and has also achieved bestseller status as an author of her own books. Born and raised in Canada, with family in Australia, Canada, and the United States, she is an enthusiastic globetrotter. She particularly enjoys traveling to England, not only for the language but also for its unspoiled nature and the people who remind her of home. London, full of inspiration and versality, is one of her favorite cities.

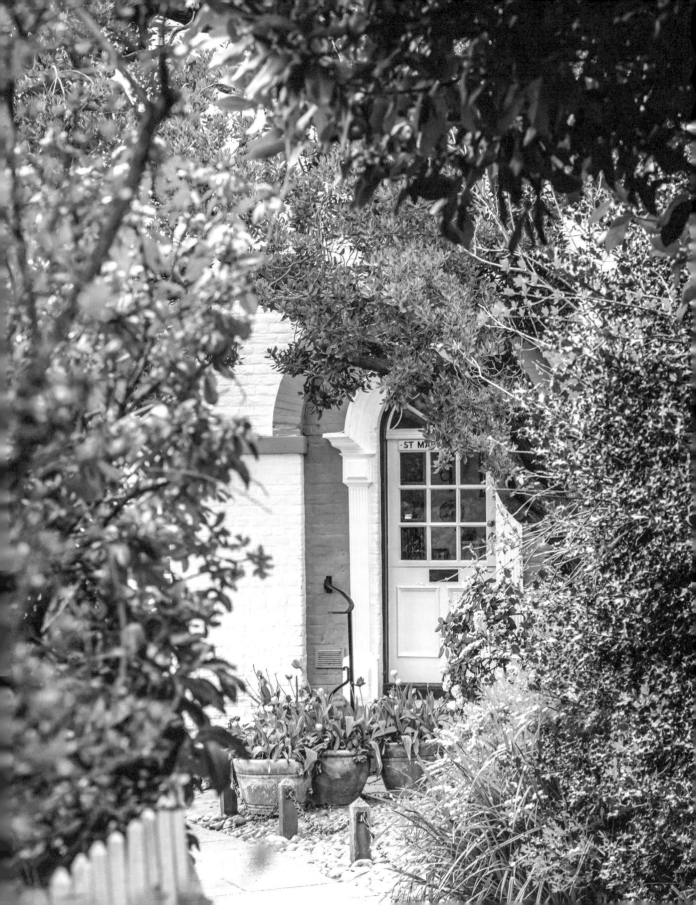

CHARMING ENGLAND
HEIDE CHRISTIANSEN

This book was conceived, edited, and designed by teNeues.

Edited by teNeues

Authorship and concept by Heide Christiansen
Text by Anja Klaffenbach
Translation by John Augustus Foulks

Editorial Management by Dr. Johannes Abdullahi
Design by Eva Stadler
Layout by Eva Stadler
Photo Editorial by Heide Christiansen
Cartography by Thomas Vogelmann
Edited by Benine Mayer
Proofread by Simona Fois
Production by Sandra Jansen-Dorn, Alwine Krebber, Robert Kuhlendahl

Printed in Czech Republic by PBtisk

Made in Europe

Published by gestalten, Berlin 2025
ISBN 978-3-96171-628-9
Library of Congress Cataloging-in-Publication data is available from the publisher

1st printing, 2025

The german edition is available under
ISBN 978-3-96171-654-8.

For more information, and to order books, please visit
www.teneues.com and www.gestalten.com

Die Gestalten Verlag GmbH & Co. KG
Mariannenstrasse 9–10
10999 Berlin, Germany
hello@gestalten.com

Düsseldorf Office
Waldenburger Straße 13
41564 Kaarst, Germany
verlag@teneues.com

teNeues Press Department
presse@teneues.com

Bibliographic information published by the Deutsche Nationalbibliothek. The Deutsche Nationalbibliothek lists this publication in the Deutsche Nationalbibliografie; detailed bibliographic data is available online at www.dnb.de

https://instagram.com/teneuespublishing

www.teneues.com